Plastics as Sculpture

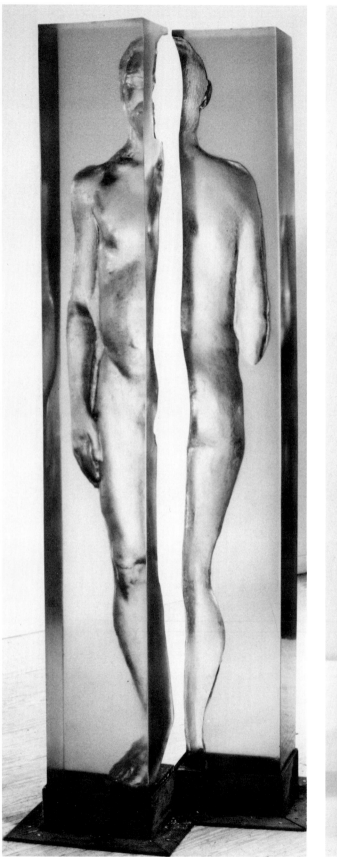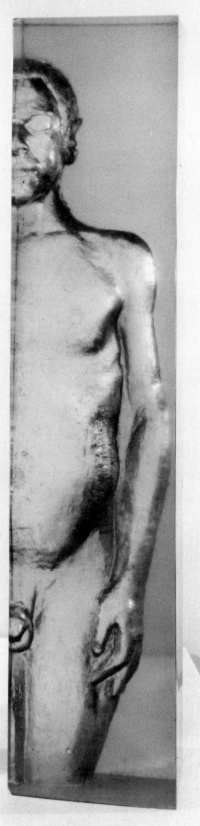

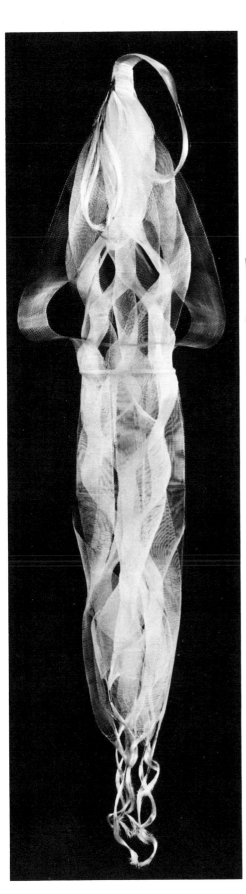

Plastics
as
Sculpture

Thelma R. Newman

Chilton Book Company
Radnor, Pennsylvania

Also by Thelma R. Newman

Plastics as an Art Form,
 published by Chilton Book Company
Plastics as Design Form,
 published by Chilton Book Company

Contemporary Decoupage
Creative Candlemaking
Leather as Art and Craft
Paper as Art and Craft
Wax as Art Form

Photos by the author
unless otherwise noted

Pictures on title page, from the left: *Imprints in the Void, Series #1* created by Marietta Warner Siegel. *Untitled* (1972) created by Marietta Warner Siegel. *Amiyose III* created by Kay Sekimachi.

Copyright © 1974 by Thelma R. Newman
First Edition All Rights Reserved
Published in Radnor, Pa., by Chilton Book Company
and simultaneously in Ontario, Canada,
by Thomas Nelson & Sons, Ltd.
Designed by Cypher Associates, Inc.
Manufactured in the United States of America

Library of Congress Cataloging in Publication Data

Newman, Thelma R.
 Plastics as sculpture.

 Bibliography: p.
 1. Plastic sculpture. I. Title.
NB1270.P5N48 731.4 74-691
ISBN 0-8019-5767-2

Preface

Plastics as Sculpture is a source book that
finely focuses on the processes and tools
needed to create sculptures from plastics.
It attempts to translate from the technical
those specific ideas that are most relevant. In
distilling ideas and concepts from industrial
approaches, *Plastics as Sculpture* presents
complete ideas so that one can actually create
a sculptural form of plastic without necessarily
looking for other resources. In doing so, even
supply sources are given.

Technical terms are not denied the reader
but are described here, because if one is to
go on to deeper explorations with plastics it
is necessary to use this specialized vocabulary,
particularly when communicating with those
in the trade.

There are some processes and polymers
that have not been discussed in depth because
of their esoteric nature. Their rare use does
not warrant in-depth description but, rather,
passing comment. Wherever possible,
concepts have been left open-ended so that
the artist's own imagination can take over to
expand plastics' possibilities into yet
undiscovered realms. There are no
trepidations on the part of the many artists
who contributed their processes and creative
efforts to this book because these secure
people have faith in the uniqueness of each
man—belief that every person has his own
way of seeing, interpreting, and performing.
The same plastic and the same process are
capable of producing countless variations.
That is the excitement of these versatile,
remarkable materials.

T.R.N.

Acknowledgments

Plastics as Sculpture focuses on a specialized group of people who have learned how to communicate with these "new" plastics. The broad scope of art pictured within this book owes its presence to the co-operation of art galleries, museums, suppliers, and artists. I thank all these people, particularly Remsen Wood of the Diffraction Co.

Special gratitude goes to Harriet FeBland, Eugene Massin and Julia Busch, Ralph and Sylvia Massey, Vasa and Albert Vrana for their great process photos and descriptors.

To Norm Smith, who processed my own photos, goes continuing thanks; and most of all to my "quartermastering" husband Jack and sons Jay and Lee goes unending gratitude for their boundless help and support.

Contributing *Artists and Architects*

Leo Amino
John de Andrea
Arman
Michael Bakaty
Valerie Batorewicz
Bruce Beasley
Feliciano Bejar
Fletcher Benton
Roger Bolomey
Martha Boto
Hans Breder
Robert Breer
Julia Busch
Achille and
 Pier Giacomo
 Castiglioni
Wendell Castle
Michael Chilton
John Claque
Bruce Dexter
Albert G. H. Dietz
Fred Dreher
Felix Drury
Jean Dubuffet
Alfred Duca
Marcel Duchamp
Fred Eversley
Harriet FeBland
Mary Fish
Sue Fuller

Naum Gabo
Daniel Grataloup
Francoise Grossen
Aaronel deRoy Gruber
Ted Hallman
Duane Hanson
Paul P. Hatgil
Ray Hitchcock
Anthony Hollaway
Tom Hudson
Wayne Jewett
Craig Kauffman
Leonard King
Phillip King
William King
Joseph Konzal
Kosice
Ugo LaPietra
Les Levine
Liliane Lijn
Arlene Love
Jeff Low
Ronald Mallory
Angelo Mangiarotti
Marisol
Ralph Massey
Sylvia Massey
Eugene Massin
Ed McGowin
Laszlo Moholy-Nagy

Frank Nakos for
 Greg Copland, Inc.
Jay Hartley Newman
Lee Scott Newman
Thelma R. Newman
Peter Nicholson
Helen Pashgian
Antoine Pevsner
Polesello
V. V. Rankine
Sara Reid
William P. Reiman
Sam Richardson
Theodore Roszak
Michael Sandle
Jacques Schnier
Lillian Schwartz
Robert S. Schwarz
Kay Sekimachi
Marietta Warner Siegel
Neal Small
Sobrino
Curtis Stephens
William Tucker
Vasa
Albert Vrana
Willet Studios
Fred Williams
Arlene Wingate
Yvaral

Contents

CHAPTER 5
Foaming, Buttering, Modeling, and Working with Fibers and Films

CHAPTER 6
Mold Making

CHAPTER 7
Large and Monumental Sculptures as Architectural Components

Plastics as
Sculpture

1
A Revolution in Sculptural Form

Until the twentieth century, sculpture was limited by conventions of material and conception. The major materials for sculpture up to that time were stone, marble, or bronze. Working in those media required a great deal of time and patience, and there was considerable concern that a work would last in terms of its content as well as its physical presence. This accounts, largely, for the universally figurative subject matter. Compositional concerns centered around the positioning of the figure, since the figure, in fact, was the work. Handling of surface textures, such as treatment of hair and of draperies, constituted problems of technique which provided some variety along with the structure and proportion of the figure. Different stylistic considerations bear similarities within different periods: classical Greek proportions differed from the elongations of mannerist figures, but both were figurative conceptions. Experiments with wood, wax, and plaster, still centering around the figure, were never grouped with major works; they were minor media. Important sculpture was made from important, difficult materials. The use of color with major works was unheard of, with the exception of the polychromed sculpture of the Egyptians and early Greeks and the wooden sculptures of medieval times. Conventions dictated by materials were not solely responsible for the path of sculpture's development. The predominant anthropomorphism of most cultures proscribed the evolution of alternative compositional and perceptual schemes, and that same attitude explains the curious stylistic conventionality that existed for so long. As Alexander Archipenko noted (in 1960), Egyptian style influences existed for 5,000 years, Gothic for 500 years, and Cubist for 10 years. Today style seems to be a seasonal performance.

Suddenly, in the twentieth century, sculptors seem to be no longer bound by stylistic conventions. Whereas painting was released from tradition gradually through the increasing ab-

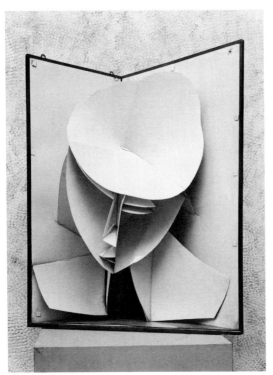

Naum Gabo made this construction, *Head of a Woman* (1917-20), in celluloid and metal, defying centuries of tradition that had dictated modeling of forms in clay, bronze, stone, or wood, always after man's image. *Courtesy: The Museum of Modern Art, New York*

straction of figurative subject matter and compositional treatments, the primary relationships of painter to paint and canvas remained the same. But sculpture was catapulted into this century by the combination of social influences and new materials and techniques. Radically different directions for sculpture emerged. Constructivism found its impetus in modern structural engineering; surrealist directions were influenced by the new field of psychology and Freudian interpretations of the subconscious mind; kinetic sculpture and object art were bred of a new concern with mathematical functions. Early symbolizations of latent energy become actual movement in later sculpture.

The conceptualization of sculpture emerges as an important element of the art. As early as 1920, Antoine Pevsner and his brother, Naum Gabo, wrote in their *Realist Manifesto* that "the tone of a substance, i.e., its light absorbing body, is its only pictorial reality." Light, air, and transparent volumes become important concerns, and Moholy-Nagy carried the early light concepts farther with his space modulators of clear heat-formed acrylic. And, as space, light, and time replaced traditional concerns with mass and volume, sculpture was freed of environmental constraints. The pedestal was no longer necessary as a base; sculpture could float on water, hover in air, emerge directly from the ground. Subject matter was no longer imitative.

But in the first half of this century sculpture still was always an object. More recent sculpture has attempted to go beyond this, by emphasizing the means rather than the ends. Sculpture might be a single process-oriented idea. Whereas once sculpture was of stone, marble, or bronze—made to last forever—process and concept sculpture is intentionally temporary, transitory, even fleeting. Lasting forever is not a concern and, often enough, is an end to be avoided.

Although process/concept sculpture can wrap a building or plow a field in huge proportions, monumental forms are still wedded to architecture as outstanding entities giving status to specific environments. And modern sculpture has also developed in the direction of more individual works. New materials have made the process of production easier, and

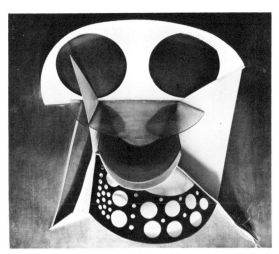

Naum Gabo's brother, Antoine Pevsner, worked similarly in his construction, *Bust* (1923-24), with celluloid and metal by abstracting from a woman's portrait. *Courtesy: The Museum of Modern Art, New York*

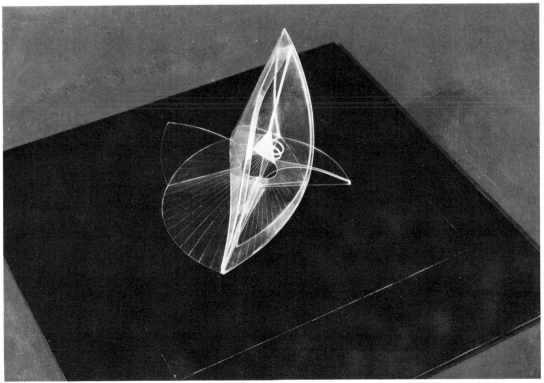

Acrylic made its debut in 1936 and Naum Gabo used it for his construction, *Spiral Theme* (1941), utilizing acrylic's light-piping property along the edges and incising lines on some surfaces. *Courtesy: The Museum of Modern Art, New York*

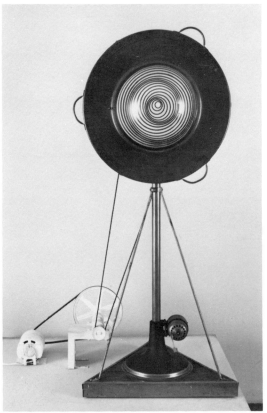

Marcel Duchamp combined wood, metal, and a clear plastic dome, probably made of an alkyd, in his *Rotary Demisphere (Precision Optics)* in 1925. *Courtesy: The Museum of Modern Art, New York*

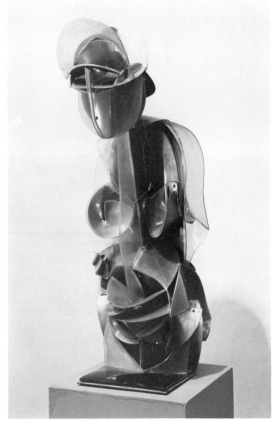

Antoine Pevsner's *Torso* (1924-26), in a clear plastic (probably an alkyd) and copper. *Courtesy: The Museum of Modern Art, New York*

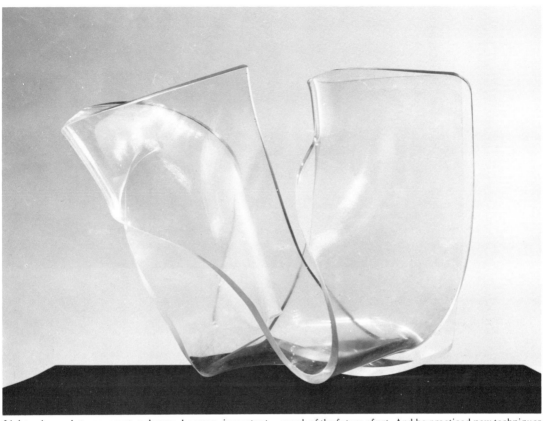

Light, air, and transparent volumes became important concerns of the sculptor Laszlo Moholy-Nagy in *Double Loop* (1946). Moholy-Nagy was a genius who predicted much of the future of art. And he practiced new techniques, as in heat-forming acrylic for his space modulators. *Courtesy: The Musuem of Modern Art, New York*

the costs and time involved have been reduced as well. Original works, once a rare and costly privilege, are now within the realm of possibility for every man. The use of the so-called less durable substances has been combined with a need for mobility. As modern man moves from location to location, pieces must move with him. This man does not, however, move as the rootless nomad of yesteryear, but as the rooted nomad of today. Possessions, his anchors and status symbols, are foldable and packable and describe him in whatever environment he chooses.

Contemporary sculpture and plastics, born in the same time and of the same parents — technology and the democratization of man — are linked strongly. Although plastics as an

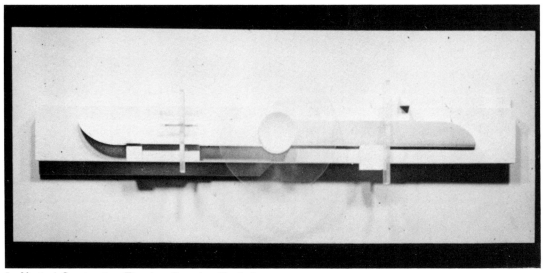

In *Vertical Construction*, Theodore Roszak utilized plastic elements in this piece created in 1943. *Courtesy: Whitney Museum, New York*

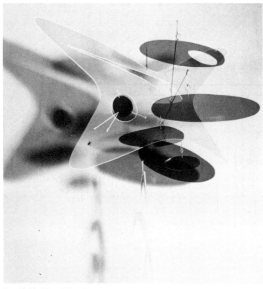

In 1948, Fred Dreher constructed this acrylic mobile using green and red with gray (18″ wide). *Courtesy: Fred Dreher*

art material did not act as an agent to precipitate a break with the traditional aesthetic basis of sculpture, its potential did encourage sculptors by extending the range of what they could do.

Ubiquitous plastics can be all things to all modes of working. Its potential is vast and its possibilities unique. That is why plastics were named for their very plastic properties in the 1920's. Today there is an appropriate plastic and a suitable process for any application. New plastics, techniques, designs, and shapes emerge every day. The field is unfolding neoteric ideas continually. It is very exciting to examine this potential.

Fiberglass reinforced polyester resin (FRP) and fiberglass reinforced epoxies are immensely flexible materials; they can assume any shape, any curve, can be structurally self-supporting, and can withstand much surface abrasion. Liquid plastics such as polyesters and epoxies can take any shape that is pourable, be cast in almost any thickness, cure into transparent, translucent, or opaque forms, and, in comparison to other materials, are lightweight. Acrylics and polycarbonates, which can be formed into large and thick shapes, have better optical qualities than glass—with much less weight. They also offer a crystal clarity in

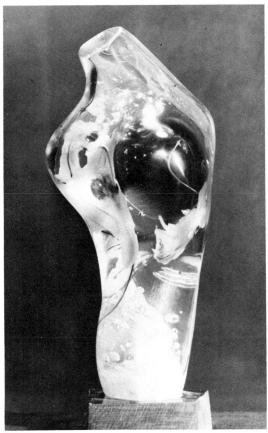

Ubiquitous plastics could be all things to all modes of working. Leo Amino in 1946 was one of the first sculptors to cast his forms using styrene. A wire form was invested in the polystyrene. He discovered, though, that the material turned brown when exposed to light. *Courtesy: Leo Amino*

great thicknesses which is impossible to achieve in glass forms. Foams can traverse large areas, become tremendous volumes, harden into any shape, and yet be amazingly lightweight. Polyurethane foams, particularly, are very strong and nearly indestructible. Filled polyesters, epoxies, silicones, and some vinyls can be buttered and molded as easily as clay. Vinyls and polyethylenes can become gossamer films.

Plastics can be molded, modeled, cast, buttered, machined, carved, incised, extruded, blown, dipped, stretched, sprayed, woven,

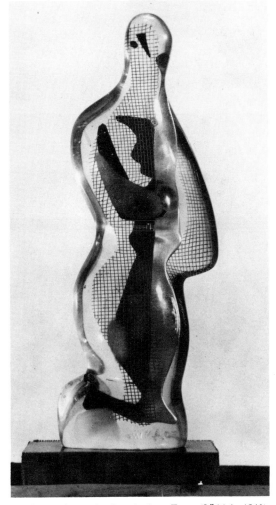

Another sculpture by Leo Amino, *Torso* (9″ high, 1946), was cast in polystyrene using color and wire. *Courtesy: Leo Amino*

and adhered to anything. Pigments create any color with any degree of subtlety. Plasticizers add flexibility. Thixotropic agents provide thickness which permits the application of liquids to vertical surfaces. Fillers impart density. Stabilizers protect plastics from weather, light, and flame.

In thin applications some plastics can become superadhesives; others become protective coatings or films. Films can be heat-sealed into containers to hold air and balloon into inflatables of almost any length and size. Sheets of plastics can be machined and adhered together to create hard-edge forms, or they can be softened and bent into angles or blown or vacuum-formed into shapes or curves. Pellets and tiles can be fused together into shapes, sagged or draped into and over molds when hot. Errors can be corrected by reheating and remolding thermoplastics. Liquids can be poured into sheets and molds. Or they can be used to impregnate almost indestructible materials such as fiberglass and Dacron®, and those materials may then be draped over armatures or onto/into molds. When mixed with various types of fillers, these plastics can be

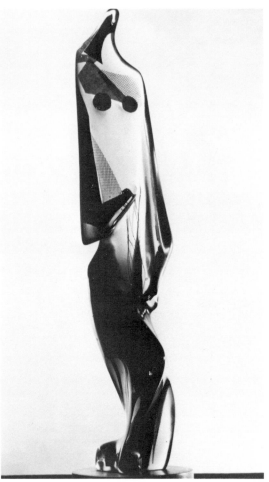

Discouraged with the instability of the new styrenes, Leo Amino turned to experimenting with casting of the relatively new polyesters in this figure (1948). These polyesters also turned brown when exposed to actinic light rays of the sun. *Courtesy: Leo Amino*

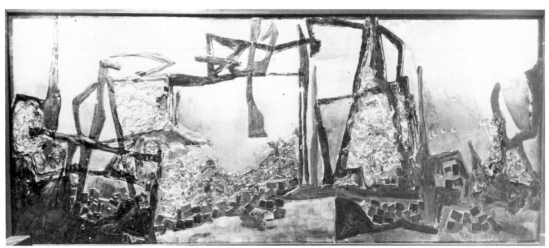

Sara Reid, another "pioneer" with plastics, cast this polyester piece in the late fifties. *Courtesy: Sara Reid*

Firewall (1962), by the author, was made of small bits of polyester, cast in various sizes and shapes of polyethylene ice-cube molds and colored with nonfading transparent colors. These were arranged, mosaic fashion, on a sheet of acrylic. Instead of grout, a thixotropic black polyester was squeezed between the tessarae. *Courtesy: Willimantic State College*

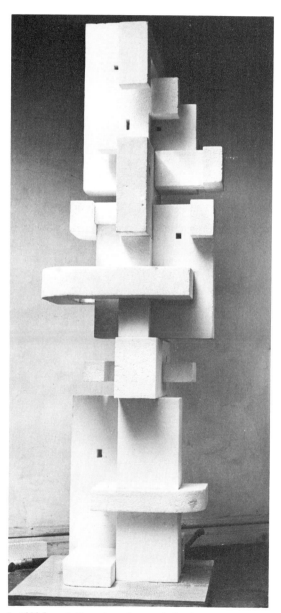

In 1959 Joseph Konzal used expanded polystyrene to serve as a full-size maquette for a stone sculpture. *Courtesy: Joseph Konzal*

modeled into shapes or buttered over an armature. Color can be frozen in the path of capillary action by timing catalyzation. Foams, rising from a relatively small amount of liquid into billowing, free-form organic shapes if uncontained and uncompressed, can be used to traverse large areas with little weight and can be carefully controlled in terms of flexibility and density as well. When sprayed over stretched burlap or other fabrics, large sheetlike forms can be created with foams. Different densities impart different surface qualities. When molded, the form may be given a soft interior and a hard, glossy skin.

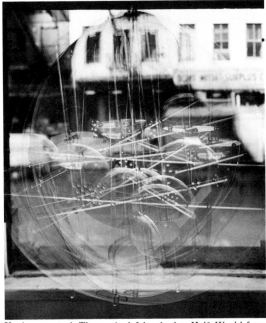

Kosice created *Theoretical Island of a Half World* from acrylic and water in 1967. The diameter measures 50″. *Courtesy: Galeria Bonino, Ltd., New York; photograph by Peter Moore*

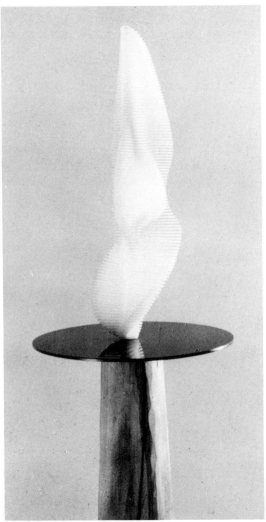

William P. Reiman constructed *Constellation* from acrylic in 1957. *Courtesy: William P. Reiman*

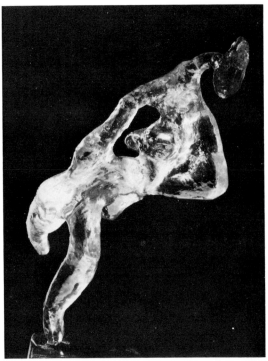

Here is an early lost-wax casting by the author (1959), using polyester instead of metal after the original wax form was melted out of its investment.

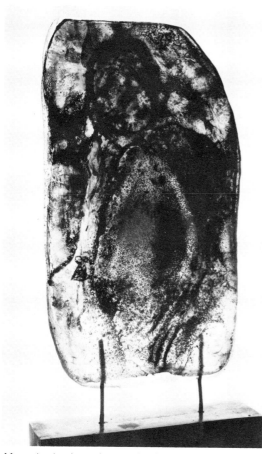

light to create illusory internal forms. Edges and incisions in the surface of acrylic—and particularly in acrylic pipes—broadcasts light, which makes it possible to create linear effects that aggregate into luminous progressions.

Plastics have their own potentials and ends, but they also can become means to ends, as in ferroconcrete that can span huge areas with great strength using a Styrofoam® core or can be cast in molds made of plastic foam. Styrofoam can also be vaporized by the heat of molten metal which replaces its shape, as in the lost-wax process. Of course, plastics can be painted, can be used as fillers or maquettes and stand-ins for traditional materials and containers.

Maternity, by the author, made of a double decker sandwich of heat-formed acrylic colored and adhered with polyester resin and acrylic, evolved in 1963.

Because of the potential for transparency with acrylic, styrene, polyester, epoxy, polycarbonate, silicone, and other industrial production-oriented plastics, it is possible to create sculptures that achieve new kinds of space definition, since space can now be seen through any depth, with vision penetrating the volume and perceiving exterior and interior simultaneously. Light becomes an essential ingredient. Surface planes and internal planes can be interrupted and intercepted; penetrating holes and incisions refract and reflect

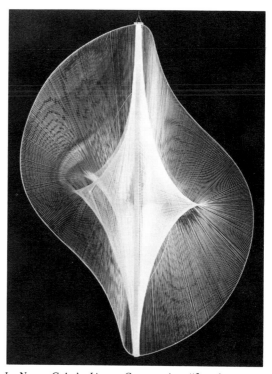

In Naum Gabo's *Linear Construction #2,* nylon monofilament is strung over clear acrylic. *Courtesy: The Tate Gallery, London*

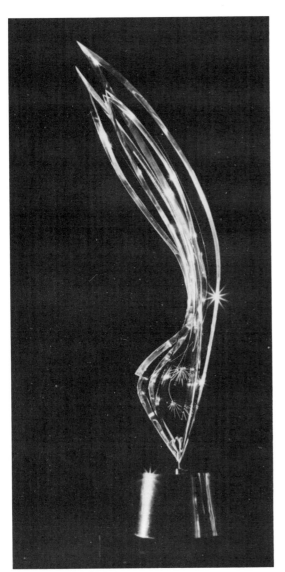

By means of modern industrial process, serial works can be created in volume. Some say this debases the art by its profusion; others claim it conveys art to larger numbers of people. There are also those who take sides on such issues as whether the artist should react against technology and reject its developments or whether he should reflect his age by utilizing and extending the techniques this civilization has developed.

What becomes increasingly clear is that time is kaleidoscoped by the speed of working with plastics and the volume of plastics. Even artists' studios look different—more like laboratories or machine shops. Technologists created, modified, and improved plastics as materials, but it was not until the artist came along with his interpretations that plastics as media have achieved creditability. Engineers and chemists spend their time and genius devising ways of forcing plastics cleverly to counterfeit traditional materials. It is almost impossible to distinguish between polyurethane-foam furniture and hand-carved wood,

Fred Dreher created *Milkweed* in 1967, carving edges and incising lines to catch light that is projected from a polished brass base. Acrylic tends to be "pretty" and decorative. This could be a fault and needs to be overcome with strong design. *Courtesy: Fred Dreher; collection: Robert Hahnel*

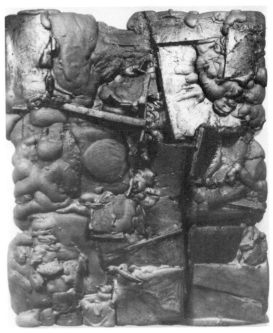

Roger Bolomey constructed *Sculptural Relief* (78″ x 66″) in 1961. *Courtesy: Roger Bolomey*

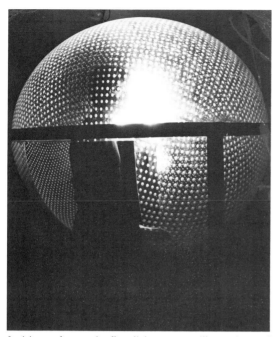

Incisions refract and reflect light to create illusory internal forms. *Immersion #2/3* by Ugo LaPietra is an environment of sound and light. *Courtesy: Ugo LaPietra*

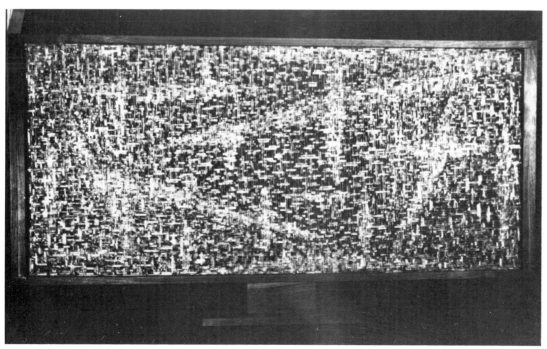

In the sixties, Leo Amino turned to working with small pieces of acrylic because he was disturbed with the degradation of color in his early styrene and polyester castings. *Courtesy: Leo Amino; photograph by Soichi Sunami*

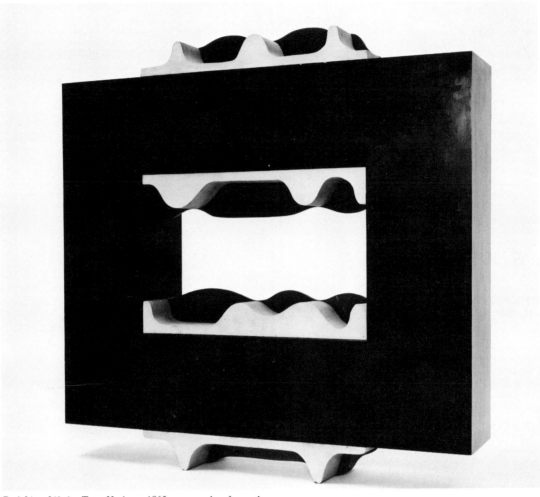

Red Line Life by Tom Hudson, 1965, was made of wood, polyester, and aluminum. *Courtesy: Tom Hudson*

or between chrome-plated ABS and chrome-plated metal, to give but two examples. That is only a symptom of our value system. It is up to the artists to set standards and to inspire industry to new directions. Ironically, it may be plastics, the technologists' invention, that will also help the artist to give up a worn-out obsession that is still with us from classical Greek times: "living" sculpture (the figure) as subject matter and philosophy.

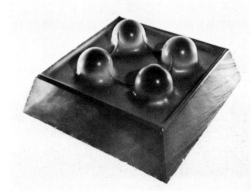

Vacuum formed of Uvex by Ed McGowin (1967). *Courtesy: Ed McGowin*

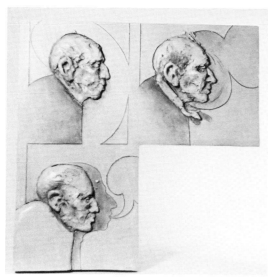

Polychromed fiberglass and polyester resin has relief made in a mold form by Ralph Massey, *Three Waiting Men* (1968, 4' x 4' x 4" thick). *Courtesy: Ralph Massey*

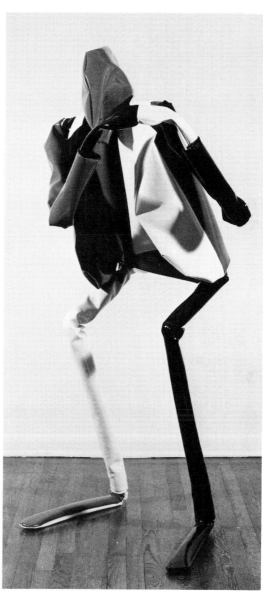

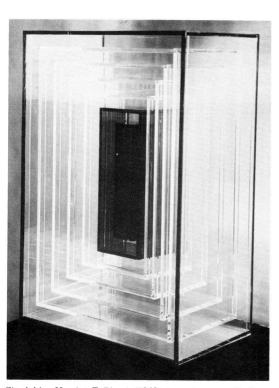

Citadel by Harriet FeBland (1968) is a clear acrylic box construction 14" x 20" x 8". *Courtesy: Harriet FeBland; collection of Dr. and Mrs. Robert Alexander*

William King tailors naugahyde to form *Nut* (60" high, 1970). *Courtesy: Terry Dintenfass, Inc.*

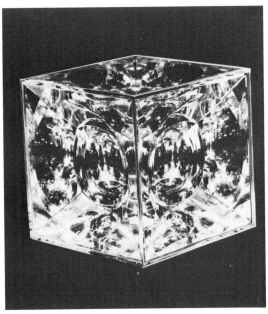

Neal Small captures and refracts light by carving, cutting, and gluing acrylic into a cube form in *#0016C* (1968). *Courtesy: Neal Small*

Sue Fuller's construction with Saran and nylon dates back to the late fifties. This one is 36″ x 48″. *Courtesy: Bertha Schaefer Gallery*

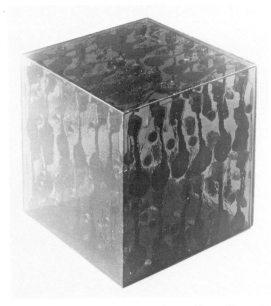

Arman embeds color and sometimes objects like paint bottles in polyester and cages the whole in acrylic. *Courtesy: Multiples*

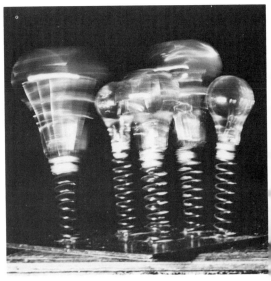

Polyester cast into light bulbs crack and bang into each other in *Group Process* by Jay Hartley Newman. *Courtesy: Jay Hartley Newman*

Yvaral engraved layers of melamine to reveal different colored strata in *Relief Optivisio #1. Courtesy: Galerie Denise René. New York*

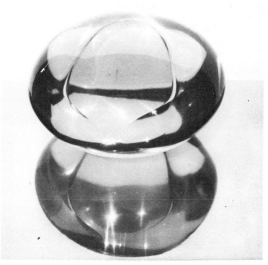

Helen Pashgian casts oval forms of polyester resin. By embedding a colored piece of acrylic in the resin, a lens effect created by curved polyester surfaces distorts the colored insert (1970, 8″ diameter). *Courtesy: Helen Pashgian*

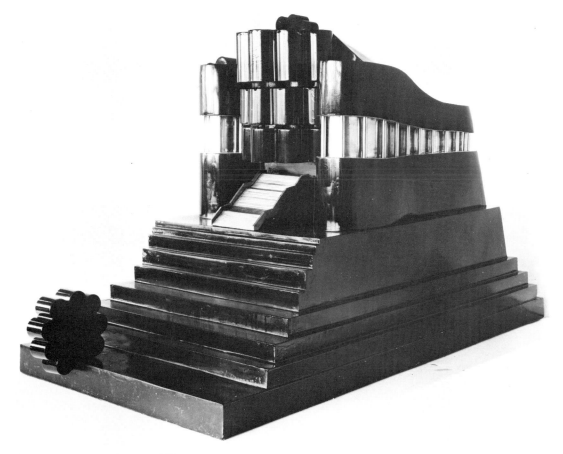

Sphingid by Michael Sandle (1967) is made of fiberglass and polyester resin and finished with polyurethane lacquer.

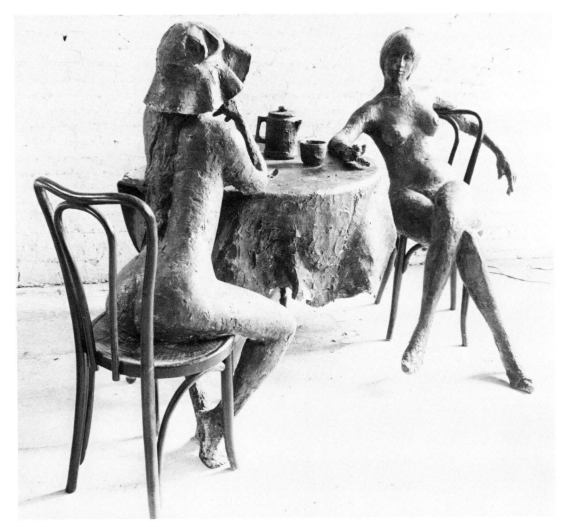

Two Women at a Table is a life-sized sculpture made of bronze-filled polyester resin and fiberglass by Arlene Love. *Courtesy and copyright: Arlene Love*

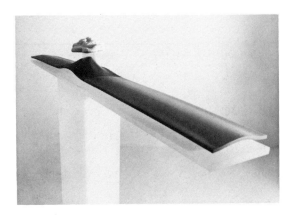

Sam Richardson utilizes several kinds of plastics and processes for this piece *The Cloud Brings Its Rain In Spring* (1972, 5 ¼ " high on 33" stand, x 4" wide x 47" long). *Courtesy: Martha Jackson Gallery*

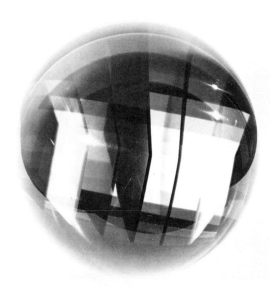

Sphere by Vasa (1971, 9″diameter). Laminated and shaped acrylic. *Courtesy: Vasa*

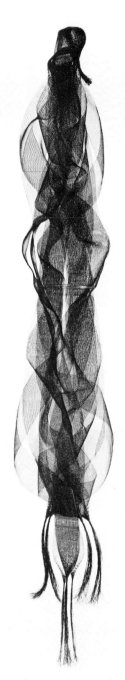

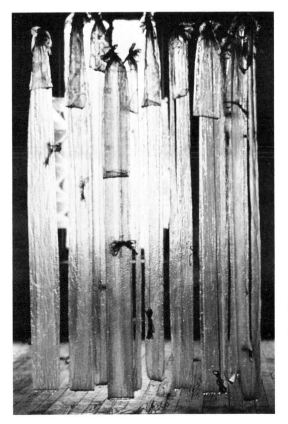

Black nylon monofilament in a quadruple and tubular weave. *Nagare VII* by Kay Sekimachi (1970, 80″ x 10″ x 10″). *Courtesy: Kay Sekimachi; photograph by Stone and Steccati*

Michael Bakaty's *Twelve Pieces* are shapes formed by pulling and folding polyester resin saturated fiberglass (1970, 7′7½″ x 6″). *Courtesy: Michael Bakaty*

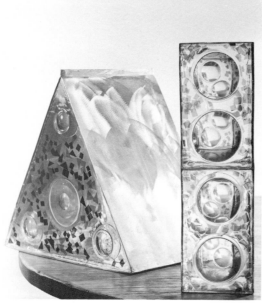

Feliciano Bejar in his series of *Magiscopes*, of which this is one, casts colors and lens forms in polyester resin. *Courtesy: Bertha Shaefer Gallery*

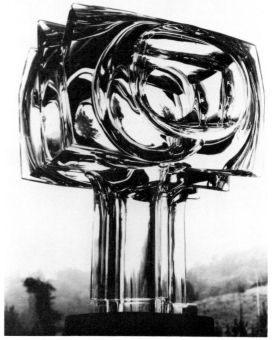

Jacques Schnier achieves remarkable reflections and refractions by carving into a block of acrylic. *Courtesy: Jacques Schnier*

ABS (acrylonitrile-butadiene-styrene) sewer and drain grade pipe 4″ in diameter was used to form Wayne Jewett's *Cage with Live Grass. Courtesy: Wayne Jewett*

The Executive waits forever because he is a full-sized polyester-fiberglass figure by Duane Hanson (1971). *Courtesy: O. K. Harris; collection: Melvin Kaufman*

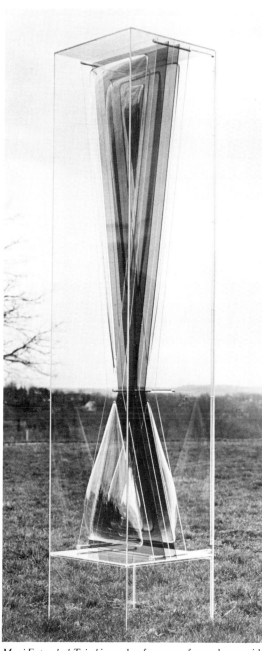

Maxi Extended Triad is made of vacuum-formed pyramids of clear and varying transparent grey acrylics. The vacuum-formed center moves via a motor. Aaronel deRoy Gruber (1973, 6'7" high x 14¼" wide x 16½" deep). *Courtesy and copyright: Aaronel deRoy Gruber; collection: Dainippon Ink & Chemicals for Contemporary Art Museum, Tokyo; photograph by Walter Seng*

2

Plastics Basics

Plastics is the generic term applied to a host of formable, usually man-made materials, as well as some natural resins and gums such as shellac and gutta-percha. Plastics can be paints, fabrics, rubbers, foams, adhesives, oils, films, sheet or structural molding, and fabricating materials. Each kind of plastic may be very different from others, even though they may be derived from the same natural materials. Most plastics are by-products of what we use as fuel—carbon-containing substances such as coal and petroleum, along with air, water, limestone, salt, and sulfur, to name a few. The process is complex. Substances are broken down, reacted with others, and combined to produce the basic raw materials for plastics. For example, styrene is created by obtaining ethylene from natural gas, or as a by-product of petroleum refining; benzene, its other basic component, is a by-product from coke ovens. The benzene and ethylene are combined with a catalyst to produce ethyl benzene. Then hydrogen is split from the ethyl benzene, leaving styrene. To create polystyrene, a long-chain molecule characteristic of plastics, styrene is polymerized. *Polymerization* is a chemical process in which a number of single molecules are joined together by heat, pressure, or a catalyst to form larger long-chain molecules. From polystyrene comes a host of products fabricated by many different processes, such as molding, extruding, machining, fusing—processes similar to those used for metals and rubbers.

Polystyrene is a *thermoplastic* material, which means that it can be heated and formed, then reheated and reformed, over and over again, much like wax or metal. Wax can be softened with heat, shaped, and when cool hardens into a rigid shape. *Thermosetting* materials, on the other hand, such as polyesters, once polymerized keep their shape and cannot be reformed. These thermosets are much like clay after it has been fired (refiring does not soften it unless the temperature is

unduly high) or like concrete, a mixture of cement and sand hardened by a chemical reaction with water. Cement is a binder, sand a filler, and water the "catalyst" that initiates a chemical change. The cement sets, producing a solid permanent body.

Fillers play an important part in modifying the properties of plastics. They add strength (fiberglass), minimize shrinkage (calcium carbonate), reduce crazing (mica), reduce dripping from vertical applications adding thixotropicity (fumed colloidal silica), to name a few. In addition to fillers, catalysts are also added. Catalysts are chemicals that initiate polymerization and, as with polyester resin, cause the resin to harden. In addition to fillers and catalysts, color stabilizers and plasticizers are also often included when it is necessary to change the basic properties of the plastic.

POLYESTER RESIN

One of the most useful materials for the sculptor is polyester resin because it can be cast, laminated, embedded, and carved. Starting as a pourable liquid, the consistency of

Ray Hitchcock pours polyester resin into polyethylene bag-like forms; removes the bag to achieve *Body Works* (1972). *Courtesy: Max Hutchinson Gallery; photograph by Eric Pollitzer*

syrup, polyester resin (the unsaturated kind we use[1]) can be cured with the addition of a catalyst at room temperature in ordinary studio or kitchen conditions.

Polyester resins may contain the following properties:

They can be water-white and quite transparent, although not so transparent as acrylic.

They are relatively inexpensive when compared with epoxies and acrylics.

Shrinkage of unfilled polyester resin is around 7% but can be reduced with the addition of fibers, such as calcium carbonate. If too much filler is added (over 50%), initial properties of the resin are lost. Fillers cause polyester resins to lose their transparency in varying degrees.

Some polyesters will withstand the effects of sunlight better than epoxies, for instance, but not so well as acrylics.

Fiberglass or other reinforcing materials that can be impregnated by the liquid polyester resin adds structural strength, reinforcement, and can also reduce shrinkage.

Polyesters can be fire-retardant or -resistant, if purchased with that formulation (Hetrons® manufactured by Hooker Chemical Co.).

Some polyesters can be emulsifiable with water that acts as a filler. Shrinkage is greater when water is used because it evaporates over a long period of time.

Polyesters can be rigid or flexible, if formulated by the manufacturer that way.

They also can cure quickly or slowly. Coatings should cure more quickly, but thick castings should cure more slowly so that excessive exotherm (heat generated by the catalyst in curing) does not build up and cause cracking.

Polyester can be thixotropic when fumed colloidal silica (Cabosil®) is added. It becomes a translucent pastelike material. If enough is used, polyester can achieve the consistency of petroleum jelly.

Cautions:

When resin is used all day or in great quantities, styrene vapors, which have a strong gaslike odor, should be cleared from the air with a good exhaust fan.

[1]Saturated polyesters are best known as films and fibers, such as Mylar® and Dacron®.

Smoking is not advisable because polyesters and catalysts are flammable.

Gloves should be used because polyesters and certainly their catalysts are irritating to skin.

The methyl ethyl ketone (MEK) peroxide catalyst generally used with polyester should be stored in a cool place. It is also a strong oxidizing agent and a possible fire hazard. Spills should be absorbed with sand or paper towels and discarded in a metal garbage can outdoors.

Polyester resin will last longer than one year (when "fresh" to begin with), if stored in a covered container in the refrigerator. (I use brown glass jugs with lids protected with Mylar.) Some metals help initiate catalyzation and the resin hardens prematurely.

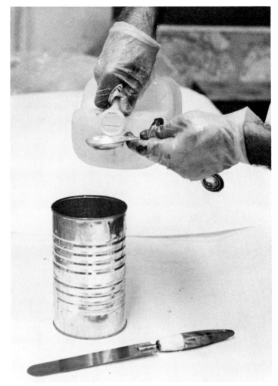

1. Polyester resin should be combined by using a scale and weighing ingredients before mixing them together. For those who are beginning, however, measurements can be made by cup, pint, quart, and gallon measures for the resin and measuring spoons for the catalyst. The same holds true for measuring epoxies, urethanes, and silicones.

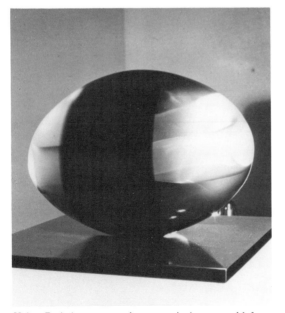

Helen Pashgian pours polyester resin into a mold form, suspends colored acrylic pieces into the mold to create her oval forms. *Courtesy: Helen Pashgian*

Fiberglass, often used with polyester because of its excellence as a reinforcement (FRP) and a drapable material, can irritate the skin because of its fine glasslike fibers. They can be dangerous when breathed (during sanding operations). Use protective clothing and a chemical vapor mask.

HOW TO MIX POLYESTER RESIN

One can use just polyester resin and catalyst and get good results,[2] or after some experience polyester resin can be tailored for specific

[2]Some resins, such as the acrylic-based polyester (Paraplex® P-444A), are unpromoted and require the addition and thorough mixing of a promoter before one adds the catalyst.

properties by adding fillers of various sorts, color, diluents, flame retardants, flexibilizers, release agents, and so on.

Basically, a specific proportion of MEK peroxide catalyst is added to a specific amount of resin. (See charts for general amounts.

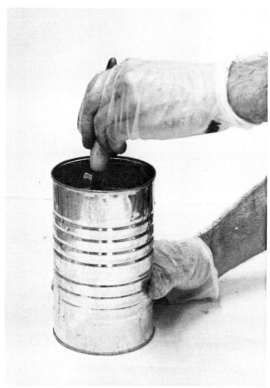

2. After the MEK peroxide catalyst has been properly metered out into the polyester resin, stir both together with a clean, dry spatula, making certain not to whip air into the mixture.

Note that thin applications require more catalyst than thick castings.) After the catalyst has been added, stir the mixture thoroughly with a clean tongue depressor or stainless-steel spatula in figure eights, so as not to entrap air bubbles. Pour the mixture immediately. It has a shelf life of about 10 to 30 minutes before

it gels (depending on the amount of catalyst used—more catalyst makes for quicker curing or hardening). After pouring the resin, it will gel in 10 to 30 minutes. At that point it has frozen the movement of molecules and obtained its permanent shape. Do not lift or disturb the form (although you can churn it or stir it to create textures), or the piece will warp when cured. Heat is then generated and the polyester hardens to a rigid solid. Curing continues slowly for days or weeks, depending upon the resin. When hardened, if tolerances are critical or areas thin, the piece should be allowed to remain undisturbed for 24 hours so that molecules have a chance to become completely oriented before the piece is handled. Overcatalyzed resin will smoke, turn the resin brown, and spoil the piece.

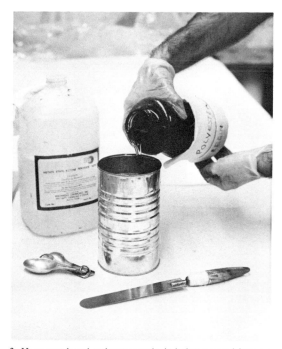

3. Here catalyzed polyester resin is being poured into an RTV silicone mold.

ADDITIVES

If you wish to modify the resin in any way, add any of these additives BEFORE the catalyst. Stir each additive thoroughly in the same manner in which it was suggested above that you add your catalyst.

For making the resin more viscous (thixotropic) in order to apply it on a vertical surface, use Cabosil or Asbestos 244®.

For coloring resin, use paste for polyesters. Specify whether you want transparent or opaque colors. The best lightfast colors are from Ferro Corp., Crompton & Knowles Corp., Interchemical Corp., BASF Corp., who supply in large quantities to Resin Coatings Corp., Polyproducts Corp., and Waldor Enterprises, Ltd., in Canada. These latter companies repackage bulk into small quantities.

For reducing viscosity or dissolving powdered color or ultraviolet absorbers so that they more readily mix into the resin, use styrene monomer (keep it covered and refrigerated).

For reducing shrinkage and opacifying polyester resin, use calcium carbonate kaolin (dried clay), talc, flint (powdered sand), mica, pumice, et cetera. All fillers must be dry. Keep the quantity below 50% by weight.

For reducing flammability, buy Hetron resins.

For making polyester more flexible, use Benzoflex® 9-88.

To build in a release agent internally so that resins release from vases or molds (particularly glass), use Internal Release #54® or Zelec® UN from Du Pont de Nemours & Co., Inc.

To protect polyester resin from ultraviolet light, use ultraviolet absorbers ¼% to 1% by weight, Uvinul® or Tinuvin®.

POLYESTER RESIN-CATALYST PROPORTIONS

It is best to weigh resin and catalyst for predictable results. Measuring by cups and teaspoons is the next best way. Each brand of resin differs somewhat from others. The proportions used here are for Reichhold's Polylite® 32-032 at 70°F. Temperature and humidity both influence catalyzing time.

Various processes for working with polyester resin will be detailed in Chapters 3, 5, and 6.

	POLYESTER RESIN	MEK PEROXIDE CATALYST
Thick castings ½"-3"	100 grams	¼-½ gram
Thin sheets 40-250 mils (10-60 sheets of paper)	100 grams	¾-1 gram
Thin coatings	100 grams	2 grams
Thick castings	1 tablespoon 4 ounces (½ cup) 1 cup (½ pint)	3 drops 24 drops 48 drops
Thin applications	2 tablespoons (1 ounce) 6 tablespoons (3 ounces) 1 cup (8 ounces) 1 pint (2 cups)	20 drops ¼ teaspoon ½ teaspoon 1¼ teaspoon

POLYESTER CLINIC

DEFECT	CAUSE	REMEDY
Cracking of castings	Internal strains	Use less catalyst or a slower reaction type of catalyst; immerse casting (protected, of course) in cold water to disperse heat; if too much catalyst has been added, use fillers to help reduce internal strains; use a flexible resin; avoid large embedments of different expansion and contraction ratios
Warping	Erratic temperatures; unequal thickness; uneven distribution of catalyst in resin; handling form prematurely	Design for more even thickness; mix resin and catalyst more thoroughly; do not disturb until completely cured; slow down curing rate; keep temperature in room at even level
Milky color	Water contamination	Keep water out of resin and away from work
Tacky surface	Incomplete polymerization; air inhibition of surface	Increase amount of catalyst and resin; use Internal Release #54 or Zelec UN (Du Pont de Nemours & Co., Inc.); add a bit of paraffin; cover surface with Mylar; use a gel coating; brush a coating of highly catalyzed resin over the surface
Dull surface	Dust; type of resin; reproduction of casting surface; wax or release agent in resin	Keep dust-generating activities away from work; change type of resin; use a glossy casting surface; coat surface with a glossy, heavily catalyzed resin
Bubbles	Air	Saturate objects with resin before embedding; dry out any plant material or fabric before adding to resin; stir resin without lifting out stirrer
Translucency, when transparency is desired	Water; pigment; dirt; additives	Change conditions, additives, type of pigment; keep work area clean
Delaminating of internal stress	Grease and oil; lack of adhesion	Watch out for contaminants; clean embedments well with alcohol; sand surface to give "tooth" so that resin may adhere

REINFORCED POLYESTER

When a reinforcing material is combined with polyester resin, the liquid resin impregnates the fibers of the material. After catalyzation runs its course, the reinforced polyester hardens to become a very strong, dimensionally stable material. Boat hulls are made of fiberglass reinforced polyester; so

are prefabricated bathrooms and chairs.

Although fiberglass is the most frequently used reinforcing material, Dacron, nylon, cotton, asbestos, and even paper have been used. Impregnating these materials can be accomplished mainly by hand lay-up in or over molds, over armatures, or through use of a spray-up machine that dispenses polyester

resin with the correct amount of catalyst and fiberglass roving at the same time, depositing it in even thicknesses.

Industry uses several other FRP (fiberglass reinforced polyester) processes. One is vacuum-bag molding, which is a refinement of hand lay-up but uses a vacuum and bag to apply pressure. The vacuum eliminates voids and forces out air that may become entrapped in the resin. Pressure-bag molding is another variation employing air or steam pressure. After pressure-bag molding has been done, a piece may be placed in an autoclave to promote curing. Another FRP process used by industry is filament winding that draws a continuous strand of glass fiber through a bath of resin and winds it on a suitably designed mandrel. The machines may be designed to lay down the glass in predetermined patterns and layers. Centrifugal casting also employs the concept of rotation, but this time chopped glass fibers and resin are placed inside a hollow mandrel. The assembly is then rotated, forcing the glass and resin against the walls. When cured, the solid form is removed.

VISUAL DEFECTS IN REINFORCED PLASTICS

DEFECT	NATURE	REMARKS
Air bubble, void	Air entrapment within and between plies of reinforcement; noninterconnected; spherical in shape	Pierce and fill with resin; roll or daub after applying the resin
Blister	Rounded elevation of surface of laminate whose boundaries may be more or less sharply defined, somewhat resembling in shape blister on human skin	Pierce and fill with resin; roll or daub after applying the resin
Burned spot	Showing evidence of thermal decomposition through some discoloration, distortion, or destruction of surface of laminate	Too highly catalyzed
Chip	Small piece broken off edge or anywhere on surface	Saturate woven roving with resin and bind the edge; stipple out excess air and resin with a brush
Crack	Actual separation of molded material, visible on opposite surfaces of part and extending through thickness	Poor wetting of fibers. Fill with body putty; sand and paint it
Crack (surface)	Crack existing only on surface of part	Fill with body putty; sand and paint it
Crazing	Fine cracks at or under surface of part	Coat with viscous paint that will saturate and fill the cracks

DEFECT	NATURE	REMARKS
Delamination	Separation of layers of material in laminate	If fully cured, remove and start again
Dry spot	Area of incomplete surface film on laminated plastics; area over which interlayer and glass have not become bonded	Inject resin and apply some pressure; daub out air and excess resin
Fish eye	Small globular mass not blended completely into surrounding material; particularly evident in transparent or translucent material	Sand away and fill with body putty
Foreign object	Particles included in a plastic that are foreign to its composition	If its contraction and expansion ratio will not affect the FRP, leave as is
Fracture	Rupture of surface without complete separation of laminate	Fill with body putty; sand and paint it
Lack of fill-out	Area of reinforcement not wetted with resin; mostly seen at edge of laminate	Saturate resin; bind with woven roving that has been saturated in resin
Orange peel	Surface roughness somewhat resembling surface of an orange	Too much heat applied to gel coat; sand and paint with a filled, viscous paint
Pimple	Small, sharp, or conical elevation (usually resin-rich) on surface of a plastic; form resembles pimple	Sand and refinish area
Pit (pinhole)	Small regular or irregular crater in surface of a plastic; usually with width approximately of same order of magnitude as depth	Spatula body putty into craters; sand and paint
Porosity	Presence of numerous visible pits (pinholes)	Sand and paint with a filled, viscous paint
Pre-gel	Extra layer of cured resin on part of surface of laminate (not including gel coats)	Leave as is, unless it needs refinishing for cosmetic reasons
Resin pocket	Apparent accumulation of excess resin in a small, localized area	If cured, leave as is, unless it needs refinishing for cosmetic reasons; if moist, squeegee off excess resin
Resin-rich edge	Insufficient reinforcing material at edge of molded laminate	Bind with resin-saturated fiberglass
Scratch	Shallow mark, groove, furrow, or channel normally caused by improper handling or storage	Fill with body putty; sand and paint
Shrink mark or sink	Dimplelike depression in surface of part where it has retracted from mold; has well-rounded edges and no absence of surface film	Leave as is
Wash	Area where reinforcement has moved during mold closure, resulting in resin richness	Leave as is
Wormhole	Elongated air entrapment either in surface of laminate or covered by thin film of cured resin	Try to inject resin into hole; if this cannot be done, slice into hole and fill with body putty, sand, and paint
Wrinkle	Surface imperfection that has appearance of crease or wrinkle in one or more plies of fabric or other molded-in reinforcement	If air is entrapped, apply the above solution

EPOXY

Epoxies are familiar to us as particularly strong adhesives. They certainly are, and can do a great deal more. Just about anything that polyester can do, epoxy can carry off as well. Epoxies are more expensive than polyesters, though, but they shrink less (below ½%). Depending upon the catalyst used, epoxies can be water-clear, amber, or opaque. Epoxies are stronger than polyesters with good chemical resistance. Many epoxies are filled with aluminum, copper, brass, lead, tin, nickel (best as 300 mesh), and other fillers to impart metallic or enamel-like surfaces and colors. Like polyesters, epoxies can be modified with various additives to cover a wide range of applications. Epoxies are also more hazardous to use than polyesters. Some of the anhydride catalysts are irritants and adequate ventilation is mandatory.

HOW TO MIX EPOXY RESINS

Follow the directions of measurement on your special formulation. Do not be surprised if instructions indicate 50% resin to 50% catalyst by weight. Stir the two components well and allow the mixture to stand for five minutes to permit air bubbles to rise. Your requirements for applications should determine what kind of formulation to use. In epoxies, tailoring the curing agent is a large part of the job. Some curing agents are clear, others amber. If you need a light-stable product, then try to use a water-clear curing agent. Also, some curing agents react very quickly, which necessitates speedy pouring and application; others cure more slowly.

ADDITIVES

For making the resin more viscous, add Cabosil or Asbestos 244.

For coloring the resin, use lightfast, transparent, or opaque pigments powdered or formulated for use with epoxies.

For filling and coloring your epoxy, use 300-mesh powdered copper, aluminum, lead, tin, nickel, brass. Sawdust, glass chips, dry clay, talc, sand, and stones can also be used.

For a more flexible formulation, use Benzoflex 9-88.

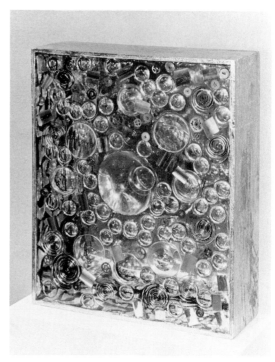

Feliciano Bejar in *I, Eye, I,* casts watch parts, lenses, and bits of colored plastic into a wooden frame, using water clear polyester resin as the matrix. *Courtesy: Bertha Schaefer Gallery; photograph by Bob Schalkwijk*

For a less viscous material and for thin coatings, use lacquer thinners such as xylene and toluene to dilute the epoxy.

To shorten curing time, use accelerators such as triphenyl phosphite (Mod-Epox®) or DPM 3-800 LC® (Diamond Shamrock Chemical Co.). For a slower curing time use Ajicure B-001®. The manufacturer (Ajinomoto Co., Inc.) also claims that it is not an irritant, that there is almost no shrinkage, and that it does not turn brown.

For safety, keep epoxy off your skin. Protect your hands with gloves. Keep room well ventilated.

EPOXY-CATALYST PROPORTIONS

There are many epoxies and catalysts on the market, each establishing its own proportions. It is possible to play around with resin-catalyst variations to lower exotherm (heat generated), to lower shrinkage, to change color, to change speed of cure, and to minimize sensitivity to the catalyst.

Epoxy catalyst #RC125 (Jones-Dabney Co. #87) cures in 20 minutes and gives off a considerable amount of heat.

#956 (Ciba Company) is a "safety" hardener.

#RC303 (Diamond Shamrock Chemical Co.) has a short pot life, hardens in about 5 minutes, is flexible.

#B-001 (Ajinomoto Co., Inc.) transparent, nonbrowning, low shrinkage, cures slowly.

When the above catalysts are mixed with Epoxy Araldite 502® (Ciba), use 100 grams by weight to the proportions and type of catalyst below.

Note that each of the curing agents, regardless of application, requires the same proportions and results in the same amount of curing time.

APPLICATION	CURING AGENT	AMOUNT BY WEIGHT (in Grams)	CURING TIME
Thick castings	RC125	25	20 minutes
	956	20	1-3 hours
Thin coatings	RC125	25	20 minutes
	956	20	1-3 hours
	B-001	50	1 hour
Adhesives	RC125	25	20 minutes
	RC303	100	5 minutes
	956	20	1-3 hours

ACRYLICS

Acrylics are thermoplastics that are purchased in sheets, blocks, rods, tubes, and domes. They are characterized by moldability and remoldability through heating, softening, and shaping.[3] Generally, these forms are manufactured by injection molding, extrusion, or casting processes. From these forms artists fabricate their own shapes, usually by sawing, drilling, gluing, polishing, and through other machining techniques similar to working with wood or soft metals. Other plastics that have been processed into sheets, blocks, rods, et cetera, can be processed in the same way even though they may be made from poly-styrene, polycarbonate, ABC (acrylonitrile-butadiene-styrene), vinyls, and so on. Generally, techniques satisfactory for one kind of thermoplastic are applicable for other kinds.

Of the transparent plastics, such as acrylic, polystyrene, polycarbonate, and vinyl, to name a few, acrylic possesses crystal clarity (index of refraction, 1.49) and because of this boasts optical properties and maximum colorability. In fact, acrylics were first manufactured commercially in 1931 as coating materials for bonding safety glass. Many automobile tail lenses and stop lights are formed of ruby-colored acrylic.

Solid acrylic is an excellent art material. In addition to its weatherability and its clarity, acrylic is warm to the touch, has the ability to bend as easily as most woods, and has impact

[3]Acrylic also is sold as a monomer that requires sensitive casting procedure. It will be discussed farther along in Chapters 3 and 4.

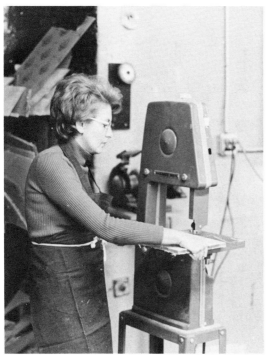

1. Working with acrylic sheet is as easy as working with wood. Harriet FeBland demonstrates this in her studio. Here she is at a band saw cutting a shape out of acrylic.

softened with heat and then formed into almost any shape. And parts can be permanently adhered with transparent adhesives, which results in unobtrusive joints. More about specific ways of working with acrylics will be covered in Chapter 3.

Coloring acrylic can be accomplished with transparent dyes and with many kinds of paints. A full range of transparent and opaque-colored acrylic sheet is available as well as a variety of patterns and textures.

Perhaps the most appealing characteristic of acrylic is its absolute crystal clarity. It is even more transparent than glass. When glass is more than 6″ thick, an object can barely be seen through it; but even if acrylic is 5′ thick, articles can be seen as clearly through the slab as if it were ½″ thick. Its extraordinary transparency invites all kinds of optical designing to reflect and refract light.

strength that resists breaking unless given hard direct blows. Acrylic is odorless as a solid and is impervious to most household chemicals, oils, greases, alkalis, and dilute alcohol. Acrylic is also slow to burn and can be purchased in flame-resistant sheets.

There are two types of sheet acrylic, shrunk and unshrunk. Shrunk sheet is really pre-shrunk, so that it remains dimensionally stable when heated; whereas unshrunk acrylic sheet will shrink about 2% when heated to forming temperature. Shrunk acrylic sheet is the more expensive.

Acrylic can be very easily machined and carved, using many of the same tools as those used in working with wood or metal. There are different polishing and buffing speeds for polishing and buffing wheels as well as different rakes to drill bits, but otherwise the tools are the same. Acrylic also can be

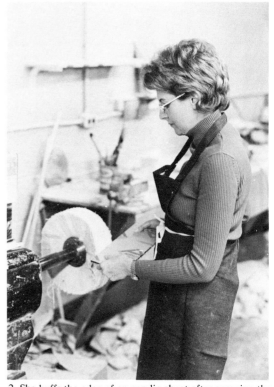

2. She buffs the edge of an acrylic sheet after scraping the edge smooth with a metal scraper.

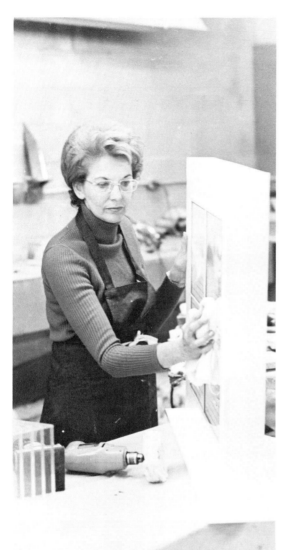

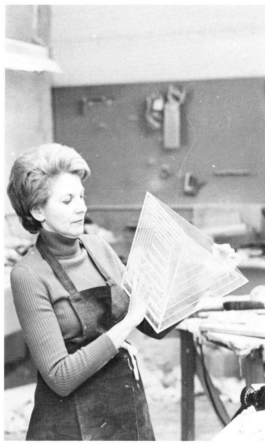

4. Here Harriet FeBland inspects the piece for glue marks made when the liquid solvent-type glue (perhaps ethylene di-chloride) escapes and mars the surface. Buffing polishes away these cloudy marks.

3. Liquid wax applied and buffed with a soft flannel cloth is used to protect and shine the sculpture's surface.

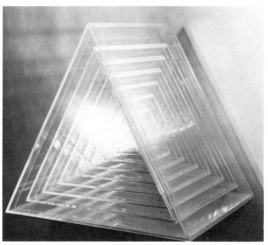

5. *Nicol Prism* by Harriet FeBland, completed (1968, 23″ x 23″ x 23″ x 18½″). *Courtesy: Harriet FeBland; photographs by Scott Cannon.*

Acrylic also can rival the diamond in its ability to pipe light. As light enters a piece of acrylic, it is reflected from the inside of the material and emerges either at polar ends or wherever the surface is broken. A glow will result while the rest of the sheet remains invisibly transparent. Light, therefore, becomes another important aspect of working with acrylic. Understanding the aesthetics of light is a rather new dimension to sculpture.

Acrylic has its limitations and, ironically, one is due to its very transparency. Although acrylic is one of the hardest thermoplastics, it is still susceptible to scratches and, because light pipes through broken areas, marks like scratches become more visible than if it were opaque. (In fact, opaque acrylic does not reveal scratches so easily.) This is not a grave disadvantage because marks can easily be buffed away.

Acrylic also attracts dust because of static electricity and needs to be coated with anti-static cleaners. A 10% solution of liquid All® in water does the job of reducing static.

Care should also be taken to keep acetone, ketones, dopes, aromatic hydrocarbons, benzene, toluene, and some alcohols away from acrylic because these will attack the acrylic surface.

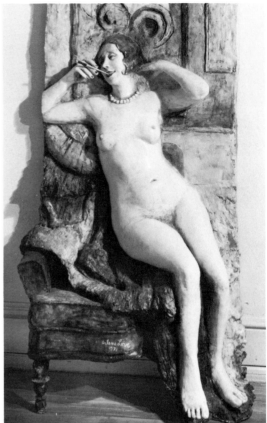

Polyester resin and fiberglass can be layed-up in molds to form very detailed sculptures, as in this one called *French Postcard #2* by Arlene Love. *Courtesy: Arlene Love*

ACRYLIC CLINIC

DEFECT	CAUSE	REMEDY
Crazing	Clamps exerting excessive pressure	Use less force or use pads to distribute force
	Excessive stresses	Anneal parts
	Excessive solvent exposure	Change adhesive
	Inaccurate fit requiring forcing or flexing	Allow more leeway in design
Cloudy joint	Excessive humidity	Reduce humidity, if possible, or use slower evaporating solvent, or change adhesive

DEFECT	CAUSE	REMEDY
Ugly joint	Too many bubbles and dry spots	Improve fit of joint; apply solvent to both sides
	Cushion and/or solvent squeezed out of joint because of excessive pressure	Reduce pressure on joint or do not induce pressure until 20 to 30 seconds
	Temperature too low	Warm solvent or raise room temperature
Poor joint strength	Temperature too low	Heat solvent
	Not enough cushion	Use open joint
	Too many bubbles	Allow bubbles to rise to surface (PS 30) after mixing
	Foreign matter on surfaces being joined	Clean surfaces
Cement will not harden	Improper mixture	Check instructions
	Not thoroughly mixed	Mix for a longer period
	One component is stale (turns yellow or amber)	Throw away component; use fresh component
	Surface tension lost (cyanoacrylate)	Do not spread; just apply drops
	Inhibitors present	Clean surface; eliminate tape, stirring rod, et cetera
Parts will not bond	Improper cleaning	Reclean surfaces with solvent, resand, rewipe with solvent, and reapply adhesive
	Poor surface finish	Resand or remachine to provide better contact
	Acidic surface (for cyanoacrylate cements)	For cyanoacrylate cements, use surface activator
Cracks around bolts	Fit too tight	Allow $^1/_{16}$ inch per linear foot for expansion
Chips on edges	Teeth on blade too large	Use metal-cutting saw blades
	Feed too rapid	Slow down feed and increase tool speed
	Piece allowed to chatter	Hold down piece with more support when cutting
Dull surface	Attack by solvent	Polish piece and anneal; avoid cleaning with acetone, hydrocarbons, et cetera
	Use of abrasive materials, such as scouring compounds	Use household ammonia and water, All and water, or plain soap and water for cleaning

DEFECT	CAUSE	REMEDY
"Burned" sections and particles sticking to holes and edges	Use of wood drill	Adjust edge of drill
	Speed of motor and/or polishing wheel too great	Reduce motor rpm or size of polishing wheel, change to a loose muslin buff
	Dull tools	Use sharp tools; try carbon tools
	Too much frictional heat generated	Use coolant or air
	Tool too hot	Reduce time tool is used; allow it to cool
	Cut edges stick together because of too much frictional heat	Observe above
Specks in paint film	Foreign material trapped	Keep spray equipment clean
		Spray and paint in dust-free area
		Clean top of can before opening lid
	Failure to remove static charge from plastic	Wipe sheet with damp chamois just before painting
Webbing, feathering, or cottoning when paint is sprayed	Improper paint viscosity	Too heavy paint can be thinned 5% dilutions
	Improper air pressure setting	Try higher air pressure, up to 80 psi
Paint runs under mask	Too thin a paint	Use thicker material
	Film too thin	Use more layers
	Knife too dull; pulls up edge as it cuts	Use sharper knife blade
Bubbling on surface	Direct heat from flame	Flame-polish faster—4″-5″ per second
Binding and twisting of saw blade	Uneven feed	Feed slowly and evenly
	Tool dusty	Clean blade with alcohol, naphtha, or mineral spirits
	Improperly set saw fence	Allow a bit of leeway
	Masking paper adhesive sticking	Fix masking paper or remove it
	Tool too hot	Let tool cool; use coolant
Masking paper sticks	Very old material, exposed to heat, water, smoke	Soak with kerosene and peel away with a polyethylene or Teflon® scraper

POLYCARBONATES

More expensive than acrylic, polycarbonate succeeds where acrylic fails. Almost as transparent as acrylic, polycarbonate does not easily scratch. It has very good dimensional stability, which means that it requires higher temperatures to soften. It is also weather-resistant, has very high impact strength, and

is the better of the two for outdoor applications. Polycarbonate can be fabricated the same way as acrylic.

POLYURETHANE

Polyurethanes are immensely versatile, very durable materials that range from coatings and paints, foams, both solid and flexible, rubberlike solids, to adhesives. Most polyurethanes are thermoplastics, but their foams are thermosetting. For use in the sculptor's studio, urethanes are usually two-part liquid systems. They require a great deal of caution because of toxic odors given off by carbon dioxide gas in some products, and in other products diisocyanate monomer, which can cause coughing. Make certain that you have excellent circulation of air and adequate ventilation. Keep the product away from your skin because it can be irritating to some people.

In spite of necessary precautions, polyurethanes are great materials to work with. The rigid and flexible foams contain millions of miniscule air cells formed by the reaction of the air or gas that becomes trapped in the plastic. This reaction is created by the introduction of a measured amount of a blowing agent such as fluorocarbons or carbon dioxide that causes the formation of bubbles or by the use of catalysts. Because of trapped gas, the foams become light and can float. Depending on the volume of gas, urethane can vary in density when rigid and in flexibility when like a rubber. While blowing agents and catalysts control reaction, surfactants control cell structure. Polyurethanes are strong, tough, and can be fire-resistant. Urethane foams, whether flexible or rigid, can be cut with knives or saws, carved and shaped, and coated with epoxy, polyester, or urethane coatings.

RIGID FOAMS

Urethane foaming is generally quite rapid and requires careful weighing or metering of components and then thorough mixing. A mechanical paint-mixing tool and pistol drill can aid in mixing. The foam components are measured, mixed for a prescribed time, and then poured as a liquid stream into a cavity, where they further react and expand to fill the void. Some pressure is exerted in the expansion phase; therefore, the mold should be sufficiently reinforced to absorb the pressure. It usually takes from 5 to 30 minutes for complete setting, depending upon the system, room temperature, and humidity.

It is also possible to froth rigid foams by using dispensing equipment that partially expands the material during application, much like aerosol shaving cream.

Rigid foams can also be sprayed (using special equipment) over forms and armatures. It is used this way to fill roof areas, for packaging large forms, and as insulation.

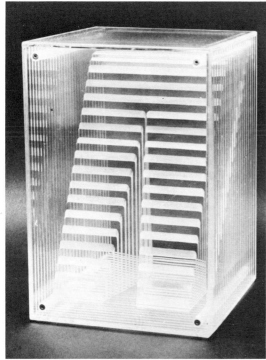

Another type of form held together by rods and rivets as well as glue. Note that inside edges are only scraped, not polished, to permit light to broadcast through the acrylic and escape through the unpolished edge. This piece is by Neal Small, called #0028 (1969, 15½" x 10½" x 11½" deep). *Courtesy: Neal Small*

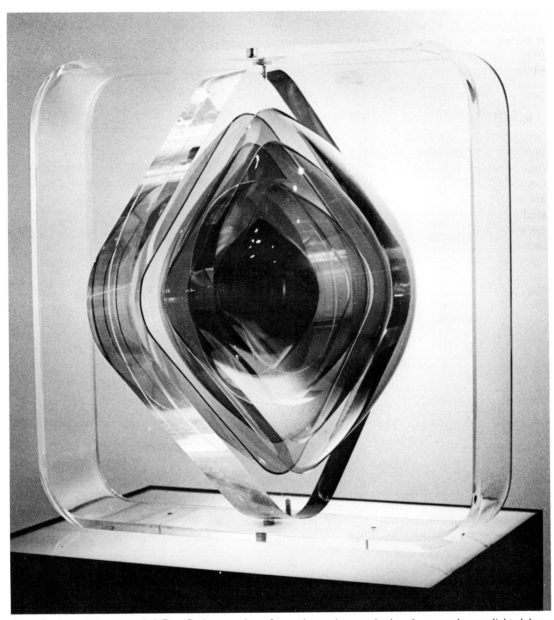

Maxi Cycloplexis by Aaronel deRoy Gruber consists of a clear frame that has been vacuum-formed of rounded squares of transparent, light blue, and bronze acrylic, mounted in a center portion of 4″-thick solid acrylic. The sculpture is motorized and mounted on a lighted base. (1972, 39″ high x 32″ wide). *Courtesy: Aaronel deRoy Gruber Collection, Hillman Library, University of Pittsburg; photograph by H. S. Coughanour*

Rigid urethane also is available as slabs or blocks that are sold in a variety of sizes. These pieces can be cut with a band saw, knife, or heated wire and glued with polyvinyl acetate or chloride, which are glues like Sobo or Elmer's, or with rubber cement.

FLEXIBLE URETHANE FOAMS

These foams are produced in gigantic, continuous buns or slabs, which are then cut into standard sizes and shapes. Foams are also directly foamed, using metering machines, into a closed mold. They come in ice-cream

colors and various densities. Heavier density foams have a smaller, closer cell structure labeled as 2.25 ± 0.15, while lighter density foams that have more air and are softer are labeled as 1.15 ± 0.05 density.

Cutting flexible foam is done professionally on a vertical band saw, using a 1.1 hp motor. An ordinary band saw used for cutting wood does a good job as well. A hot-wire cutter, used for cutting all kinds of foams, also performs well.

Polyurethane foam is being sprayed (out-of-doors) over large vinyl balloons.

It takes about 30 seconds for polyurethane foam to cream (rise). Only a small amount is needed to fill the beaker. *Courtesy: Reichhold Chemical Co.*

IAN WALKER'S DIRECTIONS FOR MAKING A HOT-WIRE CUTTING TOOL[4]

Extend a single strand of #10 Nichrome® wire at a right angle to two pivoting members. The tension of the wire is adjusted, using a turnbuckle at the other end of the pivoting members. The shape looks like an old-fashioned bucksaw or a contemporary Danish saw. Attach an electrical conductor at both ends of the Nichrome wire. This completes the electrical circuit. The electrical lead is then attached to a Veriac. This device controls the ampere flow through the Nichrome wire, which in turn adjusts the heat of the wire. 4.2 to 4.4 amperes are required to cut polyurethane foam of 1.2 density. More amperes are required as density increases.

OTHER FOAMS

Many other plastics can be expanded into foams and are sold as blocks. The most popular of these is expanded polystyrene,

[4]Commercial hot-wire cutters are available from Dura-Tech Corp., 1555 N.W. First Avenue, Boca Raton, Florida 33432. Plans for another type of cutter may be obtained from the Dow Chemical Co., Plastics Dept., Midland, Michigan 48640.

After the balloons have been deflated and removed, the foam remains rigid and dimensionally stable.

If a solvent-based material is to be employed on polystyrene, heavily coat the surface with acrylic gesso or with plaster of Paris to form a barrier before using a solvent coating.

SILICONES, VINYLS, ET CETERA

Room temperature vulcanizing (RTV) silicones as well as hot melt vinyls are used to make molds. These are but two of a wide range of excellent elastomeric (rubberlike) materials that can be mixed or applied at room temperature and provide firm, excellent reproduction of the original piece. The special use of these polymers will be detailed in Chapter 6.

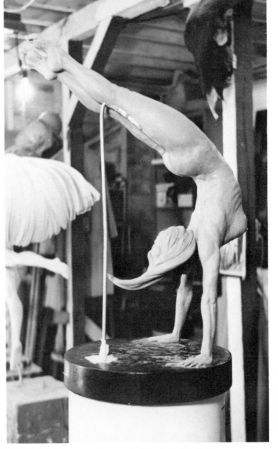

often referred to as Styrofoam. It is an inexpensive foam sold in varying densities. The techniques for working with these foam blocks are very much the same, except for use of different adhesives and coating agents.

For polystyrene foams, the best adhesives are water- or plastic-based, such as polyvinyl acetate types. (Epoxies are also excellent.) Solvent-based adhesives such as rubber cement, while good for urethane, attacks the surface of polystyrene.

The same problem applies to coatings. Coloring polystyrene foam should be accomplished with water- or Latex®-based formulations. Solvent types can be used on urethanes.

1. Ralph Massey sculptured *Handstand* of clay, one-third life size.

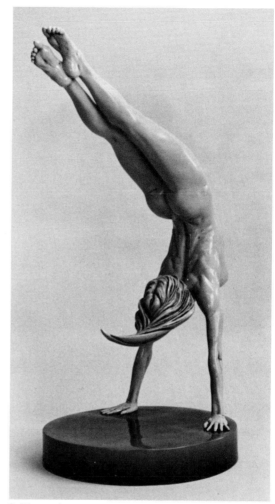

3. The surface is finished with lacquer. *Courtesy: Ralph Massey*

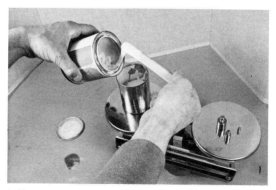

2. Then he layed-up *Handstand* with fiberglass impregnated polyester resin, using steel reinforcing in the arms, in a latex mold.

1. Room temperature vulcanizing (RTV) silicone is an excellent, flexible mold material. Mixing is by weight, according to the manufacturer's recommendations.

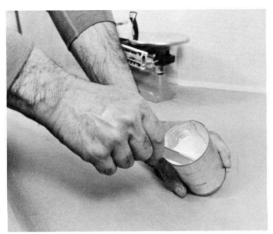

2. After the catalyst has been added, the two parts are stirred together until thoroughly mixed. After mixing, if possible, deaerate the mixture so that bubbles do not form pits on the surface.

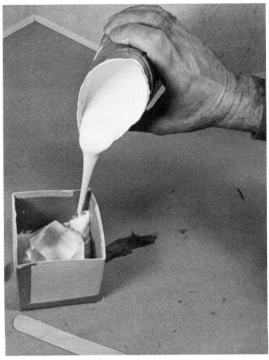

4. . . . more RTV silicone is poured around the form, as you hold the container in one spot so that the mold material will flow around the model.

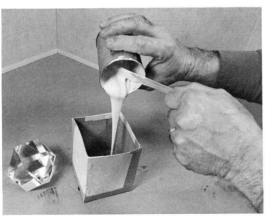

3. Construct a box slightly larger than your model. A base of RTV silicone is poured. When that hardens . . .

5. When cured (hard) in 24 hours, the model is peeled out of the mold. Definition in RTV molds is minutely accurate.

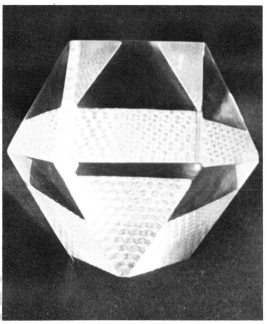

6. Two views of the completed casting. The texture that repeats itself throughout the polyhedral facets is diffraction grating.

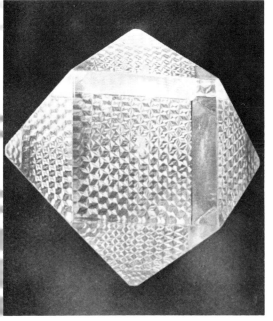

SOLVENTS* AND ADHESIVES CHART

RESINS SOLVENTS	POLYCARBONATE**	POLYESTER	POLYSTYRENE	ACRYLIC	CELLULOSE ACETATE	EPOXY	POLYURETHANE
ALCOHOLS							
Methyl	I	P	I	I	P	P	I
Ethyl Alcohol Pure	I	P	I	I	I	I	I
ESTERS							
Ethyl Acetate	I	I	S	S	P	S	S
Isopropyl Acetate	I	I	S	S	I	S	S
KETONES							
Acetone	S	S	S	S	S	S	S
Methyl Ethyl Ketone	S	S	S	S	P	S	S
HYDROCARBONS							
Benzene	P	S	S	S	P	S	I
Toluene	P	S	S	S	I	I	I
Xylene	P	S	S	P	I	I	P
ADHESIVES							
Epoxy	X		X			X	X
Polyester			X	X		X	X
Acrylic			X	X			

*Besides bonding, solvents are also used to clean implements.

**The best solvent for bonding of polycarbonate is methylene chloride; next best is ethylene dichloride.

THERMOPLASTICS

RESIN	COMMERCIAL FORM	STUDIO USE
Acrylics (polymethyl methacrylate)	Clear, translucent, and opaque solids, liquid resins, molding powder	Fabricating, casting, coating
Cellulose acetate	Sheet liquid resin	Fabricating, coating, mold release agent, mold material
Fluorocarbons	Molding powder, granules, liquid resin	Release agent, molds
Polyethylene	Powder, pellets, sheet, tube, rod, foamed	Molding, casting
Polypropylene	Molding compounds, film, fiber sheeting	Molding, casting
Polystyrene	Molding powder, granules, sheets, rods, foamed block, liquid resin	Molding, fusing, fabricating
Polyurethane	Foamed block, liquid resin	Foaming, fabricating, flexible mold material
Vinyls	Powder, liquid resin, film sheets	Coating, release agent, casting, molding, flexible mold material

THERMOSETTING

Amino resins (urea and melamine)	Molding powder, granules, liquid resin	Adhesives, castings, laminates
Phenolics	Molding powder, solids, granules, liquid resins	Adhesives, laminates, coatings, castings
Silicones	Liquid resins, greases, synthetic rubber	Mold release agent, flexible molds, mixed with other resins for coatings
Polyester resins	Liquid resins, molding compounds, solid sheets, rods, tubes	Laminating, coatings, castings, fabricating
Epoxy	Molding compounds, liquid resin, foamed blocks	Strong adhesives, castings, coatings

3
Processes with Sheets, Blocks, and Rods

Use of sheets and blocks that are crystal clear has become very popular because results are handsome, because they reflect our world — large forms appear to take up less space because the environment becomes a part of the sculpture, and because sheets and blocks are easy to work. The most accepted sheet and block are the acrylics, although polycarbonates are as effective and polystyrenes also are almost as transparent. Another strong attribute is design flexibility, a point to be considered. Because these plastics can be cut, glued, and worked easily like wood or metal is reason enough for popularity, but, more than that, thermoplastics can also be heated and, when soft, draped, vacuumed, or blown into curved contours.

LIGHT AND TRANSPARENT PLASTICS

Light plays along edges of forms as it pipes through areas, causing a luminous glow. By carving solids or constructing and filling volumes with transparent oil, refraction of light is repeated through magnification and distortion. Shapes of light and shadow bounce through solids, ever changing with the viewer's different vantage points.

By manipulating light as a component in working with plastics, one is actually manipulating an essence. Light is an essence. We see objects only because light refracts and reflects off surfaces and reaches our eyes in various wave lengths. Transparent, crystal materials would be merely an illusion if it were not for some definition of light. When one uses acrylics, for instance, light may be blocked and then allowed to pass through etched or textured surfaces, piped through holes and projections, interrupted by opaque solids, refracted by lens shapes, or defracted by gratings.

Light can reach beyond the perimeters of a form by filling an entire room with visual echoes of endless variations of the form itself. And light for its own sake embodies elements

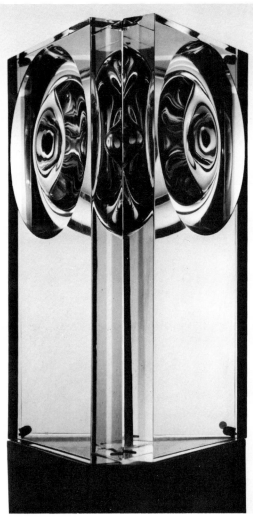

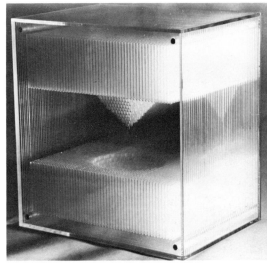

Neal Small cuts geometric progressions of cones, alternating in a series to create this intriguing sculpture, #0019. Light pipes through all the internal edges of the cones, but does not pipe through the outside where it is highly polished. *Courtesy: Neal Small*

Polesello created *Towers* (45″ x 25″ x 25″) by carving and attaching three acrylic blocks onto a triangle using mechanical attachments. *Courtesy: Galeria Bonino, Ltd.*

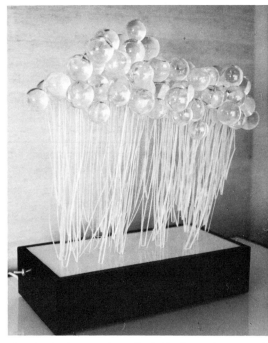

in itself such as rhythm and repetition. For example, when it is combined with transparent plastics, as in the shape of a box, volume is described by repeating edges. With transparent plastics as three-dimensional form, light lives in its space. It is space, inasmuch as it defines it; therefore, in order for a sculpture of transparent plastic to "live," light has to be used consciously as a vital component.

A soft-edged mass of acrylic balls floats above angular strips of acrylic sheet in *Frozen Bubbles* by the author.

The large problem here is how we can control light and form to express the qualities that we want, and, growing from this, how we can take advantage of a transparent material's capabilities.

Line, plane, the part and the whole, space, balance, volume, size, shape, repetition, rhythm, density, position, proportion, movement, and spatial relationships are some of the elements that need to be translated into a light-solid composition. Sculptors who succeed understand these new relationships. It would be wise, when we are studying the examples by artists in this chapter, to pay special attention to the way in which these criteria coexist.

Not all plastics are transparent. The old expression of rules, principles, elements, and their variables apply to opaque plastics. However, light as it defines, as it is illusory and mood-creating, as it highlights some areas and throws others into shadow is still applicable.

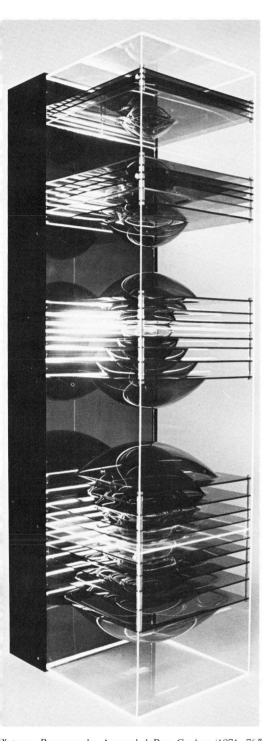

Plateaus Rayonner by Aaronel deRoy Gruber (1971, 76″ high x 16¼″ wide x 21¼″ depth) in a series of progressions of rounded, transparent, colored, vacuum-formed squares with a mirror backing. The whole piece is lighted. *Courtesy and copyright: Aaronel deRoy Gruber; photograph by Walter Seng*

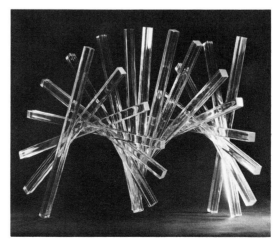

Interpenetrating sticks of acrylic form a rhythmic recurrence with a sense of continuity. The form seems to spin like a baton even though it is stationary. Sculpture by the author.

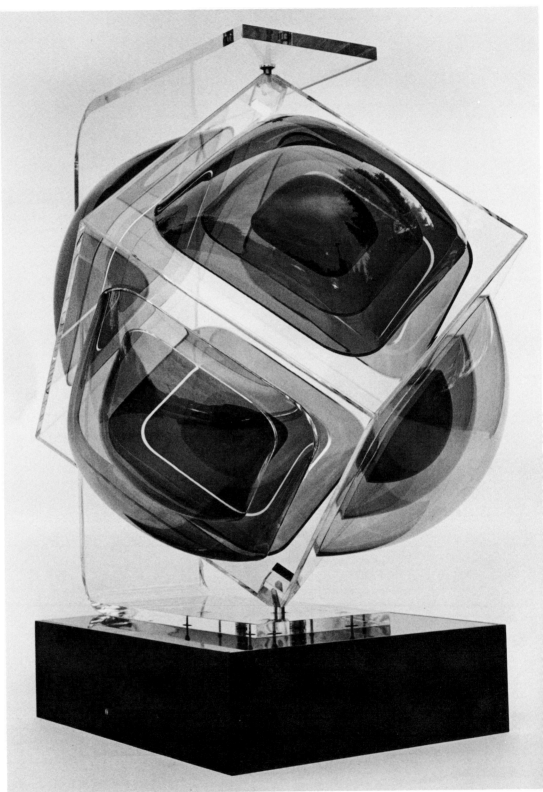

Another piece by Aaronel deRoy Gruber called *Whirling Dervish* (1973, 42″ high) is formed of a ¾″-thick, heat bent C-frame that supports a motorized, multicolored, vacuum-formed cube containing 16 raised sizes of rounded squares. *Courtesy and copyright: Aaronel deRoy Gruber, photograph by Walt Seng*

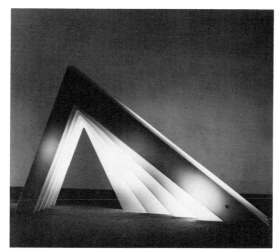

An asymmetrical "A" in acrylic of Greg Copland, Inc., designed by Frank Nakos. Flat sheets of white acrylic are machined to simulate motion through the juxtaposition of the sheets. Lighting completes the illusion. (19" x 34" x 4"). *Courtesy: Virginia Burdick Assoc.*

will expand and result in poor tolerance and finish and sticking of particles to the surface. Temperature should be controlled by use of air and coolants and by slowing the machine speed and cutting down the length of time a tool is used.

TOOLS AND HOW THEY APPLY TO WORKING WITH ACRYLICS

Acrylic, as representative of sheet plastic, is the material discussed here to demonstrate the use of tools and specific processes.

GENERAL CONSIDERATIONS

When acrylic is purchased in sheet form, it is covered with a protective masking paper to reduce the possibility of marring the sheet. It is wise to keep the paper in place until all operations previous to gluing have been accomplished.

The best tools are tungsten-carbide-tipped tools, those generally employed for metal and wood, with some important differences. An essential difference is that as frictional heat is generated, surface friction builds up and can cause a variety of problems. If heat is allowed to increase, the surface of the plastic

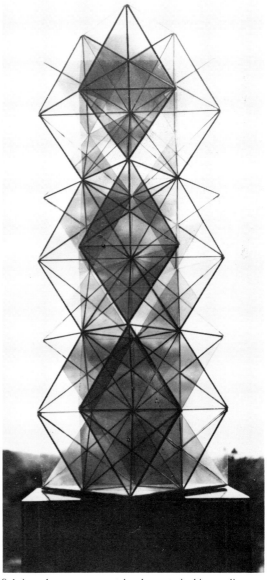

Sobrino also uses geometric elements in his acrylic construction. *Courtesy: Sobrino*

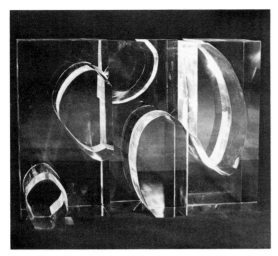

1. and 2. Two positions of the many puzzle sculpture series by the author. The pieces are cut from a 4″-thick acrylic block on a band saw.

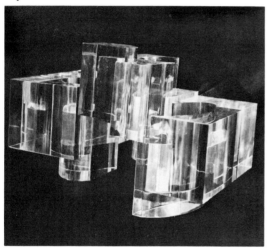

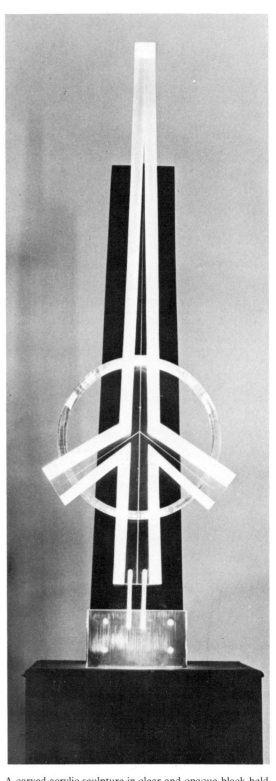

Also, plastics are relatively more resilient than metals and woods; therefore, the material should be supported to minimize distortion. It is essential to use sharp tools; otherwise, stresses are built into the material that result in crazing and cracking later.

BASIC EQUIPMENT AND SUPPLIES

When running acrylic along a surface, if the acrylic is not protected with masking paper, use a white cotton flannel between the acrylic and the machine.

A carved acrylic sculpture in clear and opaque black held by brass pins and internally lighted by Fred Dreher (48″ high x 12″ wide). *Courtesy: Fred Dreher*

Hand-power and hand-powered tools can be used, but nonhand-held power tools make the job easier. A basic workshop should contain the usual level, hammer, files, pliers, C-clamps, square, ruler, compass, as well as a radial-arm saw or other type of circular saw equipped with metal cutting blades (18 teeth to the inch for ⅛″ stock to 8 teeth to the inch for 1″ stock, for optimum results), drill or drill press, sanding wheels, buffing wheels, and a vacuum cleaner. For forming, a strip heater, heat gun, circulated hot-air oven (or make do with a kitchen oven or pizza oven), hydrogen torch for flame polishing (or propane if you

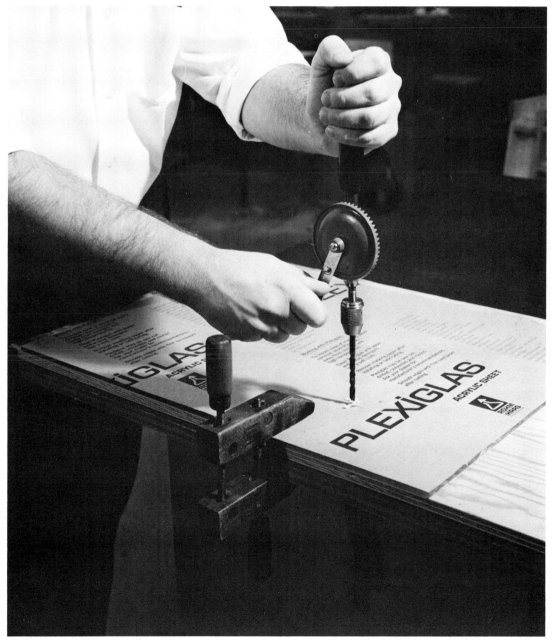

Drilling acrylic with a hand drill. *Courtesy: Rohm & Haas Co.*

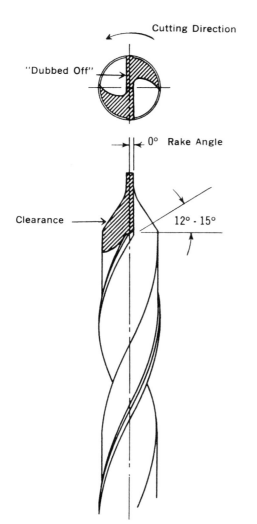

Cutting Direction

"Dubbed Off"

0° Rake Angle

Clearance

12° - 15°

Note the rake angle of a drill bit especially prepared for acrylic. *Courtesy: Rohm & Haas Co.*

CUTTING

Use saw blades designed for metal cutting. They must be sharp. Hold the piece to be cut firmly on a support to prevent chattering and chipping. Use a fast tool and a slow feed. A water coolant prevents overheating. Circular saws are used for straight cuts. Band saws are used when flat forms are to be cut into irregular shapes, such as curves. Speed should be 2,500 to 4,000 surface feet per minute with a 1,725 rpm motor. Jig saws and sabre saws are used for cutting closed holes and inside cuts. Use a fine-toothed blade with 14 teeth to the inch. A crosscut saw can also be used on work that is clamped firmly to a base. And, for those with the very minimum of equipment, an especially designed scriber can be used to score the acrylic repeatedly until the scratch is deep enough to break the piece over a wooden dowel. The dowel should be placed under the length of the intended break. Downward pressure with the palm of the hand will snap the acrylic in two.

can handle it without charring), and—the great luxury—a vacuum-forming machine complete the roster.

For bonding you need an assortment of clamps, masking tape, and syringes for applying the solvent as a bonding agent. And, to complete the list of those extra "helpers," get an assortment of sandpapers, polishing compounds, polishes, cleaners, antistatic agents, and coolants.

A drill press can also be used to drill into acrylic. Drilling into a semisphere requires a gentle touch. Foam rubber can lessen the pressure and keep the acrylic from cracking.

Acrylic sheet can be cut with a sabre saw. *Courtesy: Rohm & Haas Co.*

A band saw is also an excellent cutting tool. So are a radial arm saw . . . *Courtesy: Rohm & Haas Co.*

ROUTING, DRILLING, SHAPING

Acrylic can be turned on power lathes using 500 feet per minute with very slow speeds. They can vary from the small ones used by jewelers to large production units. Cutting tools should have a zero or negative rake angle to prevent chipping. Otherwise, the procedure is the same as for turning brass or wood.

Routers can be used to cut holes to bevel, trim, and finish edges, and to make slots. The plastic should be fed slowly and continuously. Stationary or hand-held routers are good. Two or three fluted end mills with straight or spiral

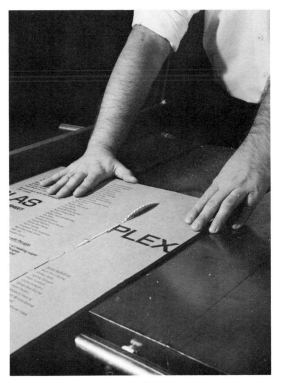

. . . and a circular table saw. *Courtesy: Rohm & Haas Co.*

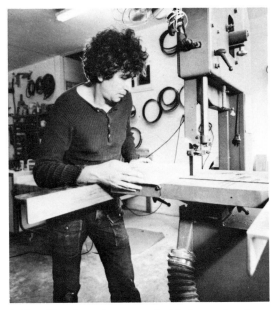

1. Here Vasa is cutting an acrylic block on a band saw.

2. Using a thickness planer, he is running the piece through so that similar pieces are parallel. Or he may straighten a side on a jointer. In the laminating process of adhering layer to layer, a polymerizable acrylic cement is the adhesive. It is poured between layers and clamped with one pound of pressure per square inch. This operation takes a great deal of skill in order not to trap air bubbles in between layers. After lamination, the piece is machined again on a jointer.

cutting edges will work better than wood router bits. Speed is usually 10,000 rpm on stationary cutters.

Drilling is accomplished with drill presses and portable hand drills, using bits modified to a blunt cutting angle. These special bits are now for sale, usually where acrylic sheet is sold. Drill speeds for smaller holes can be run at a faster speed ($1/8''$ at 4,000 rpm) than for larger holes ($5/8''$ at 900 rpm). Holes larger than one inch should be cut with a hole saw. Feed

3. Vasa machining a sphere after lamination.

should be slow but steady. Use coolants for a smoother, cleaner hole.

CARVING

To carve small acrylic pieces, use hand-powered tools such as a flexible shaft drill equipped with a rheostat-controlled foot pedal so you can vary carving speed and keep both hands free. Small rotary cutters, dental tools, burrs, and sanding disks (Dremel®-type) are useful.

4. An assistant sands the side of the sculptural unit after it leaves the jointer.

CREATING A LARGE BLOCK FROM SMALLER ONES

It is possible to create large solid acrylic blocks and save a good deal of money because large thick blocks of acrylic are immensely expensive. The stress condition of the surfaces of blocks is very important. If you use the blocks as originally cast, and do not intend to do any machining or polishing before you bond these blocks, then there are no problems with stress. If your two surfaces are perfectly flat and have no cavities or indentations, all you need to do is abrade the surface *lightly* with a fine grit aluminum oxide paper #500 or #600. This gives the surface some "tooth." Bonding is achieved by using a two-component thermosetting adhesive called PS 30, (Cadillac Plastics and Chemical Co.). It is a water-clear syrup consisting of methyl methacrylate polymer and monomer. To this one part of catalyst, mainly benzoyl peroxide, is added to 19 parts of the polymer-monomer syrup. The two components are stirred, and, if possible, air is vacuum-deaerated from the adhesive. If deaeration is not possible, allow the mixture to stand for a few moments for air bubbles to rise to the surface. Then the syrup is applied to the surface of one piece; the other is positioned properly and bubbles that remain in the joint should be worked out to an edge where they can escape. Use of some pressure can do this, but no more than one lb./in.2 of surface should be used, else excessive pressure tends to squeeze out too much of the PS 30. After the PS 30 polymerizes (completely in about 24 hours), the block is ready for carving.

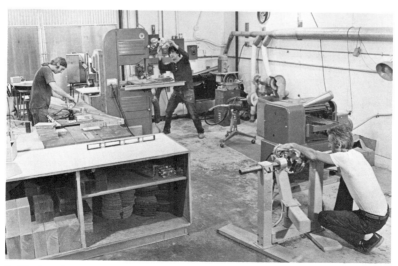

5. The length may be buffed to a high finish with a hand-held unit, or smaller units may be buffed on a stationary buffing wheel.

In the event that surfaces to be joined do not match, then they need to be sanded or ground down until they are smooth. This disturbance of the surface can cause stress cracking after bonding, unless the pieces are annealed. Jacques Schnier found that, contrary to what manufacturers suggest in their fabrication manuals, annealing *after* bonding causes unequal expansion of sections if they are of varying thicknesses and results in a slight tearing of the bond. Therefore, it is best to anneal the piece *before* bonding.

The annealing oven should be heated slowly to a temperature that softens the material enough for molecules to reorient themselves

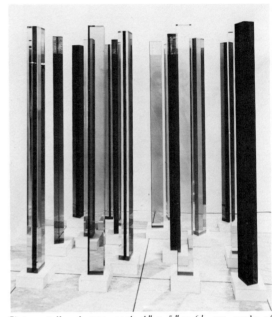

Sixteen tall columns, each 4″ x 5″ x 6′, are made of laminated acrylic. Vasa (1970). *Courtesy: Vasa; collection: Mr. and Mrs. Milton Stark*

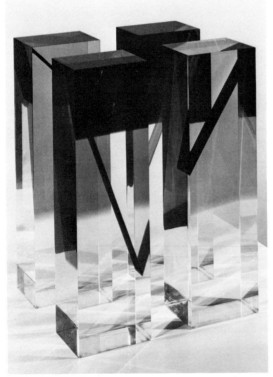

6. *Bouquet III* by Vasa. Vasa chose acrylic sheets because acrylic delineates volume while remaining almost transparent; it has high light-transmitting characteristics; and color is more controllable in sheet than in a casting. With precise fabrication, Vasa's pieces are jewel-like, with color planes transmitting within the contained space of a clear volume of acrylic. This sculpture consists of four pieces each 4⅛″ x 5⁷/₁₆″ x 18⁷/₁₆″.

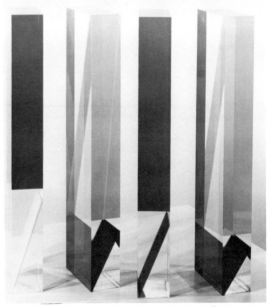

Gradients by Vasa (1970, 2½″ x 5½″ x 21⅛″). *Courtesy: Vasa; photographs in series by Richard L. Johnson*

RECOMMENDED HEATING TIMES FOR ELEVATED TEMPERATURE ANNEALING OF PLEXIGLAS® (ACRYLIC)

THICKNESS (inches)	Heating Time* in Hours for Plexiglas Placed in a Forced-Circulation Air Oven Maintained at the Indicated Temperature				
	230°F.**	210°F.**	195°F.**	175°F.	160°F.
0.060 to 0.150 inc.	2	3	5	10	24
0.187 to 0.375 inc.	2½	3½	5½	10½	24
0.500 to 0.750 inc.	3	4	6	11	24
0.875 to 1.125 inc.	3½	4½	6½	11½	24
1.250 to 1.500 inc.	4	5	7	12	24
2.000	6	6	8	13	24
3.000	10	11	12	17	28
3.500	12	13	14	19	30
4.000	16	17	18	22	33

* Includes period of time required to bring part up to annealing temperature.
** Formed parts may show objectionable deformation when annealed at these temperatures. Use caution in annealing formed parts in the higher temperature ranges without testing. Courtesy: Rohm and Haas Co.

and thus relieve strains, and the annealing oven should have a blower to circulate hot air so that there are no hot spots in the oven. (The amount of time needed for annealing depends upon the thickness. It can run for several hours.) Cooling off should be gradual.

After annealing has been completed, the parts can be bonded together. Jacques Schnier suggests that if annealing is not possible, then a Carboloy® scraper honed to a straight edge can be used gently to scrape off surfaces that will stress-crack. Heat should not be allowed to build up in this process.

To carve large blocks, Jacques Schnier uses marble chisels and approaches the carving process in the same way as that used for marble—blocking out general, large areas, using extra sharp chisels held at flat angles. Acrylic has a tendency to chip into concave-conchoidal fractures, so overcutting should be avoided. As finer detailing is needed, the chisels should be exchanged for carbide rotary burrs operating at 20,000 to 25,000 rpm with an air gun (lower speeds for other equipment). Keep speeds low to avoid generating too much heat, which, in turn, will cause stressing. After

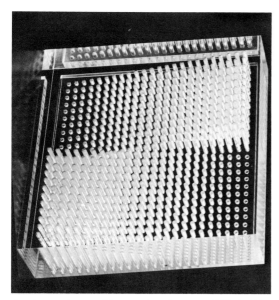

Another sculpture with two triangular areas drilled with a progression of holes. The shapes appear to multiply when seen at different angles. *Courtesy: Ugo LaPietra*

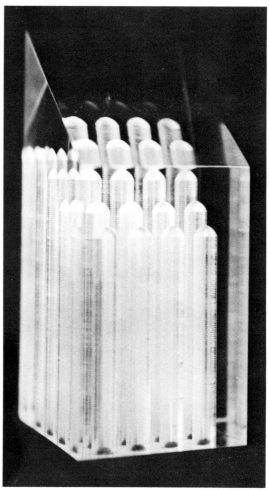

A sculptural block by Ugo LaPietra with internal form created by drilled holes. A single pyramid is mirrored internally by refraction. *Courtesy: Ugo LaPietra*

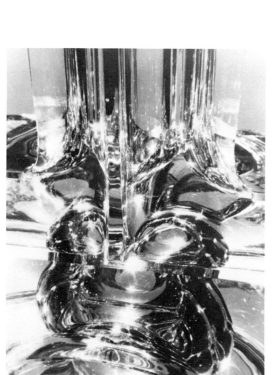

Jacques Schnier believes that the shape of this form is enhanced by acrylic's brilliance. He concludes that reflection and transparency should be included as a primary element in aesthetic concepts of sculptural form. *Light Sanctuary #2 (1972). Courtesy: Jacques Schnier*

finer details are achieved, buffing begins, using compounds from black to rouge to white. (Surface speeds of buffing wheels should also be controlled so heat is not built up in this process.) A final polishing recommended by Jacques Schnier is use of Lustrox®, Plastic Grade (Tizon Chemical Co., Flemington, N.J. 08822), a polishing compound made of submicron-size zircon crystals. It imparts a dazzling final polish to the surface of acrylic (and polycarbonates).

FORMING

Forming involves softening of the sheet, rod, or tube until it becomes pliable. Acrylic will soften at a range between 250°F. and 340°F. At this stage it becomes as flexible as a sheet of rubber and can then be stretched and shaped by hand, pressed into a mold, vacuum- or blow-formed. When allowed to cool, the piece becomes rigid and retains its new shape. If contours are not satisfactory, the piece can be reheated and, as it does so, it returns to its earlier shape. This is called "elastic memory." While the piece is hot, the shaping process can begin again. A piece of acrylic can be reheated and reformed many times. Care must be taken not to overheat the acrylic, or bubbles and blisters will form and the sheet may yellow. (I sometimes take advantage of bubbling to achieve another texture.)

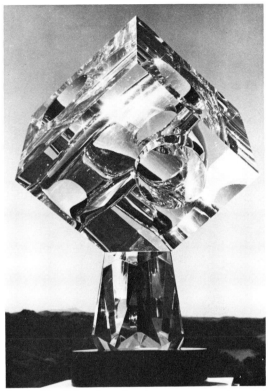

Inspired by Oriental carvings in transparent rock crystal, Jacques Schnier carves into an acrylic block. He forms thicknesses of block by bonding one block to another with PS 30 and annealing the whole. *Light Sanctuary #4.* *Courtesy: Jacques Schnier*

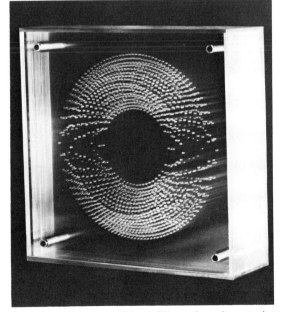

Another effect is created by drilling and routing a series of holes to create a volume that is entirely defined by light. This sculpture *#0037* is by Neal Small (1969). *Courtesy: Neal Small*

COLD FORMING

Within limits, acrylic can be cold-formed at room temperature. The minimum radius of a curvature must be at least 180 times the thickness of a sheet; e.g., a sheet of 1/16″ thickness can be bent to a curve of 11″ radius, 1/8″ to 22″, 1/2″ to 90″. Any tighter curves would cause stress. These curves are not permanent and need to be attached with mechanical devices.

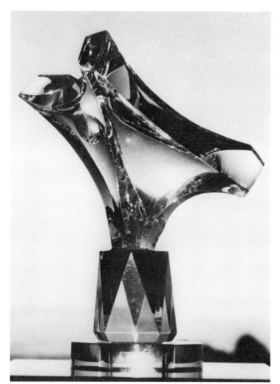

Two other carved acrylic forms by Jacques Schnier. *Courtesy: Jacques Schnier*

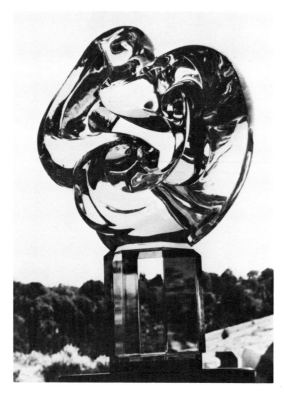

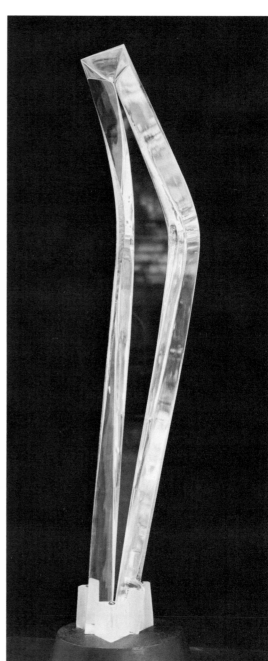

Carved shapes of internally lighted acrylic sheet by Fred Dreher. *Courtesy: Fred Dreher*

1. The basic materials for making a simple strip heater are assembled: asbestos paper (available from hardware stores), heavy aluminum foil, two ¼"-thick plywood strips 2⅝" x 36", a piece of ½"-thick plywood 6" x 42", and a Briskeat RH-36 heating element.

If great care is exerted, a propane torch can be called into service with cautions paid to blistering and flaming possibilities. Strip heaters also are utilized to heat a narrow strip for bending.

Strip Heating

When several straight line bends are required, it is best just to heat the narrow area to be bent, rather than the entire form. To accomplish this, a strip heater is used. It looks like a long unit equipped with a tubular heating unit housed in an insulation of asbestos

HEAT FORMING

There are several basic methods to heat-form acrylic: strip heating for simple line bends, drape forming of two-dimensional curves, and stretch forming of complex shapes via manual methods, blow forming, free blowing, vacuum forming, and other industrial processes.

Heat-Forming Equipment

In order to heat the plastic, some heat-generating equipment is necessary. Along with heating means, auxiliary equipment such as molds, clamps, and frames need to be on hand. Some heat-generating equipment may be air-circulating ovens used by professionals. These vary from flat, small bench units to huge units that suspend acrylic sheet vertically by means of clamps. These sheets then roll in and out of the oven on an overhead track.

A pizza oven can be used as well as a kitchen oven. For heating and deforming small areas, a heat gun that blows hot air can be used.

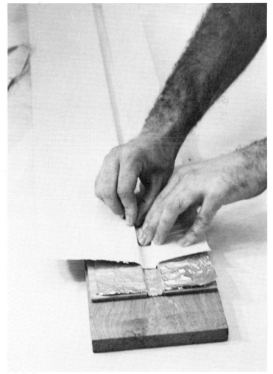

2. Nail the three pieces of plywood together, leaving a ¾" space for the heating element in the center between the two narrower strips of plywood. Add two layers of aluminum foil and a ground wire to the wood. Top that with two layers of asbestos paper and then press and smooth the aluminum and asbestos coverings into the channel.

To use a strip heater, the acrylic sheet is placed over the heating element exactly where the bend is to be, leaving ¼″ between element and acrylic to avoid marring the acrylic. The sheet is allowed to remain over the element until it softens. (Thick acrylic needs to be heated on both sides.) The piece is bent immediately to the proper angle and held there by hand or with mechanical means such as jigs and clamps until the acrylic cools. To avoid marring the surface (these areas should not have any masking tape or dirt on them), use a soft flannel cloth on surfaces of the jig.

3. Staple or nail these layers to the plywood. At each end of the channel, hammer in a nail part way.

4. Stretch the Briskeat RH-36 element along the channel, tie the strings found at both ends to the nails, and pull it tautly. The strip heater is ready for use.

or asbestos wallboard. Strip heaters are commercially available, or easily constructed of resistance-type heating elements. The elements for the homemade one illustrated here are available in kit form wherever Plexiglas (Rohm and Haas acrylic) is sold.

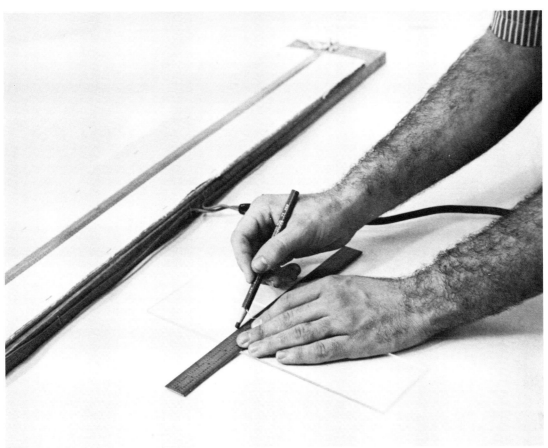

5. To form a simple bend, plug in the heating tape. Mark the area to be bent, if necessary, with a removable waxy line.

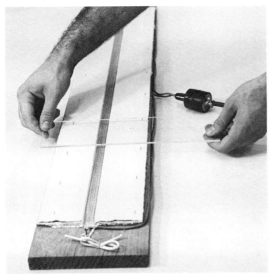

6. Place the bend line over the element, resting the piece on the asbestos.

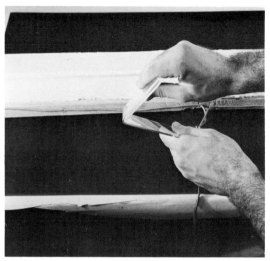 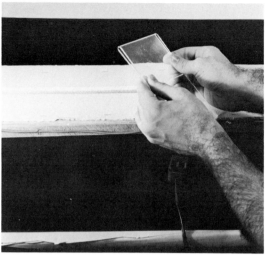

7. and 8. After a few moments, the heated area looks "textured" and different. (The heated side should be on the outside of the bend.) Fold the plastic into shape and hold it there until it cools. *Courtesy: Jay and Lee Newman; photographs from* Plastics for the Craftsman

Drape Forming

Simple two-dimensional curves can be formed by draping a heated sheet over a mold and permitting it to cool. Drape forming requires a mold and a heating unit, such as an oven, to heat the entire sheet. The simplest forms are two cleats or wooden sticks held by C-clamps that estimate the distance and contour supporting ribs (covered with flannel) to demarcate shape and the height of the curve. The more irregular the shape, the more support your mold has to provide. Cleats serve as wedges to hold the two ends of the sheet firmly in place. Hot sheet has a tendency to curl away at the edges.

In cutting your shape, expect about a 2% shrinkage. Remove the masking paper before placing the acrylic in the oven for softening to 320°F. and 340°F. for about 10 minutes for a 1/8" thick piece. When the sheet hangs like soft rubber, place it on the mold; cover it with a flannel blanket to hold in the heat. Sometimes it is necessary to rub the form to ease it to the contours. Wear cotton gloves to avoid marking the plastic. Do *not* remove the acrylic form until it has cooled to room temperature.

Trolley

Track

Hunt No. 4
Paper Clip

A detail of the trolley and clamps that holds acrylic while heating in a vertical oven. *Courtesy: Rohm & Haas Co.*

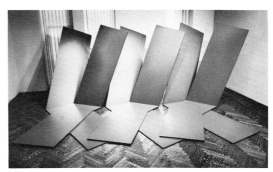

Phillip King created *Slant* of Armorite (1965, 84″ x 80″ x 475″) using a single strip heating technique. *Courtesy: Richard Feigen; photograph by Geoffrey Clements Gallery*

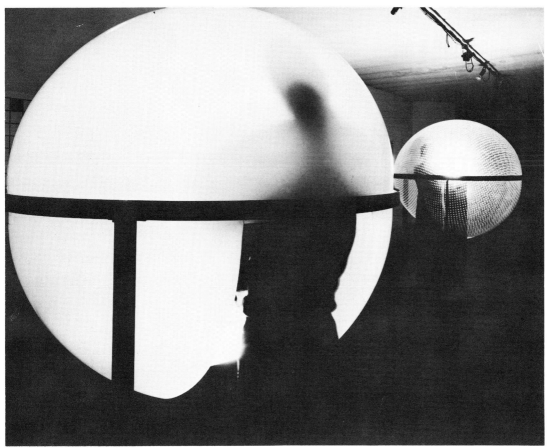

Immersione #2/3 by Ugo LaPietra. A light-sound environment of acrylic. *Courtesy: Ugo LaPietra*

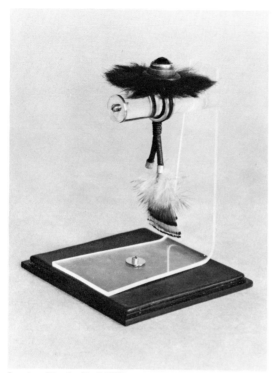

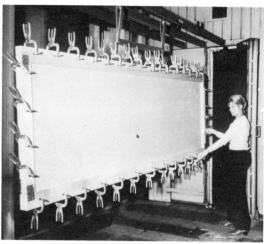

Aaronel deRoy Gruber getting ready to put an acrylic sheet in an oven for heating so that it can be formed when it softens. Note the frame around the acrylic and clamps that hold it tautly. *Courtesy: Aaronel deRoy Gruber; photograph by Walt Seng*

Leather Ring by Fred Williams was heat formed and bent. *Courtesy: Fred Williams; photograph by Jim Fisher*

Free Blowing

Free blowing is another simple forming method. A heated sheet is clamped over a vacuum pot or pressure heater and drawn or blown to shape. The opening in the vacuum pot or pressure heater will determine the contour and, to a limited extent, the outside shape. The tendency, however, is always toward a spherical shape.

A simple free-blowing hookup is to attach an air hose to the underside of a plywood board. Put flannel on top of the board, leaving a space for the air hose to fit; place the heated sheet on this board and a forming plate (ring, oval, square, et cetera) made of Masonite® on top; clamp with quick-action toggle clamps or C-clamps. Run the compressor. Get some help because speed is essential; otherwise, the acrylic will cool before it is blown. Five to 10 pounds of air pressure will form a 2″ diameter hemisphere. After the piece has been blown to the proper size, pressure is reduced to hold the piece at that height until it cools.

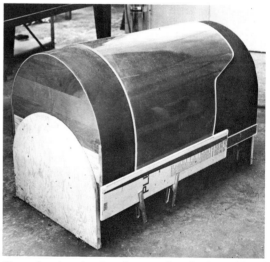

Drape forming showing the use of a simple mold and clamp. (The acrylic has to be heated first.) *Courtesy: Cadillac Plastics*

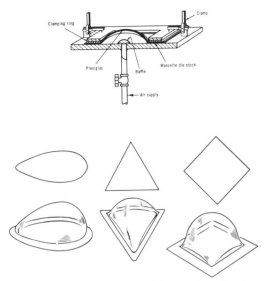

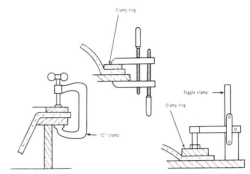

Different kinds of clamps that can be used. *Courtesy: Rohm & Haas Co.*

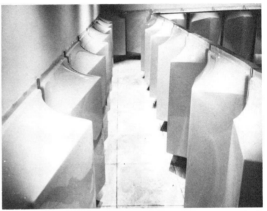

Free blowing showing mold and forms. Free blowing is used to form three-dimensional shapes by the use of positive air pressure and without the use of male or female forms. A heated sheet is clamped to a piece of plywood or Masonite. The finished part will assume the inside shape of the hole in the plywood or Masonite. After clamping, air is introduced slowly until the heated acrylic is brought to its final shape. The air is maintained until the shape cools. *Courtesy: Rohm & Haas Co.*

Les Levine *The Clean Machine* of Uvex butyrate plastic (1968, 6' x 4' x 18" each unit, 56 units). *Courtesy: Fischbach Gallery*

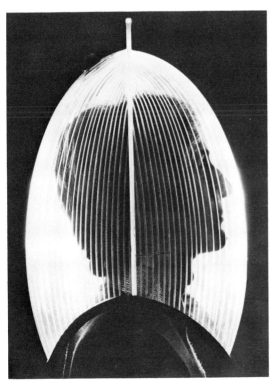

An etched and blow molded head environment by Ugo LaPietra called *Audiocasco. Courtesy: Ugo LaPietra*

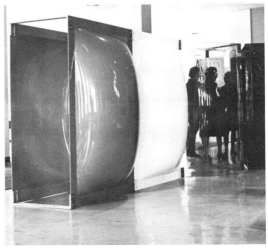

Body Color by Les Levine was made by blow molding (1969, 4' x 6' x 14" each dome). *Courtesy: Fischbach Gallery; installation: Loeb Student Center, N.Y.U.*

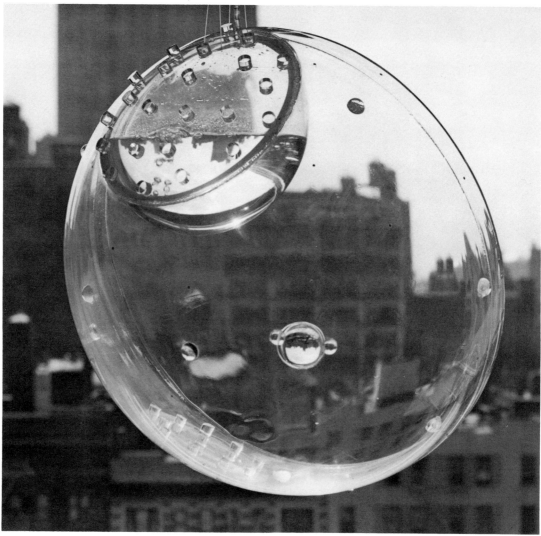

Kosice, *Antistatics of Water* (1967, 23¾″ diameter).
Acrylic. *Courtesy: Galeria Bonino, Ltd.*

Vacuum Forming

Vacuum forming is similar to free blowing, but rather than blowing the hot sheet into a shape, the sheet is drawn through an opening in a forming plate. The vacuum chamber, usually made from welded steel plate, must be airtight. Masonite is used again as the forming plate. The cutout in the forming plate will determine the contour and height (depth of draw). Control is regulated by a vacuum valve. A mold can also be used. It should be made of plaster of Paris, wood, or any other durable material that can be formed to contain exhaust ports distributed throughout in order to suction out the air. A clamping ring holds the plastic edges in place. Commercial vacuum-forming machines are expensive. An industrial tank-type vacuum cleaner can provide vacuum pressure but rigging up a table probably is not worth the effort. It is better to create the mold and/or forming plate and have a plastics shop fabricate the form.

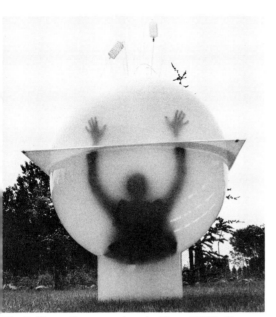

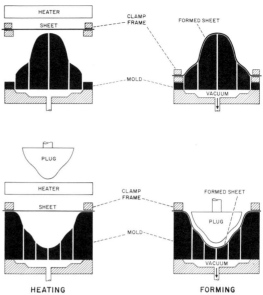

Ugo LaPietra, *Nomovovosfera Ambiente* (1968). *Courtesy: Ugo LaPietra*

Diagrams showing two aspects of vacuum-forming. The top design utilizes a male mold. Heated thermoplastic sheet is vacuum drawn over the mold. (The vertical lines represent holes that suction the sheet to the form.) In the lower diagram, a plug assists as the vacuum draws the heated sheet into a female mold. *Courtesy: Rohm & Haas Co.*

Aaronel deRoy Gruber making a wood form for a vacuum-forming machine. *Courtesy: Aaronel deRoy Gruber; photograph by Walt Seng*

Mary Fish's small vacuum forming set-up operated with vacuum cleaners. This apparatus was made by constructing a small 6″ x 6″ x 6″ airtight acrylic box, open on the top. One hole was made in each of two sides for each of the vacuum cleaner hoses to fit into. These holes were sealed with gaskets to prevent air leaks when the hose was attached. On top of the box went two templates; a gasket was glued on the bottom side of the top one and on top of the bottom one. Acetate was sandwiched between. Templates, gaskets, and acetate are clamped to a rim around the top of the box. The acetate is heated with a small hotplate from above. When the acetate is at the softening point, the vacuum cleaners are turned on simultaneously. The suction pulls the plastic down. *Courtesy: Mary Fish*

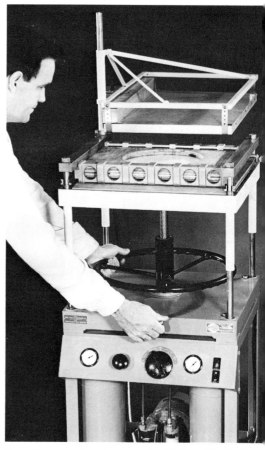

A small vacuum-forming press by Di-Arco Plastic Press. *Courtesy: O'Neil-Irwin Manufacturing Co.*

Looking down on a small forming template that will govern the final vacuum-formed shape. By Mary Fish. *Courtesy: Mary Fish*

BONDING AND FASTENING

SCREWS AND TAPPING

Screws should never be applied to acrylic as one would for wood, because internal fractures and cracking would result. Machine screws with coarse threads, wax- or soap dressed, will keep threads from burning. It is best to drill a hole slightly smaller than the screw size first. But, best of all, screw holes should be tapped to match the screw.

ANNEALING

If a formed or cut part has been subjected to too much stress during the forming or machining operations, it should be annealed. This is

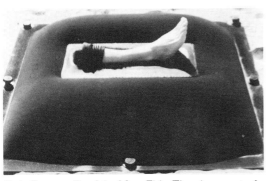

Body Form on Beach by Mary Fish. The piece, part of a series of body forms, was fabricated on a 4' x 6' vacuum-forming machine. Heated thermoplastic was mounted in a template and then pulled down over a rectangular wooden form which made the depression in the middle. *Courtesy: Mary Fish*

surfaces and causes the molecules to intermingle. As the solvent penetrates and evaporates, the two softened areas fuse together. Almost no pressure is needed to effect this type of bond. It occurs within 20 to 30 seconds after the two parts are brought together.

After edges have been brought together, brace the parts and use masking tape as a temporary reinforcement. Large pieces require elaborate methods of holding parts in place, even use of jigs. The most satisfactory

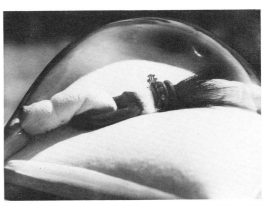

Detail of *Green Dome* by Mary Fish (12" x 12" x 10"). *Courtesy: Mary Fish*

accomplished by placing the acrylic, after all fabrication has been completed, in an oven of 120°F. to 175°F. (just below forming temperature) for 5 to 7 hours and then allowing the form to cool gradually. Parts before annealing should be clean of all coatings and masking paper and be dry. It should also be supported. The best type of oven should have forced air circulation.

CEMENTING

Cementing is simple but requires a steady hand and meticulous care in order to obtain good transparent joints. If stresses and ridges were created by sawing, then edges have to be dressed to prevent crazing when the acrylic comes in contact with the cement.

All surfaces to be joined should fit accurately but should not be sanded or polished. Cementing should be done at room temperature, low in humidity.

SOLVENT CEMENTING

The most popular type of bonding is solvent cementing. Solvent actually softens both

solvents are methylene dichloride, or methyl methacrylate monomer. Other types such as ethylene dichloride and acetone are not nearly so satisfactory. When using these solvents, take care to have adequate ventilation and do not smoke; these cements are volatile.

There are several ways to apply the solvent: by capillary cementing, dip or soak cementing, and mortar or joint bonding with viscous cements. Unthickened cements are used indoors and thickened cements may be used out of doors or when water will be in contact with the joint.

CAPILLARY CEMENTING

The most simple and popular type of cementing is capillary cementing. The liquid solvent spreads automatically, running down between the crack of the joint and remaining only in that area. To capillary cement, set the clean joints in place, brace, and tape. Then with a brush, eyedropper, or syringe draw a bead of solvent along the inside edge, letting the solvent race ahead slightly. Then repeat the operation for the outside edge. Allow the joint to remain undisturbed for at least 15 minutes.

Four Gold Domes by Mary Fish (4' high x 6' wide). The gold dome portion is fabricated from thermoformed acrylic vapor coated with gold. Small black forms were vacuum-formed of acetate on a small vacuum-forming machine. The black forms that enclose the blown ones were made of carved black acrylic, heated in an oven and formed to the contour of the dome. Black suede tubing outlines the bottom edge of the entire dome portion. Domes are mounted on black suede coat (Nextel brand from 3M) which was painted on aluminum tubing. The suede coat is an epoxy coating which is sprayed on with a cup gun. *Courtesy: Mary Fish*

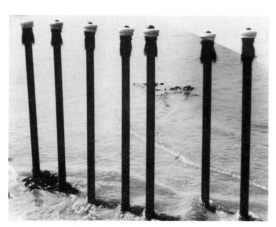

Fetish Poles by Mary Fish is made of 4' black chrome pipe, chamois, nails, peacock floss, and formed acetate. *Courtesy: Mary Fish*

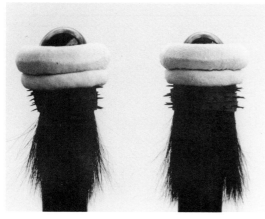

Fetish Poles detail showing vacuum-formed acetate forms. *Courtesy: Mary Fish*

DIP OR SOAK CEMENTING

Use a shallow aluminum, glass, or stainless steel tray. Line up short pieces of wire or brad nails in the tray to keep the piece from touching the tray. Level the tray and pour enough solvent cement to just cover the wires or brads evenly. Brace and stand the acrylic part on the brads upright for 1 to 5 minutes. Remove and allow excess to drain off by holding it at a slight angle. Quickly place the softened edge exactly in place on the other part. Hold them together for 30 seconds without applying pressure. Then after 30 seconds, when some excess solvent has evaporated, apply gentle pressure to squeeze out air bubbles—but not the cement. Maintain contact for 10 to 30 minutes. The first five are the most critical. Allow the piece to "set" for 8 to 24 hours before handling.

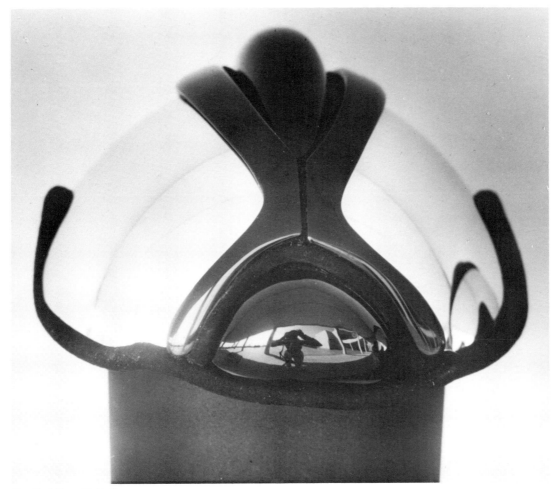

Detail of *Four Gold Domes.*

MORTAR JOINT CEMENTING

A viscous type of cement is used for this type of joint. Viscous cement can be made by dissolving small clean chips of acrylic in solvent and letting the solution stand overnight or by using PS 18 or PS 30. These cements are applied with a syringe. Viscous types of cement tend to shrink when they polymerize and sometimes require second and third applications. Close-fitting joints are not necessary because the cement fills the gap. Dams to hold the cement may be formed with masking tape (keep the adhesive side away

from contact with the cement). Excess cement later can be machined away. Water-white epoxy also can be used the same way as acrylic viscous types.

FINISHING

After cutting, forming, and bonding parts together, final finishing touches are usually polishing edges and cleaning and polishing the entire piece. I often do edge finishing along the way before bonding. For instance, it is simpler in making a box to polish the edge of a sheet before bonding than after the box is

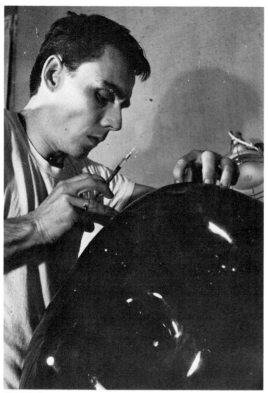

Ed McGowin filling in minute imperfections in a vacuum-formed piece. *Courtesy: Ed McGowin*

A sculpture by Ed McGowin made of Uvex that is 36″ high, consisting of bands of blue, orange, brown, and yellow. *Courtesy: Ed McGowin*

of laborious hand sanding. To scrape an edge, hold your piece firmly in a vise, then hold the blade of the scraper inclined in the direction the scraper is to be moved either forward or toward you (not in both directions as a continuous stroke), and scrape away very thin layers of edge until all indentations are removed.

put together. One has to determine which edges are to be polished.

Finishing requires all or any of these steps: scraping, sanding, ashing, buffing, and polishing with muslin wheel, flame, or solvent by hand. All edges need not be brought to a high shine, particularly if you wish a glow of light to be emitted; in that case, scraping and sanding will suffice. Scraping is the only optional finishing before cementing. If the saw marks are not evident, no scraping is necessary.

SCRAPING

Very rough saw marks may be removed with a belt sander and/or scraping with a steel "wood" scraper. This step saves a great deal

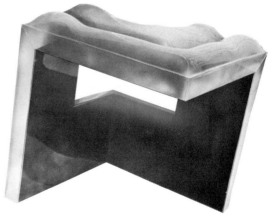

A back view of Ed McGowin's sculpture. The inside surface is blue. *Courtesy: Ed McGowin*

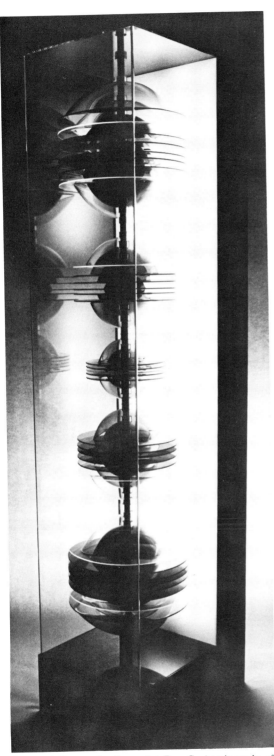

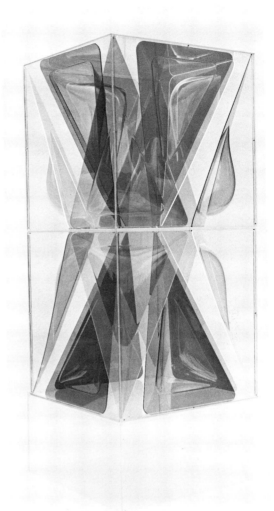

Prismod by Aaronel deRoy Gruber consists of two clear boxes 25¼" square on a 12" base. The boxes contain 8 multicolored vacuum-formed pyramids. *Courtesy and copyright: Aaronel deRoy Gruber; photograph by Walt Seng*

Spherical Plateaus by Aaronel deRoy Gruber is made of five sections of circular, rounded, vacuum-formed squares, predominantly in blues and greens. The back panel is lighted and the center shaft is motorized (1973, 73½" high x 14¾" wide x 20¾" deep). *Courtesy: Dainippon Ink & Chemical Co.; copyright: Aaronel deRoy Gruber; photograph by Walt Seng*

SANDING AND ASHING

These steps may not be necessary. Ashing consists of buffing the piece with a slurry or paste (the thickness of mud) of pumice abrasive and water. It requires protection from slinging and flying ash with a polishing hood. A 2-hp motor and cotton stitched buffs 10" to 12" in diameter are what is needed. Hold the part firmly against the wheel and move it slowly until scratches disappear.

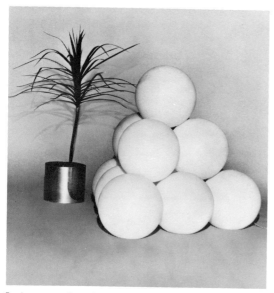

Sculpture or floor lamp by Neal Small (31″ high by 36″ base). Ten 12″ diameter interconnected polyethylene spheres, each containing a 50-watt bulb are stacked to light up at a step on a switch. *Courtesy: Neal Small*

After using 400 and 600 grit wet-or-dry sandpaper, no polishing or buffing is necessary if carried a few steps farther with Polysand. After each sanding, particles must be dusted or blown off before the next finer grit is used to prevent particles from embedding. The material can be used wet or dry. After the last sanding, the manufacturer recommends an application of a liquid wax that they supply to eliminate static. If you use Polysand, you probably will not need to go on to polishing and buffing; otherwise, you are ready to polish.

POLISHING AND BUFFING

Wheels used for plastic should not be used to polish metal. Metal particles embed in the softer surface of the plastic. For average use a 1-hp motor is adequate, but for production work a 1½- to 2-hp motor is necessary. The diameter of the wheel and the motor rpm will determine surface speed. These are the recommended speeds:

6″ diameter	1,800 rpm
8″ diameter	1,500 rpm
10″ diameter	1,200 rpm
12″ diameter	1,000 rpm

To wet sand, use wet-or-dry silicon carbide belts running at 2,800 surface feet per minute, with grit sizes varying from 220 to 280 for extra smooth edges.

Sanding by hand follows scraping or belt sanding. If scratches are very deep, use 240 or 320 grit wet-or-dry paper, sanding in one direction. After deep scratches are removed, follow this with 400 or 500 grit paper, sanding in the other direction. For a very finely finished edge I use a series of grits from 400 to 600 of aluminum oxide Mylar-coated paper (Flexi-Grit®). When the piece is satin smooth, dry the edges with a flannel cloth.

A new kind of sanding material called Polysand® (Micro Surface Finishing Products, Inc.) can create full visual transparency quickly by hand shaving (sanding) with a series of fine cloth-backed cushioned abrasives. The abrasive crystal particles are bonded to the cloth back with Latex rubber, imparting a flexible sanding action for acrylic, polycarbonate fiberglass impregnations, and so on.

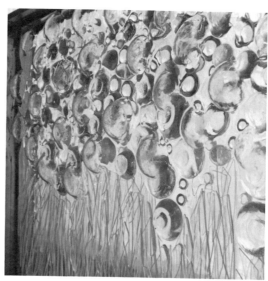

A close-up detail of the author's *Captured Frozen Sea Life,* showing in relief the heat-formed semispheres.

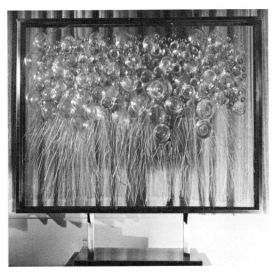

There are three sheets of acrylic contained in this sculpture by the author. The two outer ones (front and back) contain many formed bubbles. Small areas were heated with a heat gun and then, when they were soft, a curved mold form was forced under pressure (my two feet) into the softened area. The center sheet of acrylic contains many sizes of cast clear polyester domes, adhered to the sheet with polyester. (The polyester was cast into vacuum-formed Mylar molds.) The near-vertical projections are superimposed pieces of acrylic adhered to the center sheet. The whole was mounted in a stainless-steel frame containing channels to separate the three sheets.

I find that a 10″ wheel of unbleached, loose, or packed muslin, 1½″ wide, running at 1,725 rpm, does a fine job of taking out faint scratches. Do not use a rigid buffing wheel made of multistitched muslin—it sometimes marks the plastic. A loose buff permits wheel ventilation, thereby producing less heat.

Apply polishing compound frequently but sparingly. Some polishing compounds require a wheel dressing of tallow, at first, to hold the compound on the wheel. Keep the wheel clean. Polishes get hard and grimy after a while and scratch the plastic rather than polishing it. XXX White Diamond® composition (Matchless Metal Polish Co.) eliminates the need for several wheels and very little tallow is necessary. It polishes out surface scratches and brings acrylic to a high lustre with very little effort. N 42 chromium composition, 320 HR hard rubber composition, and 327 hard rubber composition (from the same company) also work effectively.

Rotation of the wheel is toward you. Therefore, always keep the *upper edge* of your piece away from the wheel; otherwise, the force of the wheel will tear the piece from your hands and send it flying. For edge polishing, move the piece across the wheel from left to right. When the bottom part has been

A close-up of *Starbridge* showing the two continuous nylon strands strung through the grommets. *Courtesy: Robert S. Schwarz*

Robert S. Schwarz's sculpture *Starbridge* is made of ½″ acrylic cut, polished, and drilled with ³⁄₃₂″ holes, which are finished with nickel-plated grommets. The string is nylon monofilament (40 lbs.). *Courtesy: Robert S. Schwarz*

polished, turn the piece around and repeat the operation so that polished areas overlap. In surface polishing, keep the piece in motion at all times. Remember to stay away from the top edge, so the wheel does not catch the piece. Some people complete the polishing operation by buffing the piece with a clean loose muslin wheel or a Domet flannel wheel, free of any compounds.

A flexible shaft tool or a polishing wheel attached to a pistol drill can also be used. Use 4″ to 6″ muslin wheels, 1″ to 1½″ wide, for pistol drills. Keep the wheel in motion, apply compound sparingly but frequently, and use little pressure.

For hand polishing, fine scratches can be removed with Simoniz Cleaner® and a soft flannel pad. When scratches have disappeared, wipe clean with a flannel cloth and apply Simoniz wax or Johnson's spray wax. Buff to a dry shine.

FLAME POLISHING

Flame polishing is a fast process but takes skill and special equipment — namely, a welding torch with a #4 or #5 tip, hydrogen, set at 8 pounds and oxygen at 5 pounds. Ignite the hydrogen first and then turn the oxygen on and set the flame. The flame should be almost

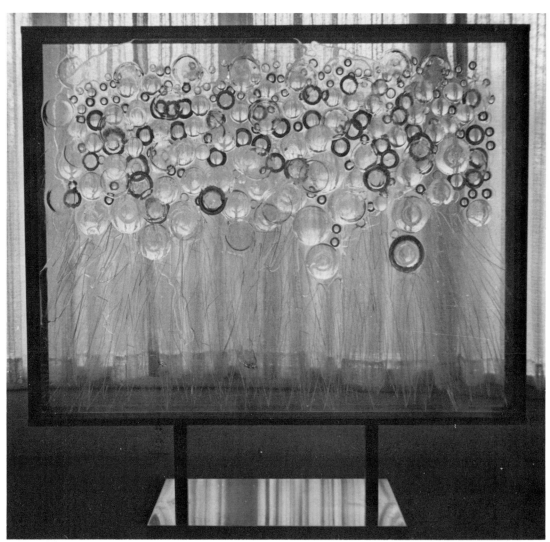

Compare this back-lighted version with the front-lighted image and note the many "moods" of a transparent sculpture.

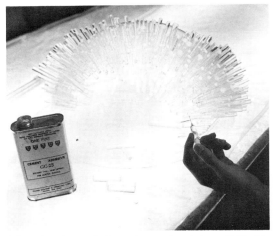

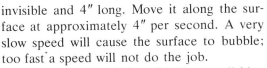

A hypodermic needle is used to apply ethylene dichloride to attach the two parts of the sphere and the acrylic rods.

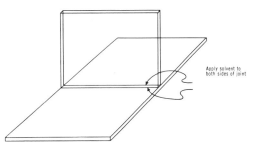

Apply solvent to both sides of joint

To capillary cement acrylic, use solvent type cement (ethylene dichloride or 1-1-2 trichloroethylene) and apply it with a brush, pipe cleaner, eye dropper, or hypodermic-type applicator to the butted edges which are to be joined. Simple jigs or supports with very light pressure should be used to hold parts together until the cement sets sufficiently to allow release of the supports. The setting time usually takes minutes. *Courtesy: Rohm & Haas Co.*

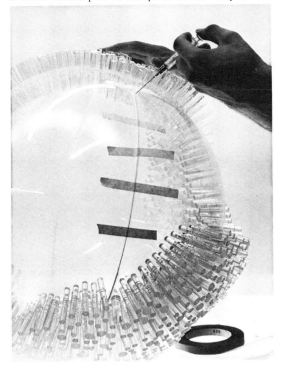

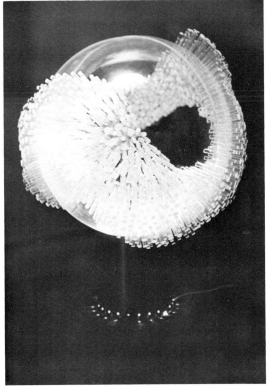

invisible and 4″ long. Move it along the surface at approximately 4″ per second. A very slow speed will cause the surface to bubble; too fast a speed will not do the job.

It should be noted that with flame polishing crazing may occur later. Annealing would eliminate this possibility.

Other kinds of fuel used for flame polishing tend to have carbon deposits that smoke the acrylic and are not easily removed.

Completed sculpture by the author.

CLEANING

Acrylic can be cleaned and some static removed in the same operation. A 10% solution of cold-water All in water applied to the surface and buffed off by hand with a clean flannel cloth does the job.

Stubborn grease and dirt can be removed with VM&P naphtha, isopropyl alcohol, or diluted household ammonia applied with a soft flannel cloth. Clean that away with soap and water. Then rinse off the soap. Avoid benzene, gasoline, acetone, carbon tetrachloride, xylene, or denatured alcohol; they will cause eventual crazing.

A final spray of Johnson's wax and a hand buffing with flannel till dry imparts a brilliant, protective finish.

2. Each piece is scraped with a stainless-steel straight-edge wood scraper while held in a vise.

1. Making a mirror and neon sculpture: A neon design is formed of wire and the parts are fabricated by a neon sign maker. A box for the base is constructed and the transformer and alternator necessary for the alternating pattern of the neon is installed in the base on ½"-thick plywood. The housing for these parts is made of smoke-colored acrylic with a top of acrylic mirror. Following the plan, the top parts are laid out ready for assembling.

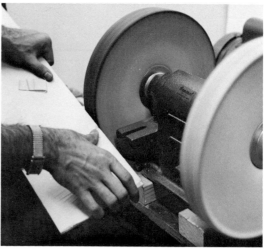

3. Then the edges that face outside (not to be glued) are polished with a diamond buffing compound.

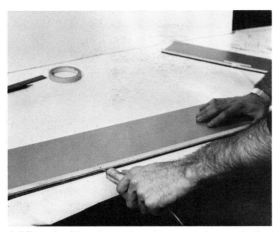

4. Mirror backing along edges that are to be attached to another piece are ground away to reveal acrylic, because solvent will not penetrate the silver material.

6. Acrylic attachment square rods are adhered to the acrylic mirror base.

5. The top case is assembled and glued with a solvent cement (GC-25).

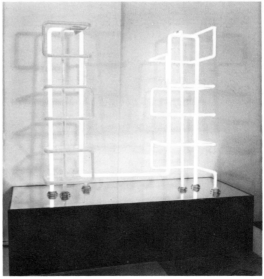

7. Before the whole is assembled, parts of the neon are tested. Mirroring causes a repeating of the neon image and an illusion of filling the space. The alternators dance the neon lights on and off in a rhythmic pattern.

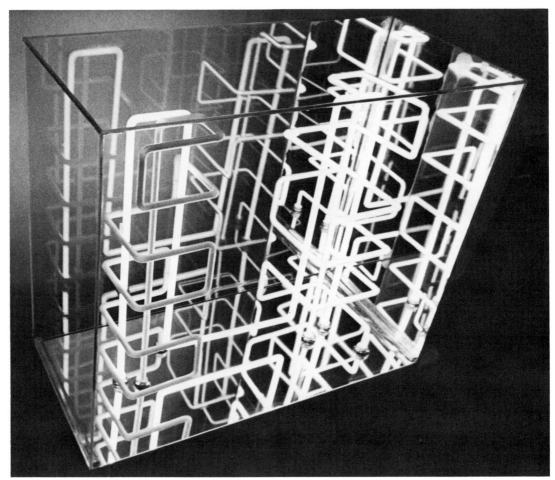

8. This is the effect seen when most of the colors are orchestrated and are broadcast in the bottom and side mirrors. Sculpture by the author.

DECORATING

Some decorating is too ugly even to discuss. Even painting clear acrylic leaves much to be desired aesthetically. But, I suppose, if the piece is a mess, paint might rescue it. Some decorating techniques are engraving, spray and brush painting, frosting, dyeing, to name a few.

ENGRAVING

A flexible shaft drill, equipped with a variable-speed foot pedal and an assortment of dental-type bits are used for engraving. Jigs, tape, and other supporting devices may be necessary to contain the tool within a de-scribed area. Various textures may be achieved through different types of bits as well as by varying pressure and direction. Different depths catch piped light in varying amounts and glow. Control is difficult, and requires much practice. It is a good idea to experiment on a scrap in order to gain some proficiency.

SPRAY PAINTING

If you have to apply paint, spraying it on the acrylic surface will impart the most even surface. Stencil masking tape or spray mask can be used to protect areas from paint.

Clean the surface and remove static. Static can cause patterns to form in the paint film

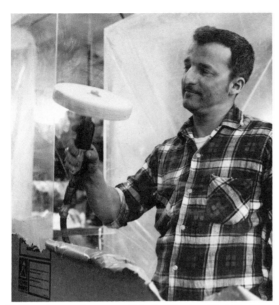

Buffing also can be accomplished with a hand-held buffing wheel. *Courtesy: Just Plastics*

Multiplo Numerato by Ugo **LaPietra** made by drilling holes in acrylic. *Courtesy: Ugo LaPietra*

Besides scraping, further refinement of edges can be made with a sandpaper-wrapped block. As successively fine grit papers are used, the edges approach a near-to-buffing finish. *Courtesy: Rohm & Haas Co.*

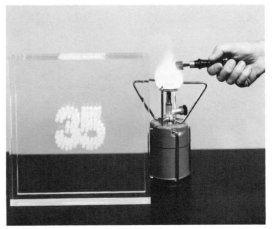

Edges can be refined as well with flame. In this case, a branding iron is to be used to sign Ugo LaPietra's *#35* (1971). *Courtesy: Ugo LaPietra*

1. Making an acrylic mirror sculpture: A sheet of polystyrene foam is attached with rubber cement to a plywood base and smaller pieces of polystyrene foam are cut into angles and placed on the base of foam in order to support projections of acrylic mirror using a mastic cement, the kind used to adhere floor tiles.

2. Small pieces of mirror are cut on a circular table saw and temporarily attached with masking tape in order to study position and design. Methylene dichloride is applied to the joint with a syringe as more pieces are assembled and other edges are glued with solvent cement.

(in some cases this may be a good idea). Apply masking, if desired. Allow four hours of drying time.

To spray, use a back light (in a well-ventilated spray booth) to determine whether paint is deposited uniformly. Acrylic, epoxy, or urethane paints work well.

BRUSH PAINTING

Artist brushes and acrylic paint are used.

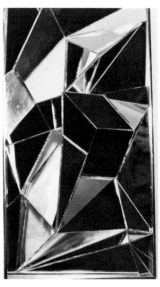

3. Jay Hartley Newman's *Mirror Sculpture II. Courtesy: Jay Harley Newman*

DYEING

Immerse pieces in a mixture of All and water, or in Duponol® WA at *140°F.* (Duponol, acetamine dyes, and Merpentine® are Du Pont products.) The pieces are ready to be dipped in a dry solution prepared from acetamine dyes.

Mix together:

Acetamine dye	0.25 grams
Merpentine	7.50 cc
Denatured alcohol	2.50 cc
Water	90.00 cc

Heat the dye solution to 180°-200°F. (lower temperatures if you wish slow dyeing rates).

1. Constructing a sculpture "decorated" with diffraction grating: A box is made from acrylic squares that have been cut, scraped, and buffed. Acrylic sides are attached temporarily with masking tape in this pattern.

3. Diffraction grating containing an adhesive backing is applied on a clean, dust-free surface of acrylic. Many shapes are covered and attached within the box with solvent cement.

4. Applying adhesive-backed diffraction grating requires a clean surface and exacting application. Every speck will show through as a bump and measurement needs to be perfect. It is nearly impossible to remove this kind of Mylar film.

2. Ethylene dichloride is used with a syringe to attach edges. The principles of gravity and capillary action move the cement along the joint.

5. and 6. Two views of the author's *Mercurial Light I.*

LACQUERS

Clear or opaque lacquers for acrylic can also be applied, preferably by dipping or spraying. They come in a variety of colors. Lacquers, like paint, do not bond to the surface like dyes; therefore, scratching of the lacquer coating is possible.

FROSTING

Sand blasting with sand, glass beads, metal, or fine powderized walnut shells, or roughening the surface with various abrasive compounds create a frosted-surface finish. A translucency is achieved that can contrast

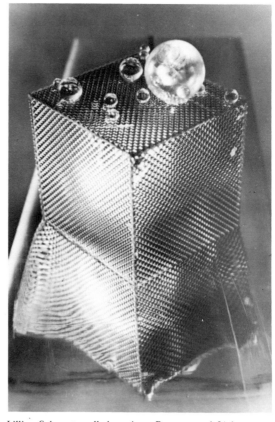

Keep the dye agitated for even dispersion of color. Dip the piece in the dye bath. The depth of color is determined by the amount of time the piece is kept in the dye. After removal from the dye bath, wash the piece in cold water to fix the dye. A full range of transparent color is available.

Lillian Schwartz calls her piece *Programmed Lights.*

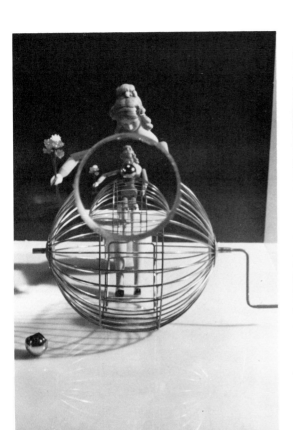

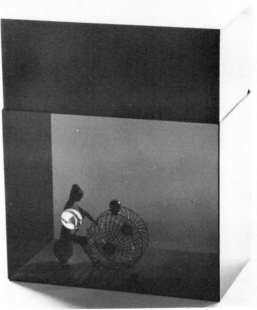

Lady with Flowers in its entirety. *Courtesy: Leonard King*

Optic Box: Lady with Flowers by Leonard King is made of ⅛″ grey transparent acrylic topped with a black light box (8″ high) that houses a tensor light. The light projects through a convex 2″ magnifying glass, which diffuses the light over the subject matter or pinpoints the light, depending upon the positioning. The front of the sculpture contains a 2″ reducing glass.

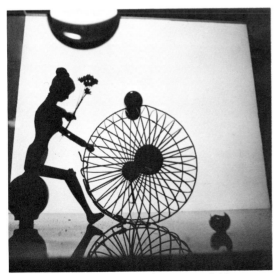

The interior contains found objects: a small bingo cage, a bisque doll, a gold ball, a broken gold ball containing a red flower, a white ceramic doorknob, and small paper flowers.

with transparent areas. Another way to cut out some transmission of light is to spray the surface with frosting lacquer compositions (Du Pont).

SOME DESIGN CONSIDERATIONS

1. Anneal your form to relieve internal stresses after polishing (and before painting).

2. When drilling for a bolt, elongate the shaft to allow for lineal movement. Cork, neoprene, or a nylon washer will prevent the bolt from slipping and will provide a cushion.

3. Do not drill a hole near a corner. If that spot is necessary for attachment, form a notch instead.

4. Do not countersink a screw at the angle of the screwhead, because compression will act as a wedge and cracking will occur. Use a bolt if it is necessary to countersink the head. Make certain that the opening is at right angles rather than diagonal or wedge-shaped.

5. Mount acrylic in a channel system that allows for contraction and expansion.

6. Sharp 90-degree bends are bad and may crack if the piece is put under pressure.

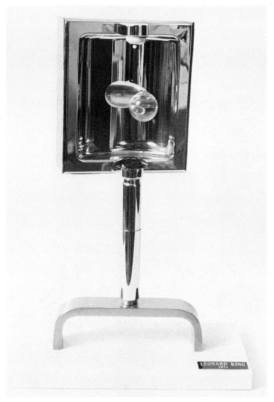

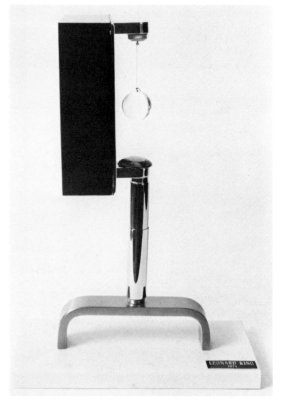

A single acrylic ball moves and refracts as it is mirrored in the concavity of an ex-chrome toilet paper holder. The

center roller became part of the stand. *Sculpture by Leonard King. Courtesy: Leonard King.*

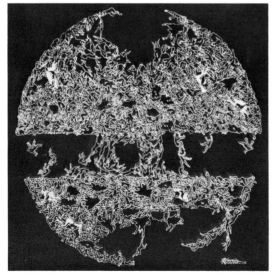

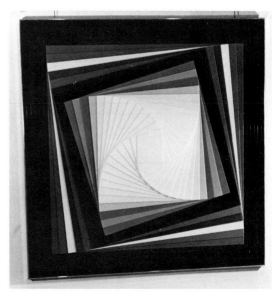

Eugene Massin's panel of miniscule people all in turmoil called *The Whole ——— World* (1973, 32½" x 42½" x 2"). Figures are cut of acrylic, etched, and laminated. *Courtesy: Eugene Massin; photograph by Shirley Busch*

Ascendancy of the Major Blue by Harriet FeBland is multilayered opaque acrylic. (62" x 62" x 5" deep). *Courtesy: Harriet FeBland; collection: Dr. John Haverly*

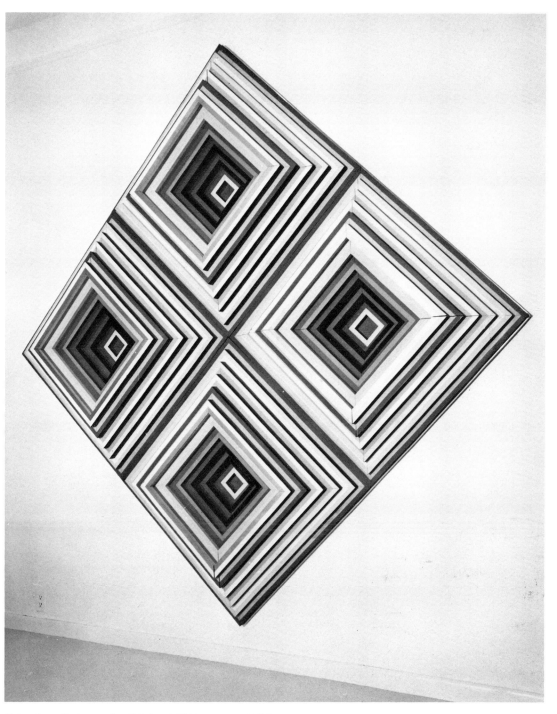

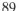

Painted acrylic in a wall relief that is 8 ½′ square and 13″
deep. *Quartet* by Harriet Fe Bland (1972). *Courtesy:
Harriet Fe Bland*

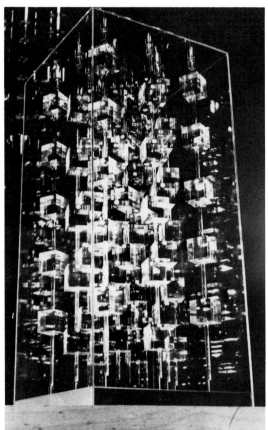

In *Structure Transparente* by Martha Boto, the acrylic elements move via a motor (1969, 48½" x 18½" x 18½"). *Courtesy: Galerie Denise René. New York*

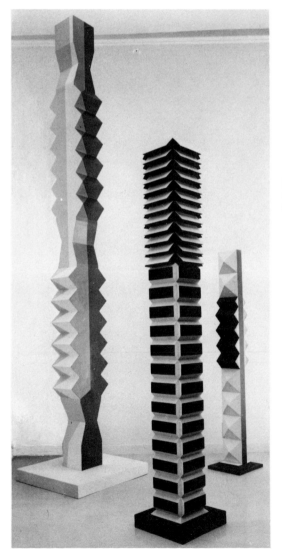

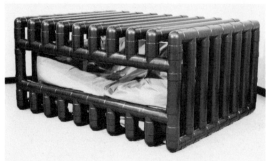

Opaque acrylic covers a wood base in *Totems* by Harriet FeBland (1971, 6', 8', and 8'3"). *Courtesy: Harriet FeBland*

Wayne Jewett's *Cage with Cushion*. An ABC sewer pipe construction. *Courtesy: Wayne Jewett*

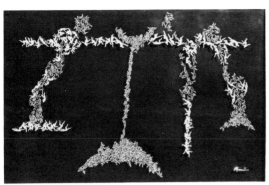

Another Eugene Massin piece called *The Balance* (24" x 36" x 1½"), also created by cutting, etching, and laminating acrylic. *Photograph by Shirley Busch*

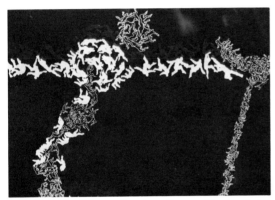

A detail of *The Balance. Courtesy: Eugene Massin; photograph by Shirley Busch*

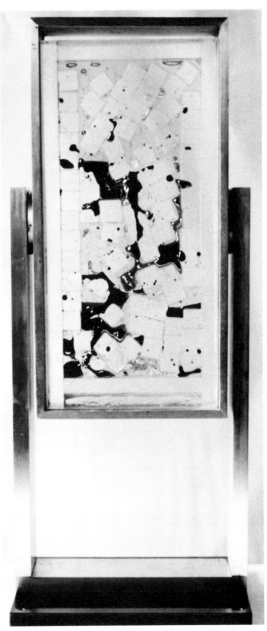

Ronald Mallory's *Activated Inertia* (11" x 26¾"). Mercury framed in acrylic. The piece flips top to bottom, bottom to top. *Courtesy: Galeria Bonino, Ltd.*

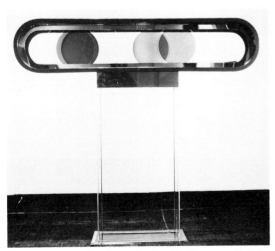

Fletcher Benton's *Synchronetic*. Acrylic. *Courtesy: Galeria Bonino, Ltd.*

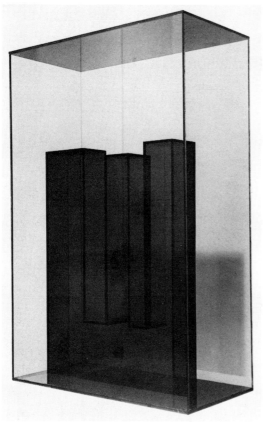

V. V. Rankine's *Atlantis* (1969, 27″ x 18″ x 9¼″). Acrylic. *Courtesy: The Betty Parsons Gallery*

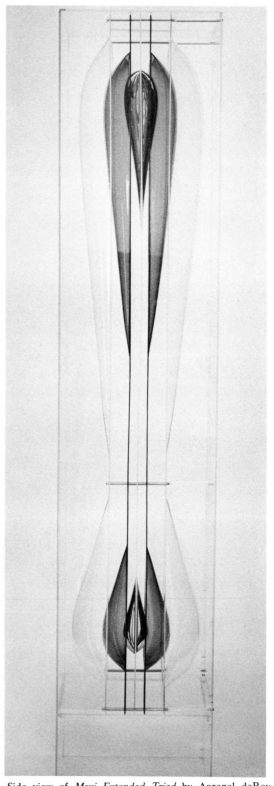

Side view of *Maxi Extended Triad* by Aaronel deRoy Gruber. *Courtesy and design copyright: Aaronel deRoy Gruber; collection: Dainippon Ink & Chemical Co.; photograph by Walt Seng*

4

Processes with Liquids: Casting, Embedding, Laminating, Fiberglassing

Casting, embedding, laminating, and fiberglassing are all accomplished by using a liquid resin system, most often with polyester resin or with epoxy resin. Essentially, the difference among these processes is one of thickness, except for fiberglassing, which is a saturating-draping process, and laminating, which uses thinner pourings of resin, sometimes utilizing a reinforcement.

Casting requires some kind of mold into which resin is poured. Embedding also necessitates use of a mold, but with the addition of some object or material which is suspended in the resin. Both casting and embedding usually result in thick pieces. Laminating on the other hand, employs thin layers that are built up one over the other, one at a time. Fiberglass can be laminated to wood with polyester resin or epoxy. Dacron impregnated with resin can be laminated to acrylic, wood, or other backings or to another piece of the same Dacron material. Fiberglass, impregnated with resin, can be draped in a mold or over an armature or form and usually results in a rigid shell taking the shape of the application.

TEXTURAL AND LIGHT QUALITIES OF TRANSPARENT CASTING RESINS

Much like acrylic, but to a lesser degree, transparent resins such as polyester reflect and refract light. In addition, if one disturbs the surface of "clear" casting resin, as it is beginning to cure, fascinating textures can be introduced and if a cavity of air is trapped internally, these surface modulations are further dramatized, contrasting with its internal excitement, to the diffused regularity of uninterrupted areas. A "rotational" cast form is an excellent example of this effect. If the hollow within the form should be filled, the beautiful textural excitement defined by light bouncing back and forth within the cavity translates into a solid, untextured piece.

In another sense, linear shapes such as wire

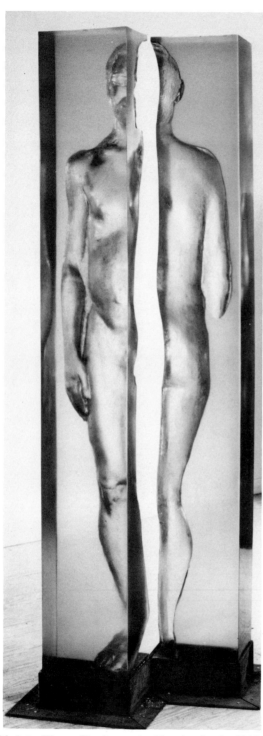

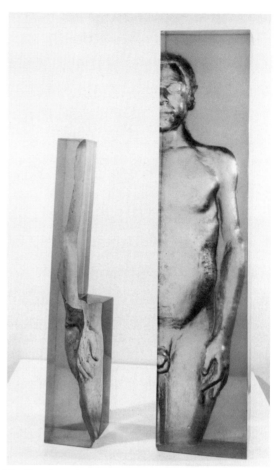

Ms. Siegel's major concern is to cast the space which is around and between things, in literally the air around us, in a way that reverses the negative and positive images into "imprints." There is an extraordinary interchangeability of front (transparent plane) views and back (indented) views, both giving identical images. And, when it is viewed from a corner, refraction causes an effect of multiple images. Transparency of the polyester resin permits us to see these residual objects and creates an appropriate light-ethereal quality, while at the same time it has very real, concrete solidity. *Untitled* (1972). *Courtesy: Max Hutchinson Gallery; photograph by Eric Pollitzer*

Marietta Warner Siegel casts her *Imprints in the Void, Series #1* from life, using plaster, silicone rubber, polyurethane, wax, and even wooden molds and then casting them with clear polyester resin molds. From her first mold, she casts a positive and then casts polyester resin around the positive. *Courtesy: Max Hutchinson Gallery; photograph by Eric Pollitzer*

and flat planes of color, perhaps acrylic inclusions cast within the resin, distort as external contours are modified, much as a lens enlarges and reduces. Looking at the form from different angles produces various images, sometimes at the same time macroscopically and microscopically magnified.

1., 2., and 3. Three textural possibilities with polyester resin on acrylic sheets. On the left, flat triangular shapes were made by cutting gelled polyester resin into those shapes using a pizza cutter and then superimposing one over the other. Then more polyester resin was poured over the whole. In the center photograph, effect of jagged edges, gelled polyester was ripped up in spots using a tongue depressor. These small pieces were then over-layed, on the base and over one another. More resin, this time of a different color, was poured over the entire piece. Three colors result: the original color that projects, the new background color, and the overlayed mixing of the two colors into a new color. The one on the right was made by mixing sand with polyester, applying it with spatula to areas and then filling these troughs with colored, transparent polyester resin.

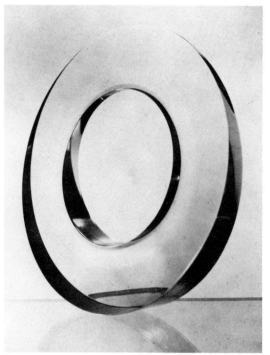

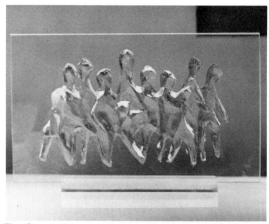

The Crowd, by the author, is designed with angles to catch and reflect light through and from the form.

Clear polyester is cast in three concentric layers using three colors in this 8″-diameter multiple called *Circular Flight* by Fred Eversley (1971). *Courtesy: Multiples*

appropriate mold materials are room temperature vulcanizing (RTV) silicones, hot-melt vinyls, urethanes, acetate, Mylar, plaster, and even metal. Selection of a mold material will depend upon the nature of the object to be cast, the number of copies, the size, and the shape. More about making molds will be found in Chapter 6.

CASTING

Casting is a familiar process to those who work with metal, clay, or plastic. The procedure is similar for plastics; a liquid is poured into a mold, and when it hardens, a solid form is released.

Molds may be one-piece, two-piece, or multipart forms. They can be made of almost any material that has been protected with a release agent. If the mold is one piece, then there should be no undercuts, projections that would lock the liquid-turned-solid into the mold. If there are projections or undercuts, a flexible mold material can be used, so that the object can be removed by pulling and flexing the rubbery walls of the mold. The most

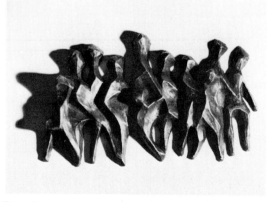

The effect of this cast epoxy (pewter-filled) version of *The Crowd* has an entirely different quality as an opaque rendition. Vision is directed to the rhythm of planes as the eye moves along the surface rather than to the ethereal reflection and refractions of light internally and off the surface in the transparent version.

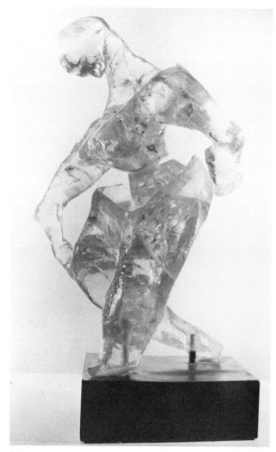

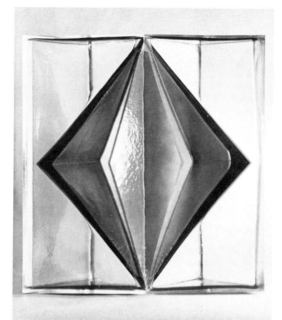

Cardboard models are translated into cardboard molds that are sealed in corners with adhesive tape. The whole form is shellacked, a release agent is coated over the whole, and then polyester resin (Reichhold's Polylite 32-032) is cast into the shape. These are small castings with hollow centers. A small amount of resin is poured on each side of the box, leaving a hollow center.

Polyester, cast and overcatalyzed, fractured into this effect in *Frozen Woman* by the author (1961).

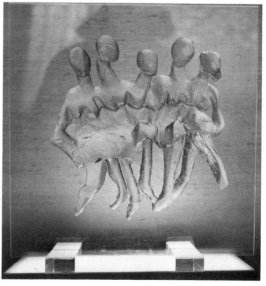

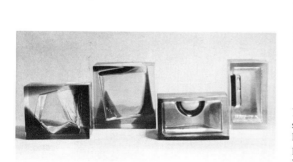

In order to achieve a high shine, sides are buffed. Acrylic shapes are sometimes added for color. At other times, Leo Amino uses transparent color for tints and accents.

Light, in polyester, does not pipe through edges with the same intensity as it does in acrylic. Surfaces moderate light into a more subtle glow. Textures, picked up by the polyester in translation from the mold, are richer and warmer than with acrylic. Whereas the effect can almost look like acrylic, as seen in Fred Eversley's multiple, this multiple *The Group* (by the author, 1967) has a rougher surface reflecting the surface finish of the original.

Cardboard models of small sculptural forms that are to
be cast with clear polyester by Leo Amino.

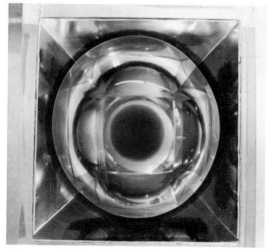
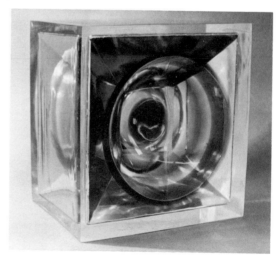

Two aspects of another "reflectional" piece by Leo Amino
exploring the use of light and inner and outer forms as
they relate as geometric components.

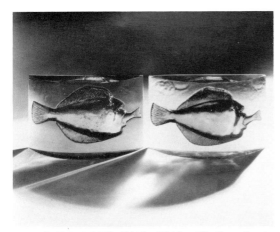

Marisol's *Fished* (1970, 10½" x 17½" x 4"). Cast of polyester resin. *Courtesy: Multiples*

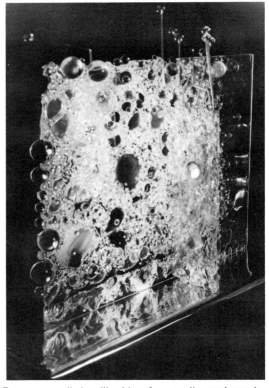

Runaway acrylic is utilized in a free-standing sculpture by Lillian Schwartz. If too much catalyst is added to acrylic in the casting process, excessive bubbling occurs. Whereas this is a disaster in commercial fabrication, these one-of-a-kind textures are great for certain effects in sculpture. *Courtesy: Lillian Schwartz*

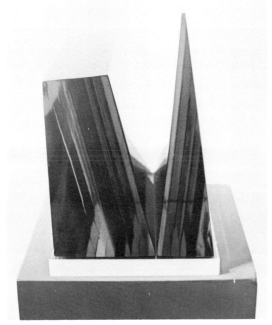

Omega by Paul P. Hatgil is one of a series cast in glass molds using double-strength glass that is taped together with masking tape. One strata of color is poured each day. The final form is milled, using a milling machine, and machined with a shaper. The whole is polished with automotive rubbing compound, waxed, and sealed. A block of layered casting was cut into four sections and then recomposed by adhering sections together with another strata to bond them. In many pieces, Paul Hatgil constructs bases with light shafts in order to shoot light into the designs. *Courtesy: Paul P. Hatgil; collection: Dr. and Mrs. F. Goehr*

In casting, the resin cures in bulk after it has been mixed and poured into the mold. Because of its volume and the potentially large amount of exotherm (heat) generated by catalysts in thick castings, care must be taken to reduce the amount of catalyst (as in the case of polyesters) or to dissipate the heat in some manner to cool the environment or mold. Otherwise, the entire piece can crack, producing a range of openings from tiny fissures to gaping holes. Thinner successive sections may be poured, layer upon layer, to reduce exotherm, but it is possible, in looking at the piece from a side view, to see faint indications of layers. Another way to reduce the potential for overheating and commensurate cracking

is to use a more flexible resin. Strains are better absorbed in a "softer," less brittle casting material. If it is not necessary to maintain transparency, a small amount of a filler can be added to the resin (including chopped fibers of fiberglass). The filler dissipates some of the heat, but also reduces the amount of resin needed to fill a given cavity.

USE OF THIN-WALLED MOLDS

If you cast in a Mylar mold (10 gauge) or cellulose acetate mold (20 gauge), walls are very thin and when the mold is filled, the casting will distort; therefore, the form must be kept small—under eight square inches. A generous amount of tape is needed to reinforce joints and corners. If possible, seal the joints on the inside of the mold with a heavily catalyzed brushing of resin. Suspend your mold upside down in a box filled with vermiculite or sand. The vermiculite or sand will support your mold and keep it from distorting while resin is poured into it through the opening in the bottom of the mold. Do not remove the mold until the resin has cured thoroughly.

POSSIBLE APPLICATIONS

Very large pieces can be cast, if precautions are heeded. Smaller pieces can be cast as units and then glued and assembled into larger pieces. Usually, when castings of polyester, particularly, are cured in a mold and away from air, the surface of the emerging piece is hard, reproducing the surface of the mold. No further finishing is necessary.

One advantage to making castings in other than disposable molds is that multiples of a sculpture can be produced—a factor in reduc-

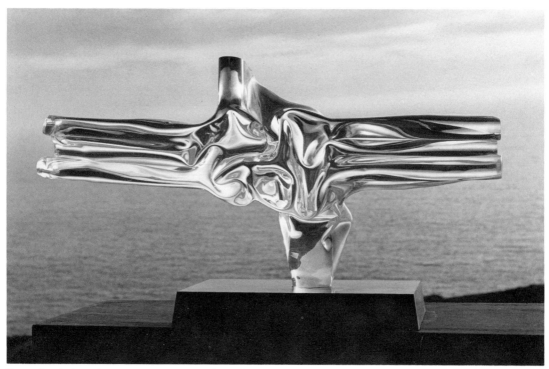

Bruce Beasley's sculpture of cast Lucite (34″ x 19″) was cast from polymethyl methacrylate (acrylic), placed in an autoclave, and then ground polished to a high finish. *Tigebus* (1968). *Courtesy: The Hansen Gallery*

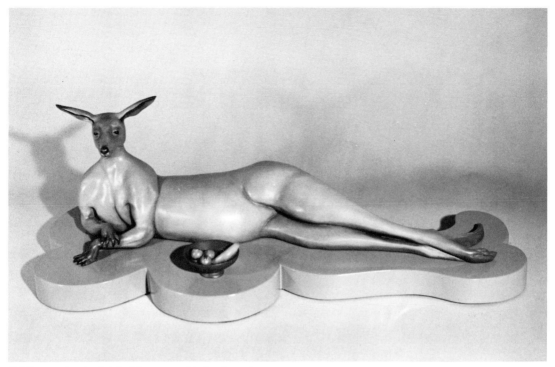

Odalisque, also by Sylvia Massey, could also have been cast from WEP. *Courtesy: Sylvia Massey*

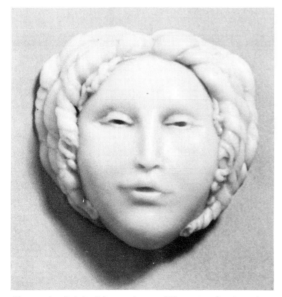

Cameo by Sylvia Massey is a solid cast polyester piece (1972) that could have been made of WEP, but Sylvia Massey would not use water-extended polyester because of continuing shrinkage and the difficulty of the surface to hold a finish. *Courtesy: Sylvia Massey*

ing costs. The number cast, from a technical vantage point, depends on the type of mold material employed. Some materials hold up better than others. (See Chapter 6.)

COLD METAL CASTING

Cold metal casting is a resinated metal casting technique of mixing metallic powders, granules, or flakes with polyester resin or epoxy. Sometimes the metal is mixed into the gel coat (described in Fiberglassing). The usual proportion is three parts metal (by weight) to one part of the thixotropic resin. To keep the metallic granules, which are heavy, from sinking to the bottom, a thixotropic filler should be used to help keep the metal particles in suspension. Metallic granules of at least 100 mesh are optimum. (Alcane Metal Powders Co. is a source.) Proportions of metal to resin can change if lighter metallic particles such as aluminum are used. Then one and a half

parts aluminum filler is added to one part of resin. Heavier metals such as bronze require an increase in quantity.

POSSIBLE APPLICATIONS

Metallic effects can be achieved by casting the entire piece with suspended particles, by using a gel coat, or by buttering or painting a metallized mixture on the surface of a piece of sculpture. When buttering or brushing is

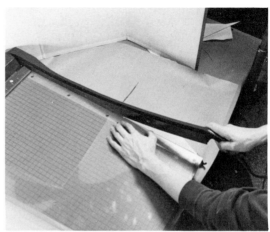

2. Parts are cut on a paper cutter for exact-fitting straight edges.

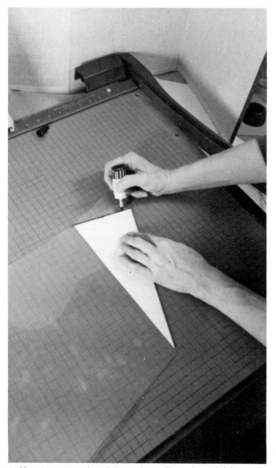

1. Hand-rotational molding: A cardboard model is made. Edges are numbered so that, when these cardboard parts are used as templates, sides will be less of a confusion and will easily fit together. Mylar or cellulose acetate is used as the mold for rotational molding. Here the template is traced onto Mylar.

feasible, the necessary amount of thixotropicity to be achieved. Of course, the thicker the resin mixture, the more difficult it becomes to use a brush; hence, the spatula becomes the next best applicator.

HAND-ROTATIONAL CASTING (OR MOLDING)

Rotational casting is an industrial process using sophisticated machinery, but its principles can be adapted by using man's original machine, his hands.

Use this process for complex contours. To begin, make a container mold of cellulose acetate sheet (20 gauge) or Mylar sheet (10 gauge). (These are natural separators for polyester. Coat the mold with silicone or wax for epoxy.) Using adhesive tape or a sticky fiberglass reinforced tape or a polyethylene tape, seal all seams. Tape and retape, using tape generously to seal all openings but one. Use that opening to funnel resin into the mold.

Divide your material into three unequal parts, using the largest amount first. Pour the resin into your mold. Seal the opening and patiently rotate the container in every direction until the resin gels. After gelation, open the funnel end by stripping away the tape and

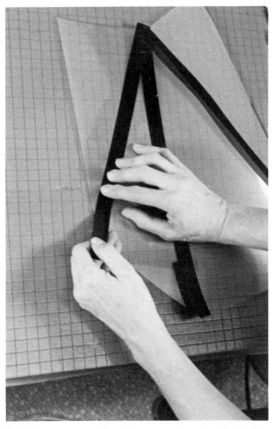

3. A heavy, sticky polyethylene tape is used to join Mylar parts.

then recharge the mold with the next largest proportion or resin. Again seal the opening with tape and rotate the mold manually. Each time you charge your mold with resin the curing time is shorter because the mold becomes hotter. That is the reason for using less resin (or less catalyst). You may feel that there is enough of a shell to maintain the sculpture's shape. In that case, wait until the resin has completely cured before peeling away your mold. Otherwise, reopen the funnel; recharge the mold and continue rotating.

The beauty of this kind of casting is that there is a hollow left in the interior that has beautiful texture and helps to dramatize the shape and material.

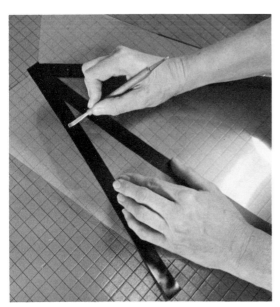

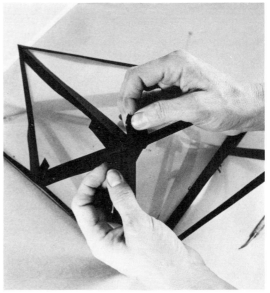

4. and 5. The tape is pressed to the Mylar so that no air bubbles are trapped. Bubbles tend to weaken the bond. Corners are reinforced doubly. One end is left untaped so that resin can be poured into the mold later.

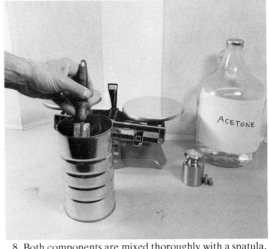

8. Both components are mixed thoroughly with a spatula.

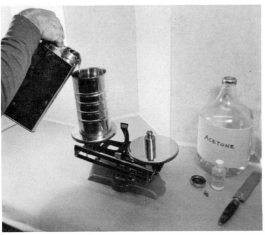

6. Polyester resin is weighed.

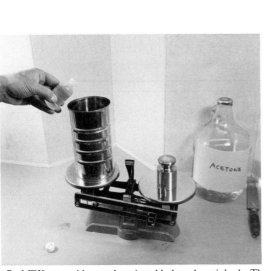

7. MEK peroxide catalyst is added and weighed. The amount of catalyst added is for thin castings. Less catalyst is used for the next pourings.

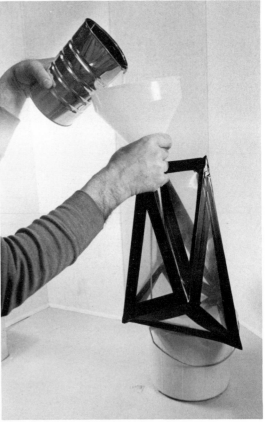

9. The catalyzed resin is poured via a funnel into the mold.

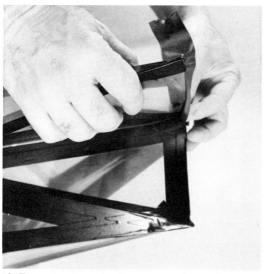

10. The untaped opening is now securely taped.

12. Three more pourings were made using less catalyst each time because there was enough heat generated by the previous pouring to accelerate curing. Each time a piece of tape had to be removed and an opening made to accommodate the new batch of resin. After the final pouring, the whole was permitted to sit undisturbed for a few hours, and then tape and sides were pulled away. The result was a smooth-sided form with a hollow interior that was roughly textured.

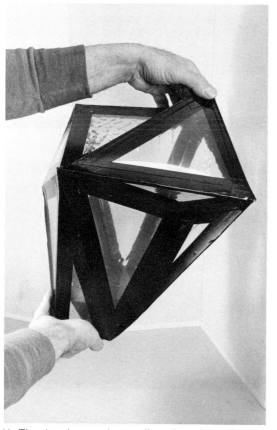

11. The piece is rotated manually and continuously.

Color can be used in the resin and can be changed each time the mold is recharged with resin to create a mixture effect.

For simple contours, rotation does not have to be continuous. You can pour one side at a time. Each time you pour change the base side. (The piece will rest on a different side for each pouring.) When you reach the side that contains your opening (for pouring the resin), seal this well with tape after recharging the mold, and let that former "opening side" become the base until the resin there cures. If you have a six-sided form, you will end up with six separate castings. Never fill the mold, of course, but add enough to create a shell and a hollow in the center. Reduce the amount of catalyst for this type of casting.

For variation, you can paint or pour bits of colored resin on the mold sides before taping them together. This will give a controlled color effect.

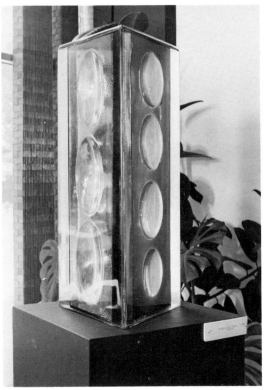

Triangular Column, Feliciano Bejar (1970). *Courtesy: Bertha Schaefer*

EMBEDDING

This is a variation of casting technique. Essentially, it is the enclosing of an object in a resin matrix. The resin is usually colorless and transparent so that the pieces that are embedded can be seen easily.

Important things to be considered in connection with embedding are the kind of mold, the quality of material to be embedded, and the kind of resin to be used. Any mold will do, so long as it is adequately coated with a release agent, or if it is made of a self-releasing material such as Mylar, silicone, or polyethylene. More important, though, is the preparation of the material to be embedded. The object to be embedded must be completely dry. The presence of water, as in flowers and leaves, imparts a haze later on. To dry out

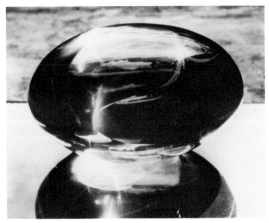

Embedding is a variation of casting technique when an object is enclosed in resin. In order to enclose a form, a layer of resin is poured into a mold; when it gels, the object is placed onto the resin and more resin is poured. This piece by Helen Pashgian contains an acrylic investment. *Courtesy: Helen Pashgian*

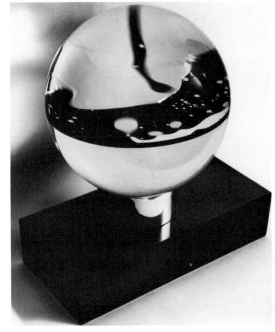

Ronald Mallory's *Diffused Mercury* contains mercury in its casting (9½″ diameter). *Courtesy: Galeria Bonino Ltd. photograph by Nathan Rabin*

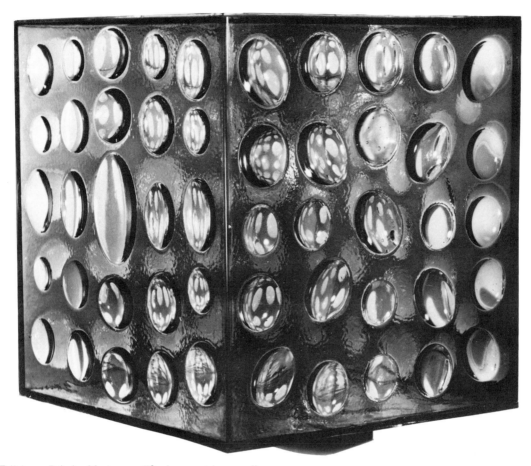

Feliciano Bejar's *Magiscope #2* also contains acrylic investments that remain partly on the surface. *Courtesy: Bertha Schaefer*

insects or plants, use silica gel or dry corn meal and let them slowly dry out, or place them with calcium chloride in a desiccator for a few days. Hollow objects, such as desiccated insects, should be filled with resin before embedment so air doesn't become entrapped. Metals such as copper inhibit resin cure and therefore need to be coated with clear enamel, sodium silicate, polyvinyl alcohol, or cellulose acetate before embedment. All grease and oil must be cleaned off objects.

The best resin to use is a flexible one. This will help to alleviate some of the stress created by different contraction and expansion ratios between resin and embedded object. If the resin is brittle, cracking is likely to result. Along with a more flexible resin, use a slower cure, particularly for organic specimens.

To suspend objects, pour a layer of resin, wait for it to gel, and place the object to be embedded on that layer. Then pour enough resin to cover the object. Repeat the process until the mold is filled. Air bubbles should be

jarred free. After the final layer has been poured, cover the top surface with a piece of Mylar or cellulose acetate (without trapping air bubbles), to produce a glossy, tack-free surface.

POSSIBLE APPLICATIONS

Large castings can contain colored, transparent acrylic sheet (sand the sheet first to give it tooth and help to prevent delamination later on), precast forms of polyester or epoxy resin, found objects, fabrics, and so on. Found forms can also be used as molds; polyethylene containers, for example, are available in a wide range of shapes and sizes and make very good molds.

LAMINATING

Commercial process employs the use of heat and pressure to achieve lamination. The most common product is the ubiquitous Formica® counter, which is usually a melamine laminated to wood. The process can be adapted to sculpture, without use of heat or pressure. Instead of using highly polished steel, the base for the lamination can be glass that is waxed or sprayed with silicone, aluminum that is coated with a release agent, or Mylar-covered wood—in fact, anything that produces a smooth, hard surface. Whatever the surface, it is reproduced in the finished product.

Catalyzed resin (polyester or epoxy) can be poured on the base. The material to be impregnated, whether fiberglass, Dacron, or paper, is cut to size and placed over the resin. More resin is poured onto the reinforcing material, completely saturating it. These materials become transparent. Colored shapes or textures can be inserted. These coloring and texturing agents can be made of thin sheets of colored polyester or epoxy, paper, colored fiberglass or Dacron, thin sheets of acrylic, dried natural materials, or fabrics. Each piece that is added should be saturated with resin. Next, another saturated sheet of reinforcing material is added. All these applications can be made while the resin is a liquid. But it is possible to add layers after the resin has cured, if the surface is abraded to allow the new impregnated layers to grip onto the "old" hard surface. Many

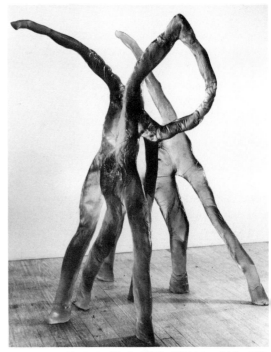

Ray Hitchcock's *Body Works* (1972, 83" high x 86" x 67"). Casting into polyethylene of polyester resin. When the resin cures, the heat sealed polyethylene "bag" is pulled away. *Courtesy: Max Hutchinson Gallery; photograph by Eric Pollitzer*

layers can be built up this way, but each time a roller or stick should be used to roll or press out air bubbles that might become entrapped. Air bubbles can result in delamination later on. If a shiny surface is desired, add Mylar sheet to the lamination while it is still a liquid, pressing out any trapped air bubbles. This sheet is pulled away when the lamination has completely cured.

When the lamination reaches a state resembling gelatin, it is a gel. At this point you can trim it with a sharp knife or scissors, taking care not to delaminate layers.

POSSIBLE APPLICATIONS

Most laminations are flat and usually are panels or backgrounds and bases for projections. Simple curves and three-dimensional

projections can be created by warping the surface or attaching other pieces. For example, laminations can be combined with castings or vacuum-formed pieces by using the same polyester or an epoxy as an adhesive to adhere the projections to the background.

FIBERGLASSING

HAND LAY-UP OVER A FORM

One can apply fiberglass mat or woven sheet over an armature or over a papier-mâché, wood, or plaster form the same way one would make a papier-mâché object. Instead of using strips of paper, one uses strips of fiberglass and rather than a wheat-paste adhesive, catalyzed resin (polyester or epoxy) is used.

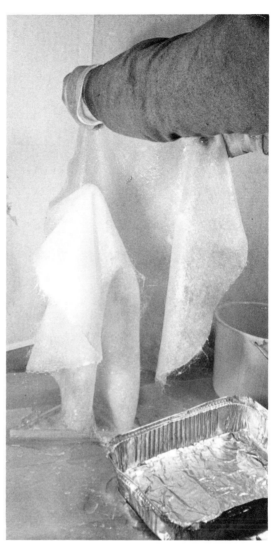

2. The saturated form is draped over an armature. (This one is made of acrylic rod mounted in an acrylic base.)

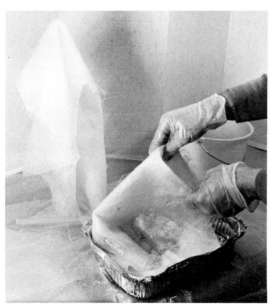

1. In hand lay-up molding, reinforcement is cut and laid on the surface of either a male or a female mold. The thickness of reinforcement can vary where extra support is needed. This reinforcement is then impregnated with catalyzed resin that is applied with a brush by working the resin into the glass fibers. (Catalyzed resin can be sprayed on as well.) The surface is then rolled to even out the saturation of reinforcement with resin and to press out any air bubbles that may have been entrapped. Sometimes cellulose acetate or Mylar in "cellophane" thickness is applied during or after the rolling to improve the surface. A piece of fiberglass mat is cut and saturated with catalyzed polyester resin.

Then layers are overlayed until the desired thickness is built up. When cured, the whole is sanded to a smooth finish, if this is desired, and holes are filled with a paste filler or plastic putty. The piece is sanded again and painted with the same resin or one of the plastic paints or varnishes such as urethane.

This is the oldest and simplest way of working with fiberglass.

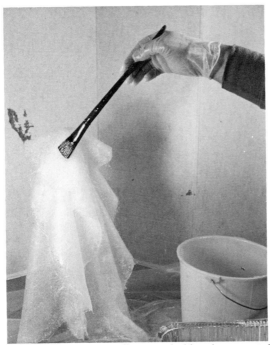

3. Areas that were not well saturated with resin are coated with more resin, and air bubbles are daubed out at the same time.

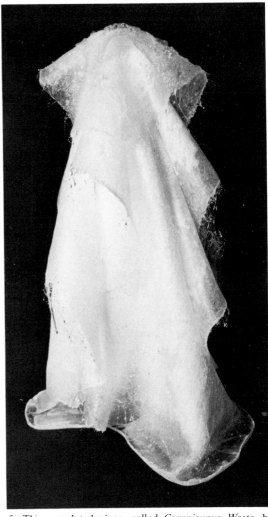

5. The completed piece, called *Conspicuous Waste*, by the author.

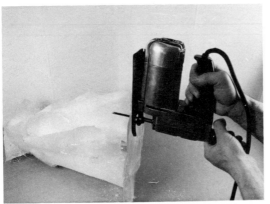

4. After the resin has cured, excess resin and fiberglass are trimmed away at the base using a sabre saw. (Before fiberglass/polyester cures, it is soft enough to be trimmed with a scissors.)

HAND LAY-UP IN A MOLD

A similar application is to employ very much the same technique as above but to use a mold. The mold is coated with a release agent, which could be polyvinyl alcohol. Then, if a high quality surface is desired, a gel coat which is a pigmented thixotropic surfacing resin is applied most often by spraying it on the mold prior to lay-up. Then fiberglass mat or cloth, cut into strips, is saturated with resin and placed in or on the mold.

The strength of the finished object is directly related to the amount of glass in the finished object. Eighty per cent of glass and 20% of resin by weight makes a piece four times stronger than one containing opposite amounts of the two materials. Strength is also related to the arrangement of the glass fibers. Parallel arrangement of glass strips provides the maximum strength, because more glass can be placed in a given volume. In an isotropic arrangement, where fiberglass is distributed in random directions, strength is divided and results in lower strength in all directions.

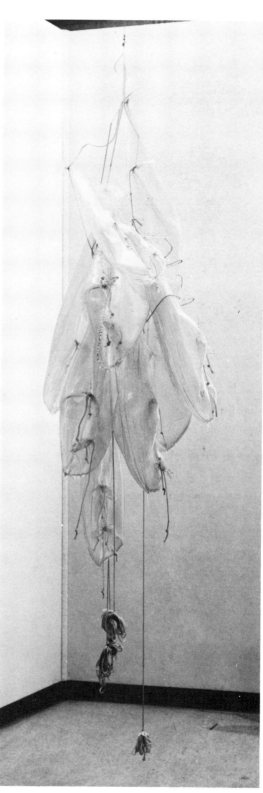

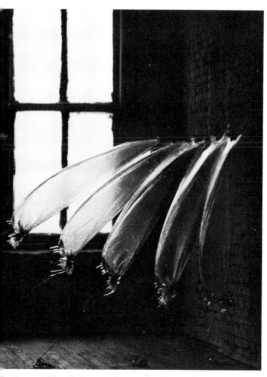

Sculptor Mike Bakaty, who worked with fiberglass for a plastics firm, utilizes fiberglass' unique properties. When saturated with polyester resins, piece curves into balloon-and-tube shapes when tied. He uses Polylite 32-032 and 32-037 with an ultraviolet inhibitor such as Tinuvin P. *Untitled* (1971, 4' long, 20" diameter).

Mike Bakaty's *Viewpoints 5* (20" long, 10" diameter). When impregnated fiberglass is gathered together at both ends, it forms "natural" pods, a characteristic of the material. *Courtesy: Mike Bakaty*

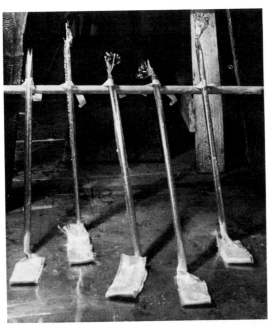

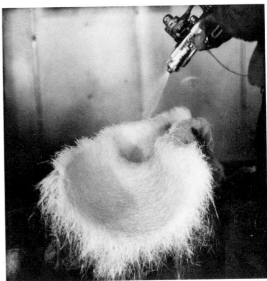

Four-feet-long units are tied with cord. Basically, the formations are similar to *Viewpoints 5*. Sculpture by Mike Bakaty. *Courtesy: Mike Bakaty*

Over a carved urethane foam form (the master) a mold is made of FRP. The positive, which is illustrated here, is made the same way as the mold except that a harder tooling resin is used. This mold, by Wendell Castle, is sprayed with release agent (polyvinyl alcohol). Then, after it has dried, a gel coat is sprayed on. Through a dispensing machine, fiberglass roving is chopped and polyester resin and catalyst are mixed all in the same action of the trigger.

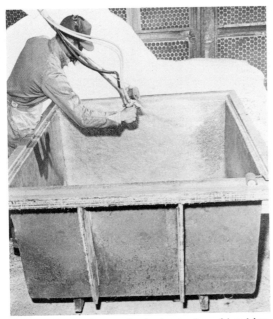

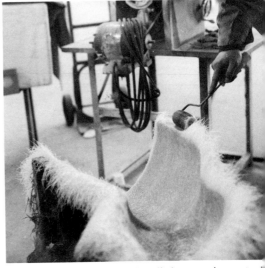

Spray-up molding is a mechanized extension of hand lay-up. Glass roving is fed through a chopper that cuts it to predetermined lengths and forces these chopped pieces into a stream of catalyzed resin (polyester or epoxy) that is deposited on the surface of the mold. The mixture of resin/glass is rolled and cured then as in hand lay-up. This method can cover complex forms with little waste and the equipment is portable, which makes on-site fabrication possible. *Courtesy: Owens Corning Fiberglas*

The fiberglass/resin lay-up is rolled, squeezing out a bubbles and distributing the resin evenly.

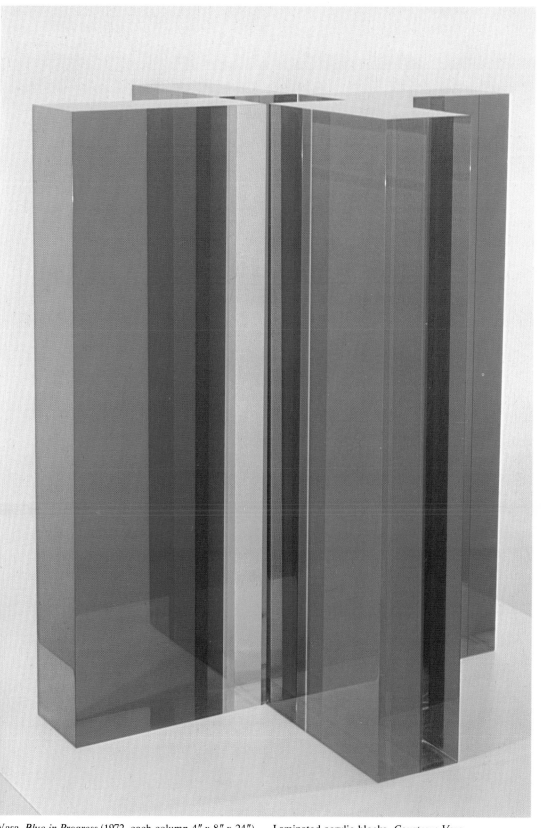

Vasa, *Blue in Progress* (1972, each column 4″ x 8″ x 24″). Laminated acrylic blocks. *Courtesy: Vasa*

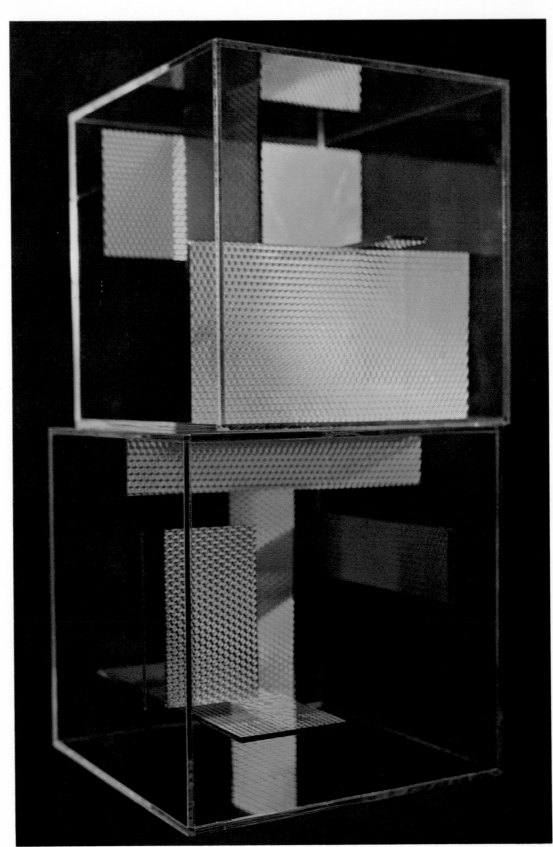

Thelma R. Newman, *Mercurial Light 2 & 3* (1973, 24″ x 12″ x 12″). Diffraction grating in an acrylic cube.

After about four layers have been applied, a brush or roller is used to daub or roll out air bubbles, to equalize the distribution of resin and to make certain that all fibers are saturated with resin. Layers are applied until the desired thickness has been achieved. The minimum thickness should be $3/16''$. This lay-up cures at room temperature. Cellophane or Mylar is often used to cover the surface for a smoother finish.

Daubing with a brush gets into places where the roller cannot go. Upon curing, the fiberglass form is pried from the mold and, if it is half of another part, it is joined with body putty (on the inside).

Body putty is mixed and applied to areas where there are depressions. Upon curing, Wendell Castle sands away imperfections and, where necessary, fills the area with more body putty; then he sands it again until the form is smooth. After spraying the form with an automobile paint, Wendell Castle polishes the entire form until it reaches a high gloss.

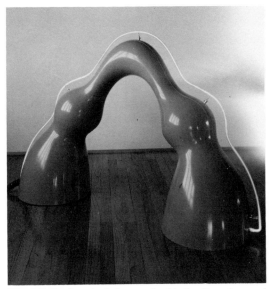

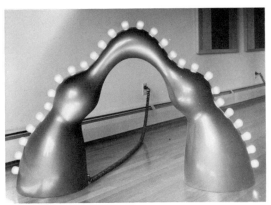

Another piece is dotted with light bulbs.

Wendell Castle, who is known for his furniture in wood, has created these sculptures based on different versions and combinations of the same molds. This piece is outlined in neon.

William Tucker's *Four Part Sculpture #4* (1966). *Courtesy: Kasmin Gallery Ltd.; photograph by Errol Jackson*

Another concept in fiberglass saturated with resin as it comes out of an extruding machine.

SPRAY-UP

A fiberglass or any other type of mold that can be highly polished, waxed, or coated with polyvinyl alcohol is used. Polyvinyl alcohol which is water-soluble can be sprayed on. It dries in 20 to 30 minutes. As in hand lay-up, a gel coat is sprayed over the dry release agent. Gel coat takes about an hour to cure. Then, with a machine that meters a prescribed amount of glass fibers and resin, a balanced mixture is sprayed on the cured gel coat. With this machine, fiberglass roving is fed through a chopper and into a resin-catalyst stream in the same forward action that deposits a spray of this FRP on the mold. After at least $3/16''$ is deposited, the mix is rolled with a hand roller to remove entrapped air, to lay down fibers and to smooth the surface. A brush is also used to daub out air from difficult, hard-to-get-to spots. The lay-up is cured at room tem-perature (or sometimes with some heat as well). At gelation, fuzz is trimmed away with a mat knife. After several hours of curing, often with some difficulty, the piece is carefully pried out of the mold. If the mold is in several parts, pieces are put together with a plastic body putty (on the inside). Edges then are reinforced with glass mat or cloth on the inside, and

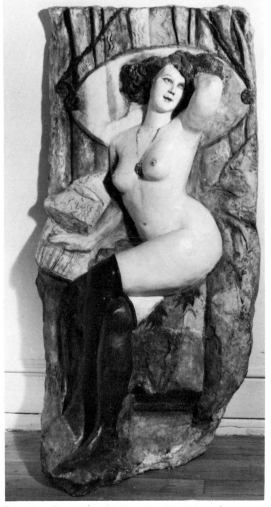

From her French postcard series #1, Arlene Love cast polyester resin saturated fiberglass in a plaster waste mold. *Courtesy: Max Hutchinson Gallery; photograph by Eric Pollitzer*

body putty is used to fill imperfections on the outside. The body putty is spread with a spatula. When cured, the whole is sanded smooth and a painting process completes the job.

Recipe for Body Putty

INGREDIENTS	PARTS BY WEIGHT
Unpromoted polyester resin	42
Cobalt naphthanite 6% (promoter)	0.4% based on resin
Talc (46 microns max.)	30
Talc (6 microns max.)	10
Talc (98% through 325 mesh)	10
Talc (90% through 325 mesh)	7
Black iron oxide pigment or other color	1

For mixing use a spiral or Hobart mixer. Add promoter and color to resin and blend for one minute. Then slowly add dry filler to the mix until fillers are thoroughly blended.

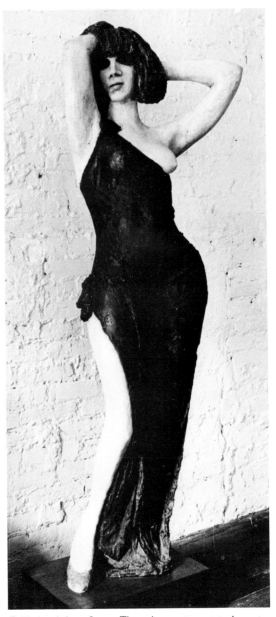

Zelda by Arlene Love. There is no attempt to impart a smooth finish to this flesh-colored life-size fiberglass sculpture. *Courtesy and copyright: Arlene Love*

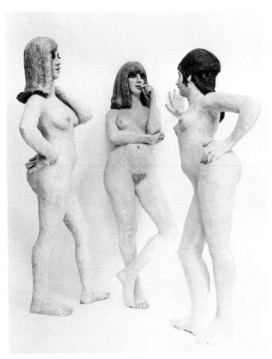

Conversation, Arlene Love. The three life-size figures are polychromed over fiberglass and polyester resin. *Courtesy and copyright: Arlene Love*

This takes 10 to 30 minutes. The result should be a smooth paste. In this uncatalyzed state it will last for 20 to 30 days at room temperature. To use it, add MEK peroxide. The gel time should be in 10 minutes. The thixotropic nature of this filler necessitates use of a spatula in order to apply it.

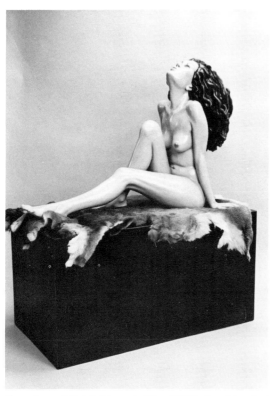

Two views of Ralph Massey's *Ultra* (1973). An airbrushed lacquer finish is applied over fiberglass and polyester resin. *Courtesy: Ralph Massey*

Straight Shooter (1970, 6'5") by Ralph Massey is smoothly finished and polychromed over fiberglass and polyester resin. *Courtesy: Ralph Massey*

Amount of Resin Needed to Saturate Fiberglass

Two ounces of resin will cover one square foot of seven and a half ounce fiberglass cloth; two and a quarter ounces of resin will impregnate one square foot of ten ounce cloth. More than five ounces of resin is needed to saturate one square foot of one ounce fiberglass mat; and over nine ounces of resin is necessary to impregnate two ounce fiberglass mat for the per square foot coverage.

1., 2., and 3. Sylvia Massey's series of animals are cast of solid polyester resin in a silicone mold. The largest dimension is 18" for "Puffin" the bird. *Courtesy: Sylvia Massey*

The detail one can achieve with polyester and fiberglass is astounding and certainly more permanent than wax, for instance: Duane Hanson's *Woman Eating* (1971) is polychromed (and dressed in "real" clothing) over fiberglass/polyester. *Courtesy: O. K. Harris*

new look in large structures is emerging because of this different design potential. Materials that can drape, bend, and flow and their commensurate effects are very different from materials that are cut and nailed into post and lintel angles. Although a fiberglass impregnation can be cut and nailed, this certainly is severely limiting its application—imposing upon it design parameters suitable for another very different kind of material.

FINISHES AND FINISHING

Polyester, epoxy, and combinations with fiberglass can be finished in various ways. In order to maintain transparency and yet end with a smooth glossy surface, brush on an additional thin coating of your resin, using an extra amount of catalyst. If imperfections need to be cleaned away first, hand sand with various grits of wet wet-or-dry sandpapers, proceeding from 200 to 500 grit, until you have a very

DESIGN CONSIDERATIONS

When you are working with fiberglass reinforced resin, scale can be as large as you wish. Size is not a limitation. Of course, if the span is huge, mat needs to be heavier and more layers of it are needed to maintain dimensional stability. Fiberglass has been used to form huge storage tanks, ship hulls, and houses.

Fiberglass also drapes well and it flows into curves more easily than it bends into angles. Flat planes should "melt" into curves, if fiberglass impregnations are to be exploited for their most effective design quality. A whole

Voyager by Jacques Schnier (1969, 52″ x 48″). Fiberglass/polyester and acrylic paint. *Courtesy: Jacques Schnier*

John de Andrea's *Boys Playing Soccer*. Polyester and fiberglass, polychromed (1972). *Courtesy: O. K. Harris; photograph by Eric Pollitzer*

smooth surface. (Or use a mechanical sanding tool, working from rough to smooth sandpaper.) Next, buff the surface on a slow wheel with a hand-held buffing wheel in a pistol drill set to the slowest rpm's. Use white buffing compounds, followed by a buffing with a clean, soft wheel. This should result in a beautiful glossy finish. If you do not choose to buff, paint the surface with catalyzed resin after sanding. Be certain to vacuum away dirt and grit, or it will contaminate your finish.

Fiberglass composites which are opaque can be sprayed with urethane finishes, or painted with polyester or epoxy mixtures. Gel coats,

Sam Richardson's *The First Cut of the Plow* (7½" high x 17" long x 17" deep). *Courtesy: Martha Jackson Gallery*

The Sea, Surf and Sandy Coast by Michael Chilton. Aluminum sheet is used for the base form. The other forms are polyester and fiberglass over wood, self-colored with aluminum powder and glazed afterwards with coatings of clear polyurethane. *Courtesy: Michael Chilton*

flocking, metallic finishes, and just plain paint can be used.

A new marine gel coat (Spray-Gel Seymour of Sycamore, Inc.) can be applied aerosol-can fashion to finished FRP pieces. After sanding and filling, remove all dust and then just spray on the gel coat.

Metallic flakes (Meadowbrook Inventions) or epoxy- or vinyl-coated aluminum foil specks (Fireflake, Mt. Vernon Mills) can be applied with normal spray equipment that has been fitted with a lacquer air cap (DeVilbiss #36, using pressure cup 10 lbs., spray gun 30 to 35 lbs. pressure). An underbase of Du Pont acrylic lacquer, close to the metallic flake color, should be applied before the metal flake. Then to 1½ quarts of clear metal lacquer add one pound of metallic flake and reduce it to 2¼ quarts with lacquer thinner; then spray. Six to eight top coats of clear lacquer should complete an exotic finish.

Urethane-, acrylic-, polyester-, or epoxy-based paints also cover well and provide a wide range of color. Apply these with brush or spray over dry, clean, greaseless surfaces.

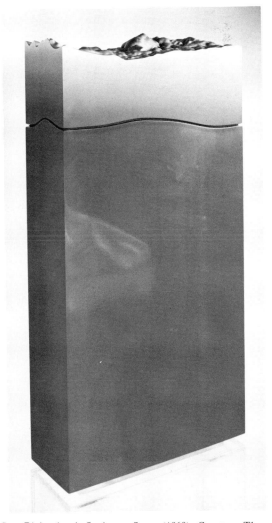

Sam Richardson's *Sculpture Scape* (1969). *Courtesy:* The *Hansen Gallery*

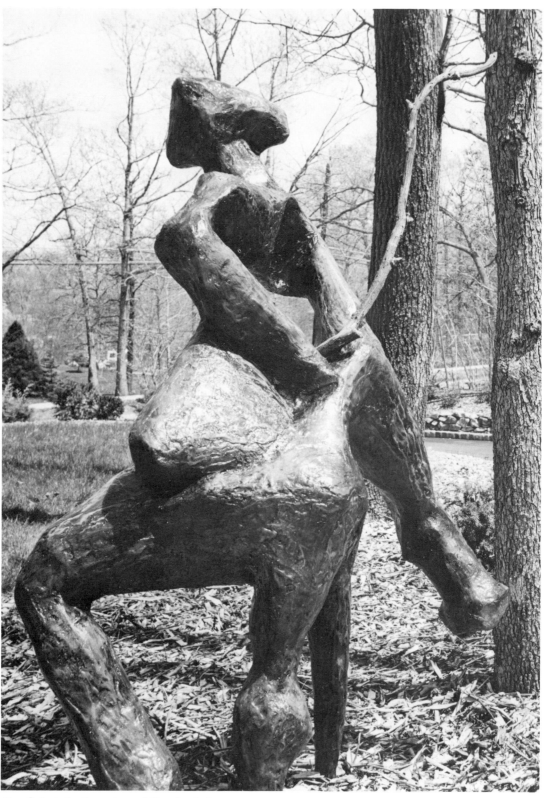

Don Quixote by the author, of fiberglass/polyester over
a carpenter cloth paper-mâché armature. Polychrome
with a brown-green polyester coating.

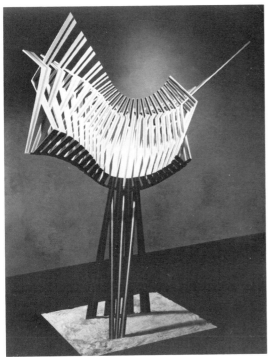

John Claque's *Odamisque* (1966, 68 " x 50 "). Fiberglass and steel. *Courtesy: Waddell Gallery, Inc.*

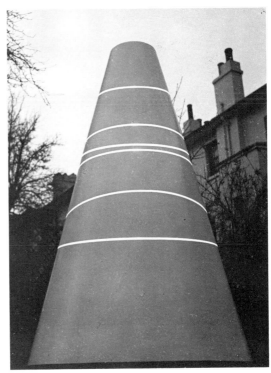

Liliane Lijn's *Anti-Gravity Koan* (1969) of fiberglass and acrylic on a turntable and illuminated from within. *Courtesy: Liliane Lijn*

Foaming, Buttering, Modeling, and Working with Fibers and Films

The plastic materials of foaming, carving, modeling, buttering, and plastic fibers themselves have three aspects in common—they are all plastics, are all opaque, and can be worked with directly without the intermediary of complex equipment (although industrial equipment can be used). From that point on, they are extremely diverse, with very different textural surface qualities and with a wide variety of forming processes using liquid pastes and solids. There are no *common* aesthetic denominators among them that are peculiar to their opaque presence, but only design commonalities similar to all opaque sculptures, whether made of plastics or of traditional materials such as wood or metal. However, among these plastics unique differences exist due to their fabrication methods. For example, the form of a construction made with yarns is very different from a casting made of flexible urethane foam. Yarns usually are woven, are flexible, express patterns, and are two-dimensional unless they are draped. On the other hand, foam usually has a great deal of bulk, may be flexible or rigid, is never woven, and assumes the surface texture of its mold. Similarly, plastics that may be buttered can be very different in final form from a piece of rigid urethane or styrene foam that has been carved.

FOAMING

Flexible urethane foams can have their own skins, an integral covering that needs no other protective finish. Foams can be designed to be dense or less dense, or both combinations can exist in the same piece, again as a homogeneous material, with no gluing or fastening necessary. There are also foams that can be as dense as wood or as soft as cotton candy. Rigid and flexible foams can be layered and combined in the same piece. Imagination can go soaring here because there are few limitations. Size, fastening, weight, hardness, softness, strengths, are all easily solved problems

Polylite 34-843 and 34-746 (a urethane foaming system) is weighed and mixed together in a container that will permit expansion. Meanwhile, the mixing blade is readied in a hand drill and the sculpture base is in position.

Foaming is rapid and needs to be manipulated quickly before it hardens. Here it is being poured over the sculpture.

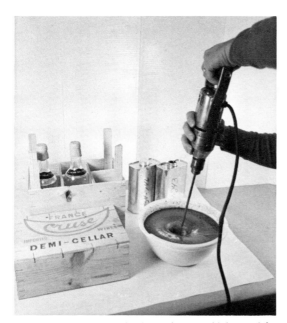

Both components are mixed together at a high speed for about 30 seconds. When the mixture begins to radiate some heat, foaming action is about to begin.

with these very durable, long-lasting materials.

One imaginative possibility is to stretch burlap, aluminum screening, or a similar woven support between cables, spray about three inches of foam on the burlap, and then finish it off with a urethane finish or a thin layer of fiberglass. A variation on this theme is to spray foam over a huge balloon and then deflate the balloon, to reveal a rigid shell.

A drill equipped with a paint-mixing blade is all the equipment needed to mix together

A pop-art piece with foam oozing out of a wine case that contains wine bottles. All parts are adhered because of the bonding quality of urethane.

What does one do with a tree stump? Spray the stump with isocyanate foam (polyurethane). The ex-stump is outside Valerie Batorewicz's urethane foam house near New Haven, Connecticut. *Courtesy: Valerie Batorewicz*

Polyurethane is strong, can be fire-resistant, and is long-lasting. Some older types of formulations turn very brown and require painting, if that color is not desirable. Use of paint may be desirable because some ceramic-based paint also can act as fireproofing material.

HAND POURING RIGID POLYURETHANE

Polyurethane tenaciously adheres to almost anything. If you do not want it to stick, then

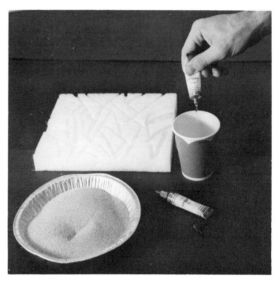

1. and 2. Polystyrene foam can become a disposable mold for a bas-relief. Here parts of a piece of polystyrene foam are being melted away with a burning pencil. A soldering gun can also be used.

a two-component polyurethane system. The mixture creams (starts its rising, foaming action) in seconds and then must be poured because it expands to many times its size.

Polyurethane foams are thermosetting, rigid, closed-cell, dense materials employing a resin and a blowing agent, to name two components. These blowing agents, much like propellants used in aerosol cans, produce a gas which causes bubbles to form and thus produces a foam. The volume of gas trapped in urethane foams can vary from 20 to 80 times the original volume of the liquid urethane. That is what causes the lightness and floatability of the foam.

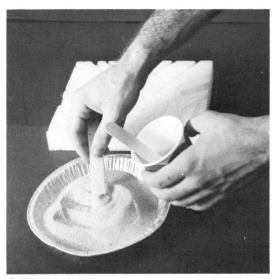

3. Epoxy resin and catalyst are being mixed together in a paper cup. Sand (up to 40% by volume) is added to the epoxy.

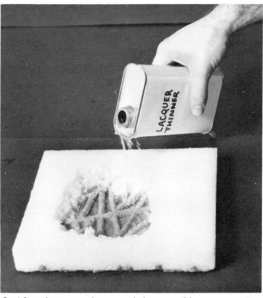

5. After the epoxy has cured, lacquer thinner or acetone is poured over the foam (on the other side) to dissolve the polystyrene foam, revealing the sand-filled epoxy bas-relief. Polyester *cannot* be used in place of epoxy because polyester resin attacks polystyrene foam.

a release agent must be used. (Carnauba paste wax and polyethylene are two.) Polyurethane is also degraded by water. Therefore, as soon as the can is opened, use it; don't allow it to stand around unless you protect it from moisture by using dry air or nitrogen to fill the air space in the can. (Small pressurized cylinders of dry nitrogen are available from Liquid Carbonic Co.)

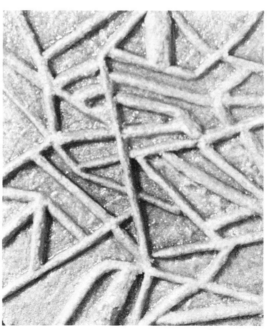

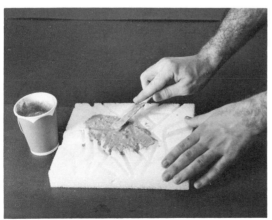

4. The sand-epoxy mixture is applied over the foam block, forcing it into the channels.

6. The bas-relief by Jay and Lee Newman. *Courtesy: Jay and Lee Newman; photographs from* Plastics for the Craftsman.

The two-component, self-foaming, and self-curing urethane system for pour-in-place application used here is Reichhold's Polylite 34-746 and 34-843. It produces a molded foam density of from 4 to 7 lbs./ft.3, depending upon the foam mass and cavity pressure used.

Cautions

Polylite 34-746 contains a volatile fluorocarbon liquid which boils at 74.8°F. and volatilizes readily at room temperature. It could be hazardous in confined areas. Adequate ventilation must be available. Polylite 34-843 contains a reactive isocyanate that is also toxic. Avoid contact with skin, eyes, or clothing and avoid breathing vapors. If you get it on your skin, wash it off immediately with alcohol and then plenty of soap and water. Store these components in a cool place. If unattacked by water, it is stable for at least six months.

Mixing

Weigh off 130 parts by weight of Polylite 34-843 or 122 parts by volume into a clean container, one that will permit some expansion.

2. He glues one part to the other.

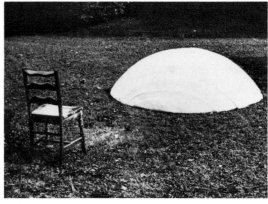

3. Robert Breer's unfinished model that will be the form for a polyester/fiberglass rendition.

1. Robert Breer is constructing a prototype for his *Rider Float* from polystyrene foam.

4. A sketch by Robert Breer of *Rider Float*, which is a slow-moving place for dreaming.

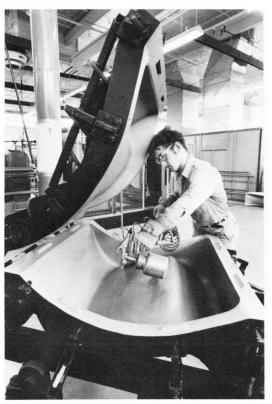

3. Holes in the mold lid indicate that the urethane has foamed and that the mold is almost ready to be opened.

1. Foaming a urethane sculpture at Cassina Center: The mold is being sprayed with a release agent. The lid then is closed in preparation for adding urethane foam components.

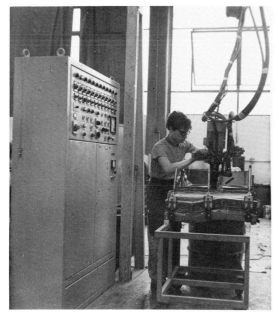

2. A machine is adjusted to meter out components and control quantity and density, and the urethane is introduced into the mold.

Add Polylite 34-746 by weighing 100 parts by weight or 100 parts by volume. Use a 2″ paint mixing blade in an electric drill at speeds of 2,000 to 3,000 rpm. Place the blade beneath the liquid level and begin to stir. Manipulate the mixer or container to get a thorough blending. During mixing, the first indication that the foam is going to rise is an elevation in the heat of the container. A slight change of volume announces that foaming is beginning. Mixing should take from 30 to 40 seconds. Start to pour the foam on your prepared surface. The foam sets in 5 to 10 minutes and can be worked (carved or cut) within 24 hours. A mixture of 1:1 of alcohol and benzene, toluene, or acetone makes the best solvent. Cured foams (after 24 hours) can be trimmed, cut, and shaped with woodworking tools, and can be painted with a wide variety of paints.

There are other polyurethane systems. Flexible Products Co. has Flexipol® 9022/8013-8AA. One hundred parts by weight of 9022 are mixed with 68 parts by weight of 8013-8AA. The Upjohn Co. has several isonate systems

4. The lid is opened.

5. And the bas-relief is being removed carefully.

HAND CASTING RIGID POLYURETHANE IN A MOLD

The system used and method of weighing and mixing is the same as above with hand poured polyurethane. Extra consideration must be given to the mold. If it is rigid, it should not have any undercuts that would lock the piece into place; otherwise, it should be a two-piece or multiple-part mold. Silicone rubber makes a fine mold; it is flexible and does not require a release agent. Other materials should be sprayed with a release agent. (A 5% Ivory Flakes® solution in methanol will work as a release agent.) If you have a one-part mold, it should be equipped with a rigid lid with some holes in the lid for venting. Commercially, a breathable-type paper is used (Part Wick® by Paper Corp. of America).

Apply your release agent to the mold, weigh and mix the components thoroughly for the amount of time the manufacturer recommends, and then quickly pour the material into the mold, being certain in the process to wet all the mold surfaces so that no dry spots will result in defects. Immediately attach the lid

that can be mixed and poured at room temperature, as does Conap, Inc., with its Conathan® UF3. The Stepan Chemical Co. makes an excellent foam, Stepanfoam® HW-12/60, to be combined with component A.

6. After removal, the form is pounded to release trapped gasses.

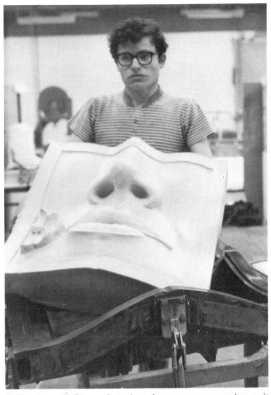

7. The bas-relief is ready to be taken to a compression unit where all air will be removed to lessen bulk for shipping.

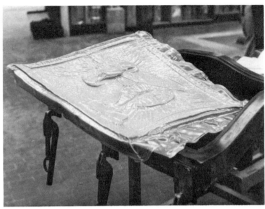

8. After the foam has been compressed, removing almost all the air, the piece is heat-sealed in a jacket of polyethylene film. A valve is attached for later introduction of air.

Carving Rigid Foams

Carving rigid foams, whether styrene, urethane, or any other plastic, is easier than carving soap. The same principles are entailed, except that a mistake can be repaired by gluing the piece back into place and recarving the area.

and seal it with C-clamps. Demolding takes 15 to 20 minutes. Strip the mold from the form and remove it before complete exotherm (heating) is reached, to extend the life of the mold.

SPRAYING POLYURETHANE FOAM

Machinery and excellent ventilation are needed for spraying foam. This is usually a commercial operation and requires a form such as draped burlap, balloons, or similar supports for the spray-up system. There is a partial pre-expansion prior to the chemical reaction, which results in a stronger but less dense material. One caution is that, when the foam is being dispensed, air can be enfolded and trapped, leaving voids.

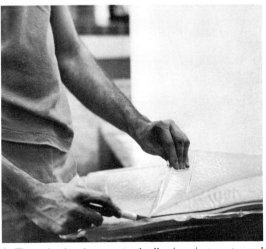

9. The valve has been opened, allowing air to enter and to help inflate the cells of the foam; the rest of the jacket is cut away, permitting the piece to swell back to its original shape. An edition of several thousand sculptures can be made this way and shipped with a minimum of bulk and weight.

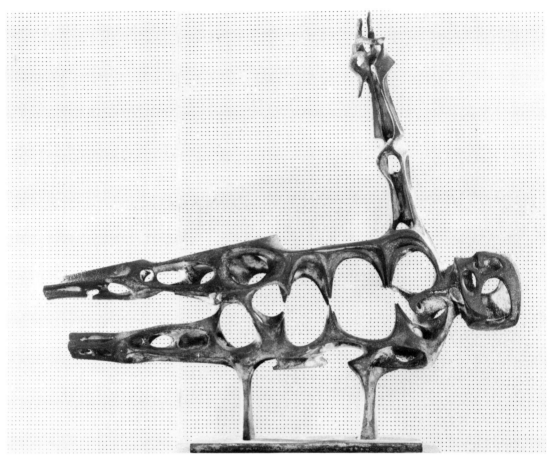

This piece originally was a carved polystyrene foam form. Sprues were attached and the piece was invested in sand in preparation for foam vaporization casting. The green sand was pounded and the foam was vaporized with the introduction of a molten metal, thereby replacing the foam with metal. *Courtesy: Alfred Duca*

Robert Breer's self-propelled styrofoam floats for *Linoleum,* a theater piece by Robert Rauschenberg, produced at the "Now Festival," Washington, D.C., 1966. *Courtesy: Galeria Bonino, Ltd.; photograph by Peter Moore*

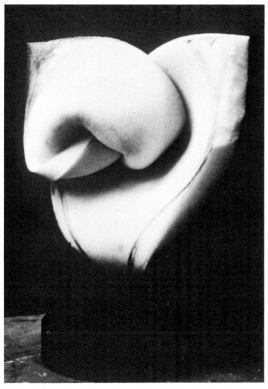

1. Flexible polyurethane foam is sculptured via a knife or scissors, glued and mounted.

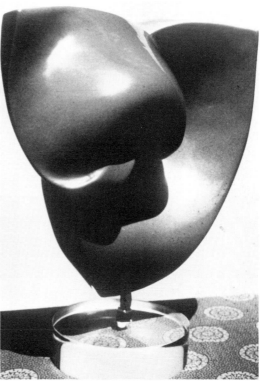

3. Jacques Schnier's completed sculpture may have been "glazed" with polyurethane paint. *Courtesy: Jacques Schnier*

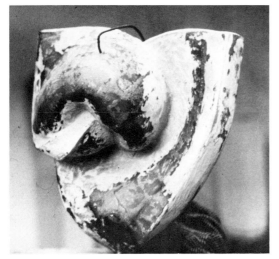

2. The entire piece is covered with plaster (or epoxy) and sanded smooth.

Rigid foam, which comes in slabs and blocks of all sizes, can be cut with a band saw, knife, or heated wire (keep it moving so it does not stick). Parts can be glued with polyvinyl acetate or chloride (Elmer's type) or urethane (Indopol A3000 Urethane Adhesive/Sealant).

FLEXIBLE POLYURETHANE FOAMS

Flexible urethane can be cast into closed molds, using dispensing equipment, or are manufactured in gigantic, continuous buns or slabs, which are then cut into standard sizes and shapes. Most common products of urethane are pillows and mattresses. An uncommon material is flexible polyurethane foam logs, 8" in diameter and 5' in length, with a 2" diameter hole through each to allow them to be strung like giant beads. These are used to absorb oil spills but have much potential as sculpture (Source: Johns-Manville Corp., Denver, Col.).

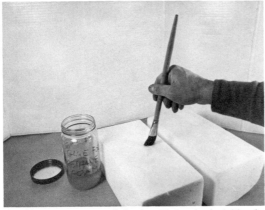

A rubber-cement type of glue is added to both rigid polyurethane foam blocks in preparation for attaching them.

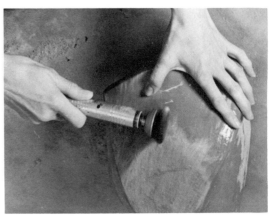

When the epoxy has cured, rough areas are ground away, using a wire brush in a flexible shaft drill.

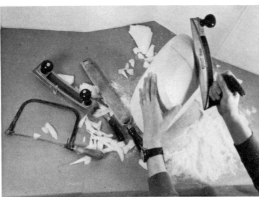

Large areas are blocked out, using a knife. Finer shaping is accomplished with Surform tools (Stanley) that quickly grate away the foam into a fine powder.

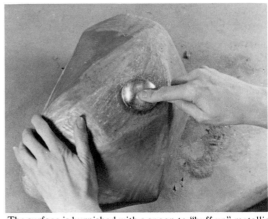

The surface is burnished with a spoon to "buff up" metallic glints in the epoxy.

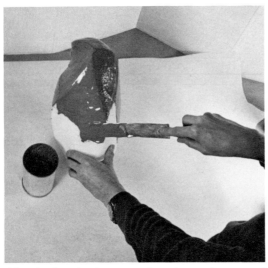

After the form has been carved, a mixture of epoxy and aluminum metal powder is applied to the foam with a spatula.

Slabs of urethane can come in ice cream colors of various densities. The heavier the density, the closer the cell structure and the longer wearing it will be.

All that is required in working with flexible urethane are cutting devices, an adhesive system, and some covering or protective coating for the foam.

Cutting

Use of a flexible band saw or heated Nichrome wire, an electric knife, or a scissors for leather works very well. The choice of which tool to

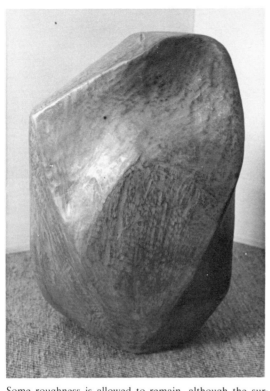

Some roughness is allowed to remain, although the surface could be refined to a smooth glossy texture.

BONDING FOAMS

No one material will do the job of bonding for all foams. Water-based adhesives are easy to apply but take longer to dry. They are polyvinyl acetate types, such as Elmer's and Sobo, or latex. Adhesives such as epoxies and urethanes (Indopol A3000) also bond very well. Just apply the bonding agent to one or both surfaces; allow a short time, in the case of water-based adhesives, for evaporation; then press both surfaces together. Allow enough time for the adhesive to dry before working on the foam.

FOAM AS A CORE MATERIAL

Because of foam's light weight, it can provide bulk with very little weight. Any number of coverings can be applied over a foam core, from fiberglass and polyester resin or epoxy to metal-filled epoxy or non-polymers such as concrete. All that is required is to butter the material over the foam surface, using a spatula. In the case of expanded polystyrene (Styrofoam) protect the surface with a layer of plaster of Paris, or else polyester will eat into the foam and dissolve it.

use depends upon the thickness and complexity of the contour. Because of the lack of resistance of the material, hand tools are difficult to control. It is a good idea to develop some kind of jig to help to guide the cutting tool.

COATING AND COVERING FOAMS

Upholstery is one way to cover foams. Vinyl has been used as a popular covering. Coating the foam is another possibility.

Lacquers can be used over polyurethane foams (but not over styrene). There is also available an elastomeric thermosetting "enamel" and an elastomeric lacquer (Durethane®). These elastomeric coatings allow for flexibility. Many other coatings serve well and are worth trying. To determine whether a coating will hold up, give it the Scotch tape test. If Scotch tape pulls off any coating, it is not good.

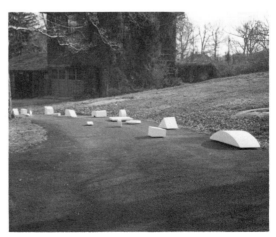

Robert Breer's styrofoam floats with hidden motors and wheels march in procession along a driveway. *Photograph by Frances Breer*

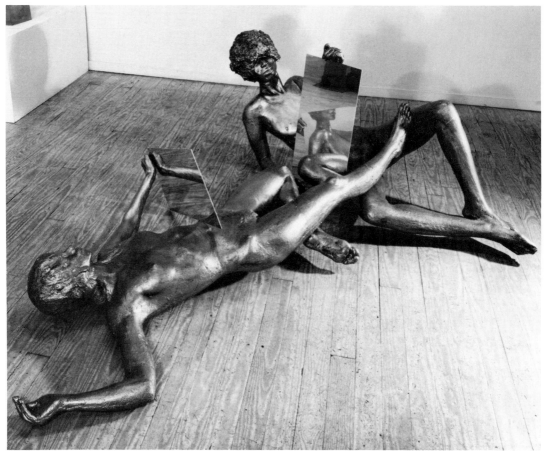

A rigid polyurethane sculpture by Hans Breder. Forms like this can be foamed under pressure in a two part mold that has been clamped together immediately after the two components of foam are introduced. The mixture swells to fill the mold form within seconds, creating a dense material. *Courtesy: Max Hutchinson Gallery; photograph by Eric Pollitzer*

FOAM AS A MAQUETTE

Huge forms can be displayed as an intermediary form, to illustrate how a more expensive material, such as marble or bronze, will look as a large-scale structure. These foam forms can be pegged together temporarily with dowels, so that parts later can come apart for storing or reuse.

FOAM VAPORIZATION CASTING

It is possible to use foam instead of wax in the lost-wax casting process. Expanded polystyrene foam vaporizes, leaving a cavity for the injection of metal.

FOAM AS A MOLD MATERIAL

Foam as a mold material is detailed in Chapter 6.

BUTTERING

Buttering is the process of applying a paste-like material to a base. The base can be made of anything from papier-mâché, hardware cloth, and chicken wire, to plaster of Paris and fiberglass and resin. Most liquid plastics can be made to a buttering consistency by using a thixotropic filler, as recommended in Chapter 2, coloring it, or filling it with powdered metal or sawdust. DA Monzini® (Ad-

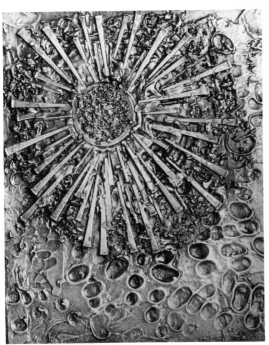

hesive Products Corp.) is a commercially pre-
pared material available in a pastelike
consistency. Some commercial adhesives also
can be used with a spatula or palette knife.
And acrylic gesso is particularly good because
of its pastelike consistency. Gesso may be
colored beforehand or painted later. Acrylic
emulsion may be thickened with marble dust
to create a thixotropic material similar to
acrylic gesso.

Nailburst, also by Barbara Darr, was textured with masonry
nails and fingerprints. The modeling paste was stained a
darker color. *Courtesy: Barbara Darr*

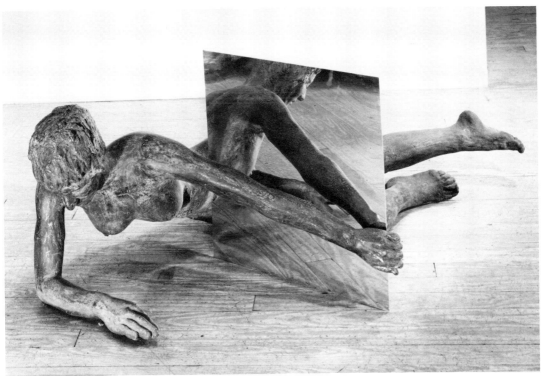

Another Hans Breder polyurethane sculpture (1972). *Cour-
tesy: Max Hutchinson Gallery; photograph by Eric
Pollitzer*

Man-sized floats that move imperceptibly and issue mysterious sounds play hide-and-seek with people at the Osaka World's Fair. Machines were incorporated in the base of the ex-foam bodies. *Courtesy: Robert Breer*

A bas-relief by Jeff Low, created on a foam backing by texturing modeling paste and adding stones. *Courtesy: Jeff Low*

A detail of Jeff Low's panel. The pieces of styrene foam
coffee cups are evident in the parallel, horizontal forms.

A close-up of Jeff Low's panel detailing a rich impasto.
Courtesy: Jeff Low

Another bas-relief by Jeff Low, textured with modeling paste and the addition of texturing materials such as pieces of styrene foam coffee cups. The entire piece is painted with acrylic paint. *Courtesy: Jeff Low*

MODELING

There are few plastics that can be handled and molded. These are available commercially as epoxy putties that are manufactured in various colors—white, brown, gray, bronze, et cetera. They are a two-part system that requires that two bars be thoroughly kneaded together. After they are mixed, there is enough lead time to model small forms or larger forms if small batches are mixed at each application. Regular modeling tools, a knife, and a spatula or tongue depressor can be employed to model the surface.

It is also possible to do a small amount of modeling with pastes if they are very thick, as in buttering, but no hands should touch the resin unless the hands are covered by gloves.

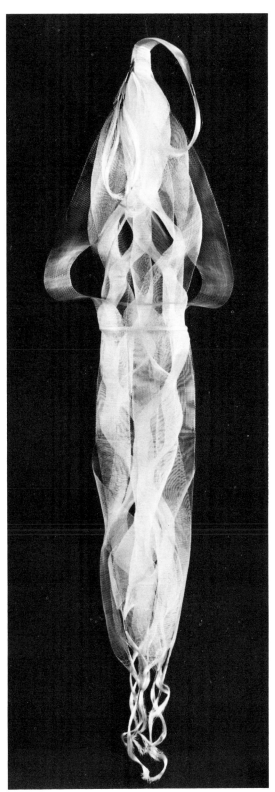

Francoise Grossen's wall hanging made of nylon rope braided and knotted. Ends are sealed by flame, which melts them into globules. *Courtesy: Francoise Grossen*

Kay Sekimachi's *Amiyose III* (1971, 65″ x 15″ x 14″) is woven of clear nylon monofilament with silver wrapping in quadruple and tubular weaves. *Courtesy: Kay Sekimachi; photograph by Stone and Steccati*

Sculpmetal Co. manufacturers an aluminum-filled plastic that may be thinned with its own solvent. The Woodhill Chemical Co. manufactures several plastic pastes that offer possibilities. One is Duro-Plastic® Aluminum and another is Liquid Steel®, which can be applied at room temperature to any nonoily surface without the addition of a catalyst. The Devcon Corp. manufactures epoxy-based putties containing about 20% epoxy and 80% metallic particles. These are available in paste and putty form in aluminum, steel,

A metal armature is readied for spraying by a technician. Then a webbing of styrene is sprayed over the metal like a cocoon.

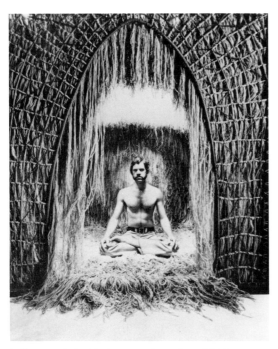

A *Contemplation Environment* from the exhibition of the same name for the Museum of Contemporary Crafts, created by Ted Hallman of acrylic yarns by Monsanto. Fringes are knotted into a yarn grid which in turn is supported by a 6' steel frame in the shape of a cube. Concentric circles radiate outward from a point in front of the meditator to engulf the entire space. *Courtesy: Ted Hallman and the Museum of Contemporary Crafts*

Coatings of vinyl are sprayed over the webbing until the vinyl builds up into a skin.

bronze, and lead. Dura Weld®, a product of the Dewey & Almy Chemical Division of the W. R. Grace Co., is a vinyl acetate copolymer latex additive for concrete. It is mixed with 50% water and can be applied, pastelike, over a strong armature in a stucco effect.

Application of all of these pastelike plastics is done simply by applying the material in any kind of textural effect to a base. When it has hardened, if a smooth surface is desired, sanding is possible. A final coat of catalyzed clear resin will provide a finishing coat.

WORKING WITH FIBERS

Most synthetic fibers are made of acrylic, polyester, nylon, et cetera. There are some fascinating new materials, such as Cadon®

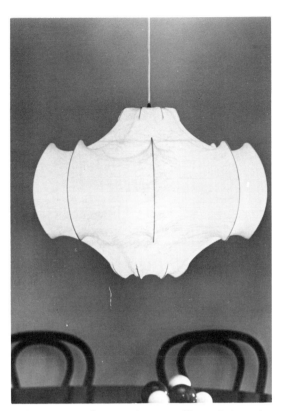

Lighting or sculpture—whatever—this technique has enormous possibility. The forms were designed by Achille and Pier Giacomo Castiglioni. *Courtesy: Atelier International Ltd.*

(Monsanto), a second-generation nylon that is antistatic, antisoiling, and nonflammable. Synthetics react differently than woods and nature's other fibers. For instance, when subjected to a heat bath, synthetics will vary immensely in the way in which they will react. Some will curl down; others will bloom, with the tips of the fibers opening out.

Some synthetic woven fabrics can be thermoformed to shape. Nylon, when burned, forms ball-like globules. Ends of nylon projecting from a woven piece can be textured with a careful bit of flame. Very little has been done with these materials as sculpture, but the potential is there.

Sue Fuller's *String Composition #103* (24″ x 24″). Saran threads are stretched toward the outer perimeters of the square. *Courtesy: Bertha Schaefer; photograph by Michael Katz*

A fragment of a reflective Mylar structure by Peter Nicholson. Adhesive-backed metallized Mylar is adhered to a meticulously clean, smooth surface.

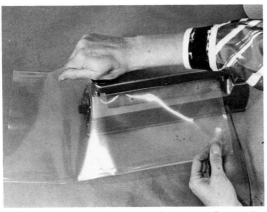

1. Creating a liquid sculpture: A heavy-duty 8-ply polyethylene bag is heat-sealed using a heat sealer.

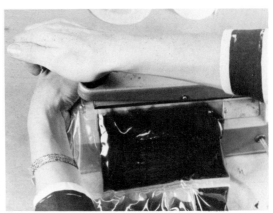

3. The area is sealed with the heat sealer. Other areas are filled using a funnel so that different colors are kept separate.

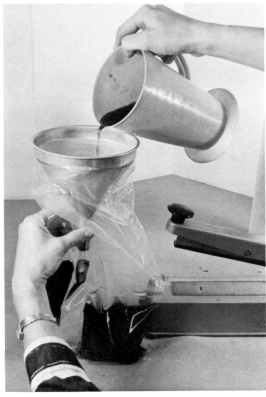

2. Water colored with dye is poured into one section.

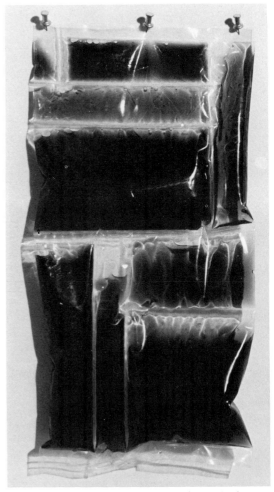

4. The last section is sealed, thus completing the form.

Eugene Massin, *The Bourse* (1972, 52' wide, 14 panels
varying from 6' to 10'). Acrylic figures on acrylic panels.
Courtesy: Eugene Massin; photograph by Les Rachline

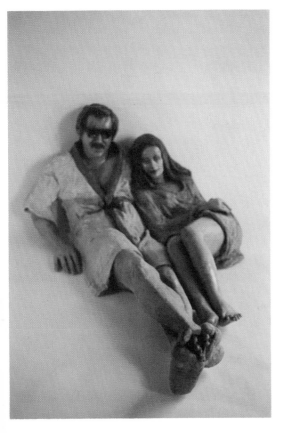

Arlene Love, *Stanley and Harietta*. Fiberglass and poly-
ester hand layed-up in a mold. *Courtesy: Arlene Love*

Thelma R. Newman, *Orchestrated Light* (1973, 28″ x 36″ x 15″). Neon broadcast into acrylic mirror in an acrylic box.

Ed McGowin. Vacuum-formed bas-relief. *Courtesy: Ed McGowin*

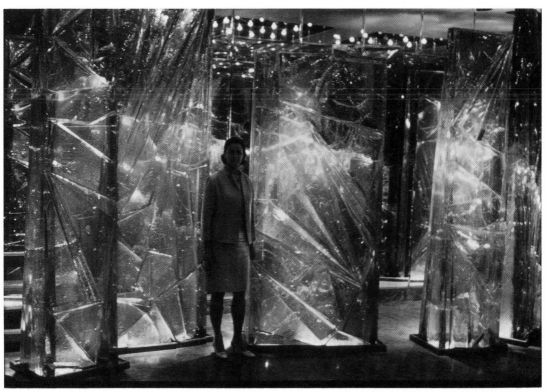

Sara Reid, panel wall of cast polyester hollow pylons (2-4′ wide, 8-10′ tall, walls 24″ thick at bottom, 18″ thick at top). Manila Electric Co. Building. *Courtesy: Sara Reid*

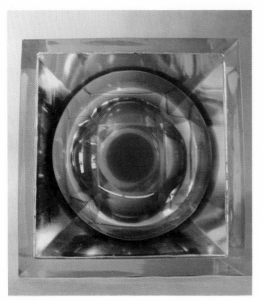

Leo Amino, *Reflectional Sculpture*. Polyester cast in cardboard molds.

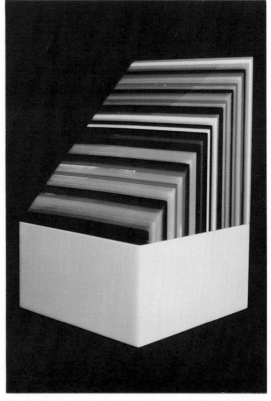

Harriet FeBland, *Mexican Dream* (1972, 12′ x 18′ x 12″). Laminated acrylic. *Courtesy: Harriet FeBland*

Sylvia Massey, polychromed, solid cast polyester duck. *Courtesy: Sylvia Massey*

WORKING WITH FILMS

Plastic films (up to 10 mils) are available in various thicknesses and colors, including metallized films and *moiré* patterns. Some are pressure-sensitive and can be applied to rigid surfaces. And some of the thicker flexible films such as vinyl have been used to form air structures. Edges can be solvent-glued, sewn, or heat-sealed into baglike forms. Through thermal sealing, films are melted together by direct heat. Small hand-held units are available that provide the right amount of heat and pressure to form a permanent bond. Mylar and metallized Mylar can be scored and curled much like paper into sculptural forms. Other films such as cellulose acetate can be made into sculptures by cutting shapes and solvent-cementing them together with acetone.

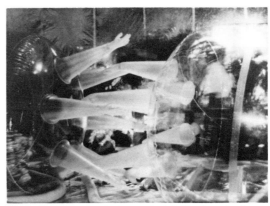

Workers' gloves attached to a vinyl "pillow" and inflated. By Bruce Dexter. *Courtesy: Bruce Dexter*

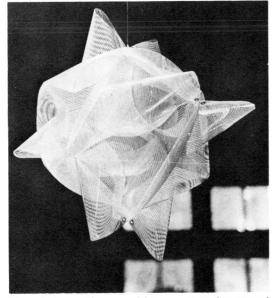

Clear vinyl was silk-screened into a pattern that created a moire effect when overlapped. Parts are assembled with grommets. By Curtis Stephens. *Courtesy: Curtis Stephens*

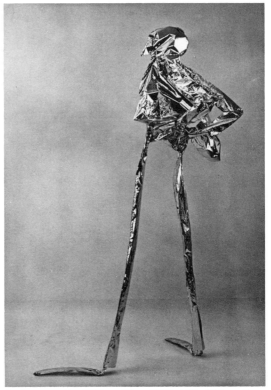

Businessman by William King (1970, 60″). Mylar. *Courtesy: Terry Dintenfass, Inc.; photograph by Walter Rosenblum*

1., 2., and 3. Three patterns of diffraction grating made with a metallized coating.

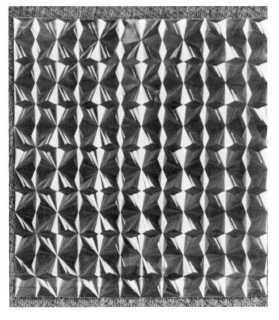

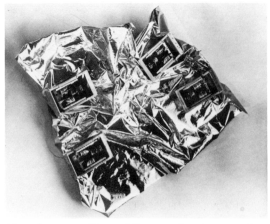

One of many positions of the ever-changing amorphous patterns of *The Rug* by Robert Breer. *Courtesy: Robert Breer*

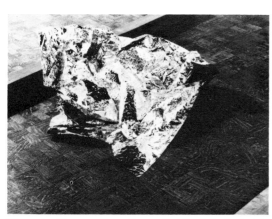

The underside, revealing self-propelled "tanks" attached to metallized Mylar flexible sheet (4′ x 4′).

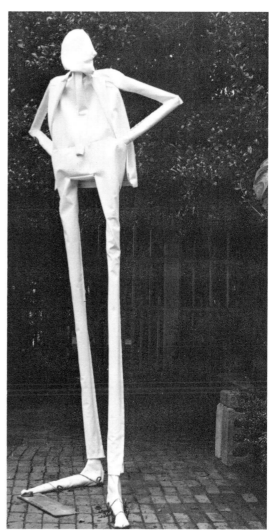

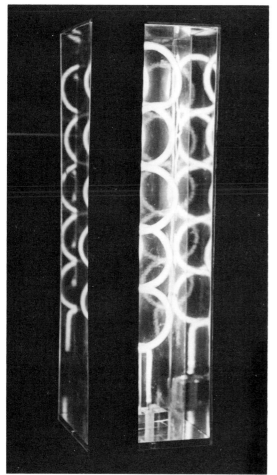

William King's *Businessman* (1966) is made of white naugahyde around a wire armature. *Courtesy: Terry Dintenfass, Inc.*

Mylar-backed acrylic mirrors neon into multiple reflections. Sculpture by the author.

6

Mold Making

With the use of plastics, sculpture is no longer prohibitively expensive for the middle-class pocketbook. Because of the castability of plastics, editions turned out by the artist, rather than by a middleman, are now possible, which thereby reduce the cost of the otherwise time-consuming sculpture-making process. The cost savings operates in two sectors—in making molds and in casting an edition of many pieces from the same mold. All this is possible within the studio environment and entails no more in equipment than what is usually available there.

Molds may be rigid or flexible, permanent or temporary. Waste molds are temporary. They are used once and, in the process of removing the sculpture, are destroyed. Section or piece molds and flexible molds are more permanent, capable of producing multiples of a sculpture; often their potential is in excess of what the artist would want to set for edition limits. Flexible molds peel away from a sculpture like removing a glove from a hand.

THE POSITIVE

The positive, or master mold, which is your sculpture can be made of a variety of materials—plaster of Paris, ceramic, wood, metal, glass, fiberglass, or even wax. Of course, wax cannot be used with hot-melt mold materials but will serve well with all room-temperature curing mold materials. Porous materials such as wood or plaster should be sealed with several coats of lacquer or some other sealer, followed up with a spray coating or brushing of a suitable mold release.

RIGID MOLDS

Rigid molds are generally made from epoxy, fiberglass and epoxy or polyester resin, silicone, urethane, vinyl, rigid foam, cellulose acetate, metal, plaster of Paris, clay, or glass. Although plaster of Paris is, by far, the least

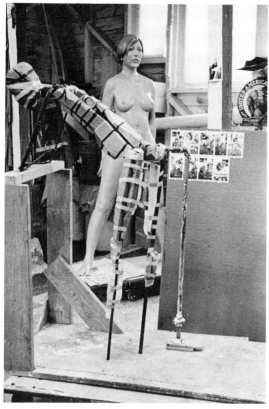

1.
An armature of steel rods and pipes is put together with tying wire. Polyurethane (density 2 to 4 lbs. per cubic foot) filling material is taped to the armature. Later, when the mold is completed and sections must be pried apart, the foam can easily tear away from the steel armature without damaging the mold surface.

RALPH MASSEY CREATING A RIGID MOLD

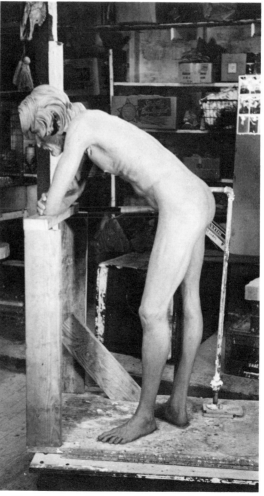

expensive mold material and is commonly used in making both waste molds and piece molds, it is rapidly being replaced by RTV silicones, vinyls, and urethanes, which are less involved in construction, less fragile, and possibly can produce more pieces with as much or more fidelity to the original.

For making a waste mold, which is sacrificed when the positive is removed, use a common plaster of Paris such as Red Top. The material sets quickly and is soft enough to chip away. For piece molds, a harder plaster such as Hydrocal® or Ultracal® (U.S. Gypsum Co.), which have plastic components, will hold up better and longer.

2. Plastilene is applied over the low-density polyurethane foam. To create a smooth surface, chamois is soaked in turpentine and rubbed over the entire clay piece.

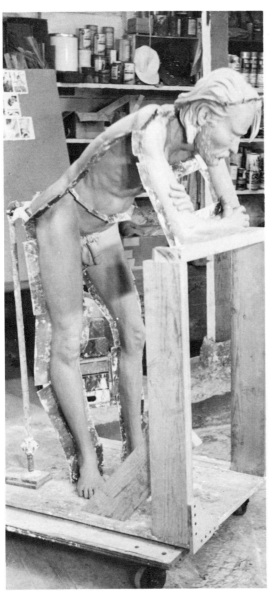

3. Then the sculpture is divided into sections with brass shims. And the entire sculpture is sprayed with acrylic "lacquer" to seal the oil-based clay.

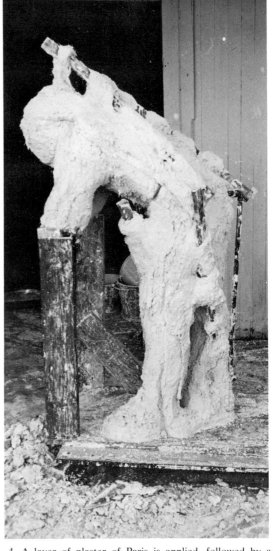

4. A layer of plaster of Paris is applied, followed by a covering of plaster of Paris mixed with perlite (a volcanic ash). Finally, hemp fiber is added to the plaster for reinforcement and then wood braces are attached, bonded with more plaster mixed with hemp.

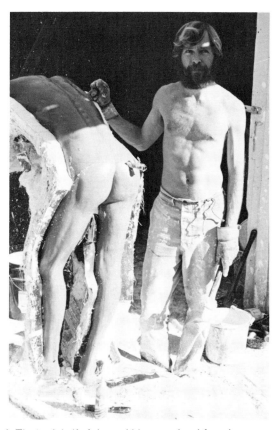

6. The back half of the mold is opened and from here on, the clay is scooped out of the remaining sections. Any damaged portions of the mold are repaired with white glue (Elmer's, Sobo, and so on). The plaster sections are dried at 200° F. and two layers of shellac are applied to seal the mold surface. Then a hard-wax release agent is brushed over the shellacked plaster.

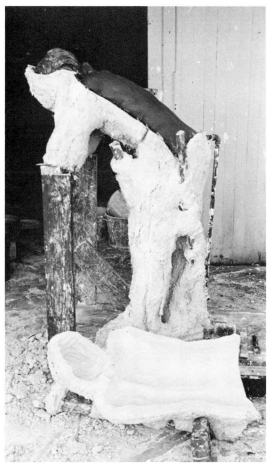

5. When the plaster has hardened, a wedge is pushed along the separating lines of the shim stock and the first mold section is removed.

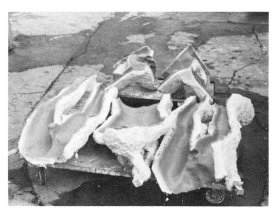

7. Polyester resin and fiberglass are hand laid-up in the mold. The molds, which are very heavy, are wheeled around on dollies. Because of the heaviness of this type of mold, Ralph Massey now uses latex skins with fiberglass housings or RTV silicone molds.

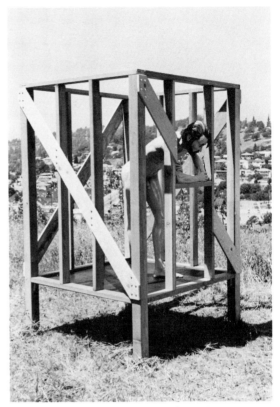

9. *Cage* by Ralph Massey (1972, 4½' x 4½' x 7').

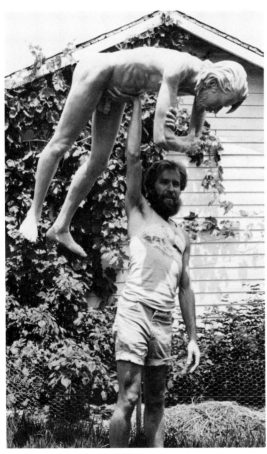

8. When the lamination is cured, the plaster is chipped, chiseled, and scraped away from the cast (if it cannot be pried loose), and the edges are ground smooth and fitted together with a layer of fiberglass cloth across the inside seam. The surface is sanded and rubbed with steel wool until smooth and ready for a finishing patina or poly-chroming. This casting is 40 lbs. A similar sculpture of bronze or stone would weigh 300 to 900 lbs.

WASTE MOLDS

In making a waste mold, the positive can be made of wax or any other material covered with the plaster of Paris; leave two openings at one end and connecting passageways between sculptural parts for the later passage of plastic throughout the piece—the entrance of plastic and the exit of air. The original wax can be melted out, in an oven or with a propane torch, and the cavity can be filled with polyester or epoxy.

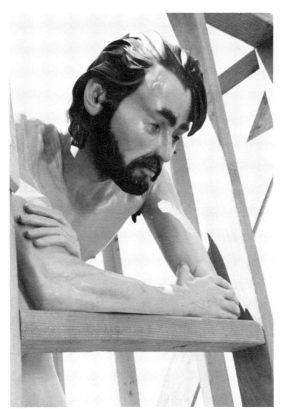

10. Detail of the polychromed head in Ralph Massey's *Cage. Courtesy: Ralph Massey*

PIECE MOLDS

In designing piece molds, avoid undercuts, projections which would lock a rigid casting into the mold and make removal of the casting impossible. Because piece molds have to be accurately matched, incorporate registration devices such as wooden blocks or cut notches in the plaster. Plaster of Paris should be thoroughly dry, bone dry, and sealed with about three coats of lacquer before you apply a paste wax or mold release such as Sonite® #815 Wax or Sonite Seal Release (Smooth-On, Inc.). Release should be applied each time a casting is made.

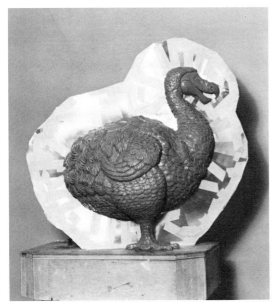

Sylvia Massey's *Dodo* in plastilene showing shims taped together with masking tape. The next step will be a first coat of latex in making a flexible two-part mold.

The form covered with several layers of latex and showing little blocks around the edges used to key in an outer housing of fiberglass and polyester resin.

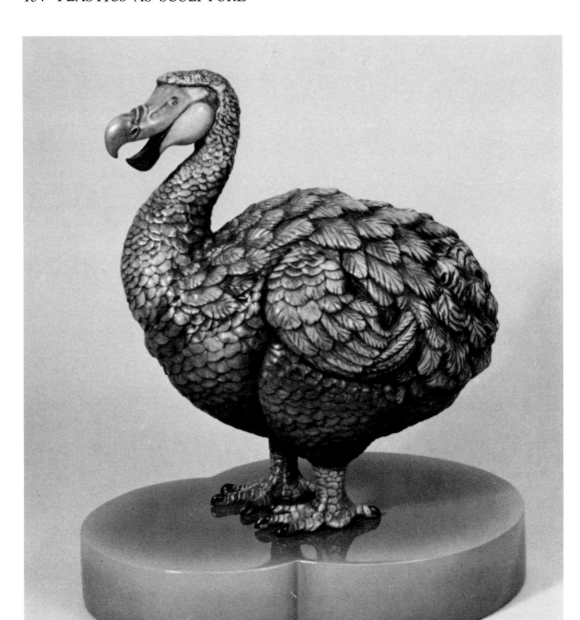

The completed casting of *Dodo* is itself of laid-up fiberglass and polyester resin. The form, which is about 15″ x 15″, is then painted in a rubbed finish. *Courtesy: Sylvia Massey*

Other rigid mold materials such as fiberglass impregnations are lightweight, durable, and require use of a release agent such as polyvinyl alcohol, silicone, or wax. These molds are capable of spanning large areas without sacrificing their strength.

Semirigid materials such as vacuum-formed cellulose acetate, polyethylene, and Mylar do not necessarily need a release, but they last longer when release is applied. Glass bottles, bowls, and glazed ceramic pieces need to be free of undercuts and coated well with

Another completed half-life-scale plastilene figure, *Jo Anne*, by Ralph Massey on its supporting armature of rods.

FLEXIBLE MOLDS

Flexible plastic molds may be made of silicone, vinyl chloride, or polyurethane. Unless the work is small, it needs to be braced with wood or a plaster jacket to keep the mold from losing its shape, unless, at great expense, the flexible material is applied thickly.

RTV SILICONE MOLDS

RTV silicone means room-temperature vulcanizing silicone. The mold is simply made at room temperature by weighing two components, resin and catalyst, and applying the

a release. Unglazed ceramics (as with other porous materials) should be sealed with lacquer before applying a release agent.

The process of making rigid molds is detailed in captions of photos in this chapter.

MOLD RELEASES

Mold releases vary from films and film-forming materials which are sprayable or brushable, such as polyvinyl acetate and silicone, to greasy lubricants, such as green soap, wax, petroleum jelly, and silicone. Thicker materials should be applied by brushing or by fingertips.

Jo Anne is divided with shims into sections and covered with latex and then with latex and burlap. Small blocks are attached to the shims around the flanges of the six sections. A fiberglass and polyester housing will support the flexible skin mold.

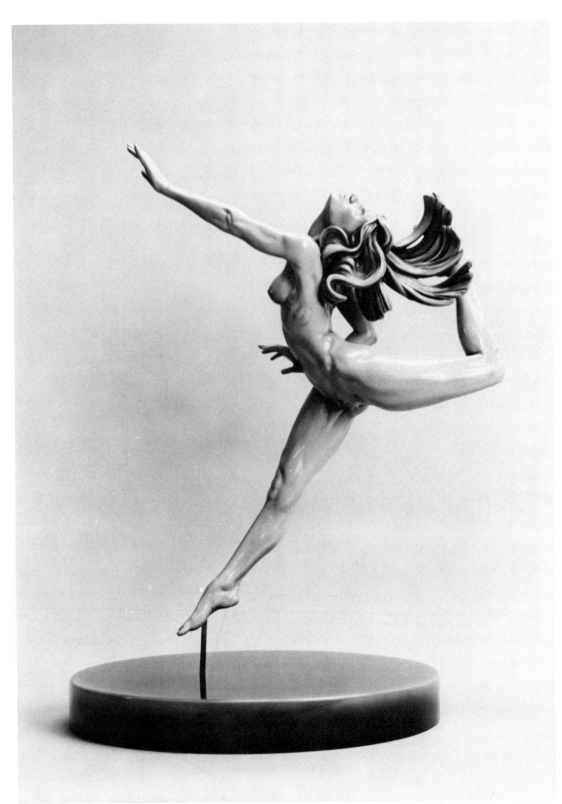

Jo Anne is a completed polychromed sculpture, one-half life-size. Because the material is so light, 15 to 20 lbs., a single mounting pin can be used to support the sculpture. This cantilevered position would not be practical for traditional castings in stone or bronze. *Courtesy: Ralph Massey*

Working with RTV
Silicone and One-Piece Molds

Select the desired RTV silicone. Weigh out the necessary amount. Combine the resin and catalyst and blend vigorously with a spatula until the parts are thoroughly mixed. Try not to incorporate air. If possible, deaerate the mixture under a vacuum for 3 to 10 minutes, after making certain first that your container will accommodate expansion. If the silicone is too thick, you can thin it with a small amount of RTV silicone thinner. Paint

1. Making a one-piece RTV silicone mold: Cracks and imperfections in the master are touched up with acrylic gesso. Rough spots are sanded smooth. As an optional step, silicone release agent is sprayed over the master and inside the housing that is to determine outside limits of the mold. The depth of the mold is indicated on the mold wall. Ingredients are gathered. General Electric's RTV Silicone 662A and 662B are to be used.

mixture with a spatula or pouring it into a form over your sculpture. One can get 1,000 polyester castings or 250 polyurethane castings from RTV silicone. Mold costs, although high initially, can be reduced by pulverizing old molds and blending no more than 50% of the pulverized material with virgin silicone. There are different classes of RTV silicone — a thin variety, a paste variety, medium-viscosity systems, and high-heat tolerance kinds. Catalysts are also interchangeable and vary in the amount of time it takes for a mold to cure.

2. The RTV silicone is weighed and then the catalyst is added and weighed. The two components are mixed thoroughly. Then the composite is poured into a jar for vacuuming out the air. Air is vacuumed from the mixture until the mixture stops rising to the top of the jar, which indicates that air has been expelled.

3. The RTV is poured from high onto the mold, stretching out and breaking any existing bubbles. The rubber is allowed to flow from one point onto the master.

4. In 24 hours, upon curing, the mold is cut away from the side of the mold housing. And the mold is pulled away from the master.

bubbles will elongate and burst. If you run out of mold material, immediately mix more and add it. Do not wait for the first batch to cure. Many RTV silicones take 24 hours to cure at room temperature. Torn molds may be repaired with special RTV materials. Or, for repairs, cut away the torn area; reseat the mold over the master, clean the mold surface with acetone, and pour in more catalyzed RTV. Reinforcements can be made with Dacron cloth mesh.

the surface of your pattern with RTV silicone, place it in a container (cardboard will do), and then slowly pour the material, starting at one corner of the mold and allowing it to flow in the piece to push out air. Hold the mold material high so that remaining air

5. Polyester resin and catalyst are mixed together and poured into the mold. A release paper or Mylar sheeting is placed over the top and a board is clamped into place with "C" clamps. When the resin cures, the mold is removed from the casting (not the other way around).

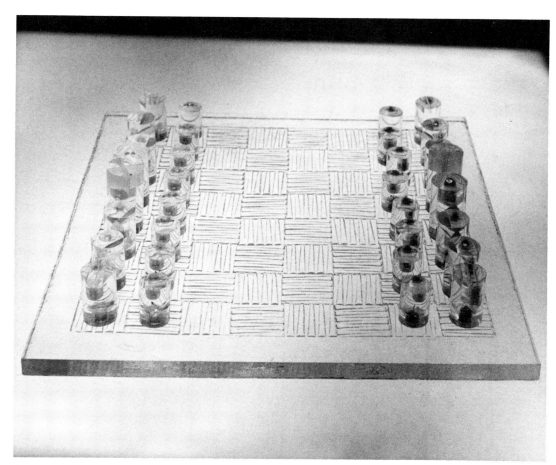

6. The completed solid cast chess board by the author.

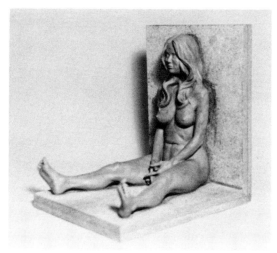

1. A completed plastilene figure, one-third life-size, *Betty Jean,* by Ralph Massey, sits on a particle board platform ready to be made into an RTV silicone mold. The plastilene and board are sprayed with a clear acrylic lacquer to seal any oils which may retard the curing of the RTV. (Some clays cannot be used because they retard the cure and cannot be sealed.)

2. The sculpture is screwed down to the base board to keep it from floating or moving later. Dow Corning's RTV-G, which has high tear strength, is weighed and mixed. Then it is brushed over the entire sculpture so that no air bubbles will be trapped near the surface. (If a vacuum pump is available, you can skip this step.) Wooden mold housings are fabricated in advance to fit over the sculpture in three sections, allowing a ¼″ space between sculpture and housing to be filled with RTV. Sharp corners of the housing were filled with plastilene to round off potential tearing places in the RTV and to seal seams and cracks the RTV might flow into and get caught in. (The inner surfaces of the housings are sprayed with clear acrylic lacquer as well.)

3. The housing sections are assembled around the sculpture and clamped into place. Plastilene is used to seal the seams around the housing. Note that holes are drilled into the housing above her toes for air to rise out as RTV is poured in. Otherwise, air would become entrapped. Weighed and mixed silicone is poured into an opening that has been left on the top of the housing. The mold is vibrated to loosen any air bubbles. Ralph Massey uses a drill motor to help to vibrate the mold.

4. In 24 hours, the mold sections are opened and the parts are removed. Note that keys had been cut into the mold with a scalpel after the back housing was removed. At the same time, the back wall of RTV was sliced off the rest, making two sections of RTV and three wood supporting sections (two in front and one in back). The back mold was routed out to fit the keys on the front section. Note that the RTV is sliced at solid sections of the leg so that the casting could be removed without tearing the mold. Additional slits were made at the fingers as well.

In-the-Round Castings — Two-Part Molds

Molds for three-dimensional pieces have to be made in two parts. (Some undercuts are still possible because of the flexibility of the material.) One half of the sculpture has to be masked. A simple way is to embed one half in paraffin or clay within a dam or box. Make grooves in the top edge of the base for later mold matching and aligning. Meter, mix, and pour the mold material as you would for a one-part mold. After it has cured, the whole piece —mold and all—is removed from its wax or clay base and the silicone half of the mold is coated thoroughly with a paraffin wax-xylene mixture or a 5% Vaseline® and 95% methylene chloride solution—and placed in a box to contain the material. The release agent is allowed to dry and the second half of the mold is poured. When it has cured, remove the master form, join the two parts together, and cut two holes in one end, one for pouring and the other to act as an air vent. Tape the halves together and you are ready for pouring. If

5. After a facing layer of polyester resin is painted into the mold sections, the mold is reassembled and clamped together. With the mold held upside down, the entire bottom is open for pouring the polyester resin. *Betty Jean* by Ralph Massey. The first edition numbered 10 pieces. *Courtesy: Ralph Massey*

you wish to increase the life of your mold, you can coat it with 3 to 5 parts of a household detergent in 100 parts of water. After use, clean out the mold with acetone and dry it before your next pouring. Dow Corning (Silastic®) and General Electric Companies make excellent RTV silicones. Remove a casting of polyester, epoxy, or polyurethane as soon as possible, before the last stage of exotherm is generated; it will help to extend the life of the mold.

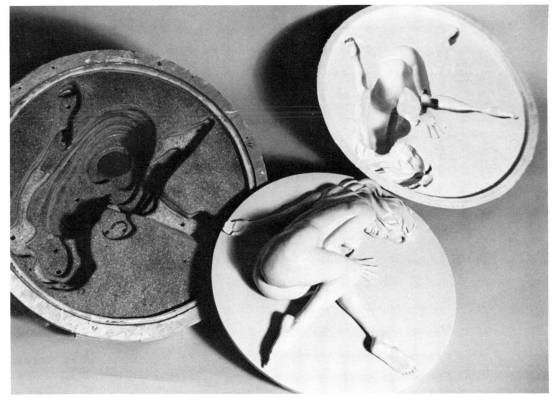

Betty Jean again by Ralph Massey, in a solid polyester resin casting. The housing was made of particle board that was built up by contouring the opening. Holes were drilled into the top to allow air to escape. At the right is a ¼″ RTV silicone (Dow Corning RTV-A) skin. *Courtesy: Ralph Massey*

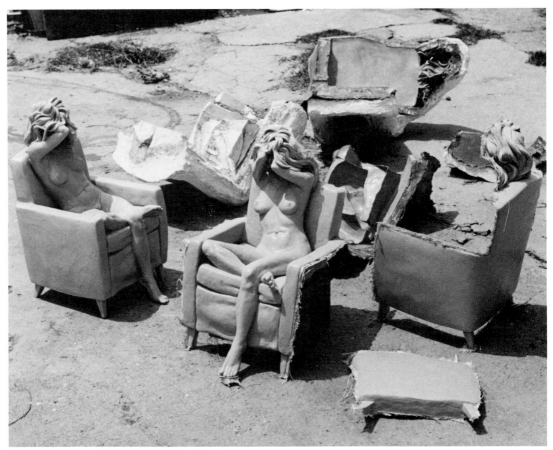

1. Here is *Betty Jean* again, this time showing stages of assembling in the first of four castings. The edges have not been ground smooth. Usually, edges are trimmed with a knife while they are leather-hard and still curing in the mold. In the background is a Latex skin mold.

Skin-Type Molds

To save money, use a more thixotropic RTV material and brush on catalyzed silicone. If it does not stop running, work under the heat of an infrared lamp. When the temperature reaches 200°F., it will begin to cure. Make certain, though, that your sculpture will not melt at that temperature. After the first coating cures, repeat the operation for a second coat. Then, when cured, apply a third coat and if your figure is large, add a layer of cheesecloth, Dacron cloth, or fiberglass to the wet RTV silicone. Coat that with more silicone and allow it to cure. This will act as a reinforcement. Your skin mold should cure to about ⅛″ thick. You will need to make a plaster jacket or a wooden holding box to brace and to support the piece in order to keep it from distorting. A very good holding box can be one made of wood, filled with expanded polystyrene foam pellets used in packing or vermiculite. Insert the skin mold into a partially filled box, level the mold, and add more vermiculite or pellets. Then pour your plastic into the mold. Skin (or sleeve) molds peel off of the positive very easily because of the elastic quality of the mold material.

In addition to the RTV silicones, Kwikset® (Adrub RTV, Adhesives Products Corp.) makes a brushable RTV material that may be a urethane or vinyl. It is excellent for forms with extreme undercuts.

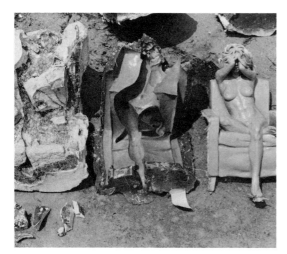

2. The mold for the seated *Betty Jean* was built up with four layers of latex, a layer of gauze, more latex, a layer of burlap, and more latex to finish it off. The figure was divided into three sections with brass shims. Latex was painted 4″ onto the shims and on the clay, creating a flange. Onto this flange were bonded little ½″ x 1″ x ½″ blocks to key the latex skin into the plaster (or fiberglass) housing. Everywhere there was an undercut, plaster plugs were added (Sylvia Massey points to them), to keep the housing from locking on. About 30 plugs were used, which necessitated numbering them (also seen in this photo). When the housing is removed, the latex comes off with plugs intact. Before the latex is peeled away from the polyester sculpture, however, the plugs have to be removed, hence the need for numbering them.

MAKING POLYURETHANE MOLDS

Making a polyurethane mold is much like making an RTV silicone mold. The polyurethane used for molds is an elastomeric (a rubberlike) two-component system that cures at room temperature.

Unlike RTV silicone, which is a natural release agent, polyurethane sticks to almost anything, which necessitates the application of a wax or silicone release. After applying the mold release, place the mold on a level surface. Determine the amount of each component that is to be used, following the manufacturer's recommendations for proportions. Weigh the components in a clean,

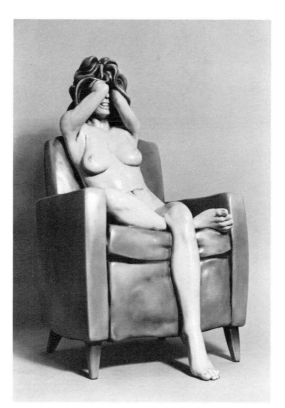

4. This is *Betty Jean* by Ralph Massey (1972) trimmed, polychromed, patinaed, completed. *Courtesy: Ralph Massey*

3. The center form is flipped over here, revealing the inner side of latex skin. On the left, still more plugs are in position in the housing.

post-curing is necessary, follow the supplier's instructions.

There are many urethane elastomers. Upjohn makes Castethane CPR2117; Smooth-On's equivalent is PMC-704.

VINYL CHLORIDE MOLDS

Vinyl chloride is a hot-melt type of rubberlike mold material available either in shred or in a liquid that has to be cooked and remelted (I use an electric frying pan or a double boiler) at 350° to 400°F., depending on the manufacturer's instructions. When the material

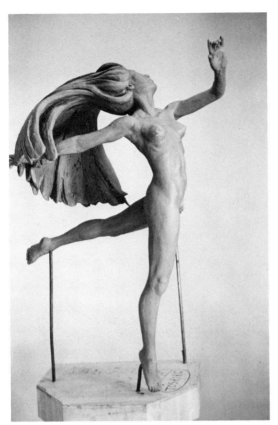

1. *Toshiko* by Ralph Massey, sculptured one-half life size scale showing a partially completed clay original.

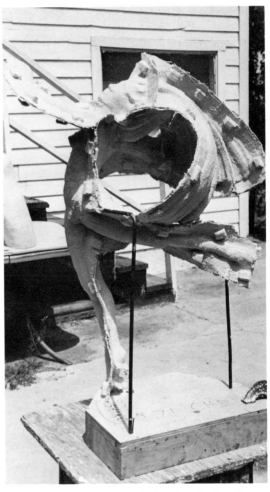

dry container and combine them. Immerse a mixing blade and start mixing immediately at high speed. Repeatedly scrape the walls and bottom of the container with a tongue depressor or spatula. After mixing the material thoroughly, deaerate the mixture if you have a vacuum pump capable of achieving 5 mm. of mercury in 30 to 45 seconds. Pour the urethane into the mold until it is ½″ above the highest section. If there are air bubbles, they can be eliminated by passing a flame over the surface of the urethane casting. Clean your implements with methylene chloride. Allow the urethane to cure until a light jab with a pencil reveals that it is firm and resilient. Remove the urethane from the form and if

2. A latex skin mold was applied as described earlier.

3. There are eight completed sections of latex mold in their fiberglass and resin housings. (Inner surfaces of the mold are showing here.)

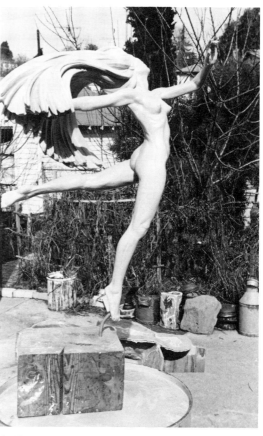

6. *Toshiko* showing cast sections assembled with seam lines partially chased. A steel mounting pin is bonded to the interior surface of the leg prior to assembling the sections.

4. *Toshiko* showing details of the mold sections: outer surface of the latex arm section and its housing; inner surface of the latex hair section; a plaster plug and fiberglass and resin housing complete with square holes to key the latex skin.

5. Eight completed cast sections of *Toshiko*.

has melted, it is poured in its hot state over the sculpture (which is in a box). Of course, the sculpture material has to be able to withstand the heat of the vinyl chloride. When the material has cooled, it can be removed from the positive.

Shredded vinyl chloride called Plastiflex comes from General Fabricators and liquid vinyl chloride from Flexible Products Co.

These are the major do-it-yourself plastic mold materials. Other types are available ready-made of glass, cellulose acetate, and polyethylene. They all should be spray- or brush-coated with a release agent before use.

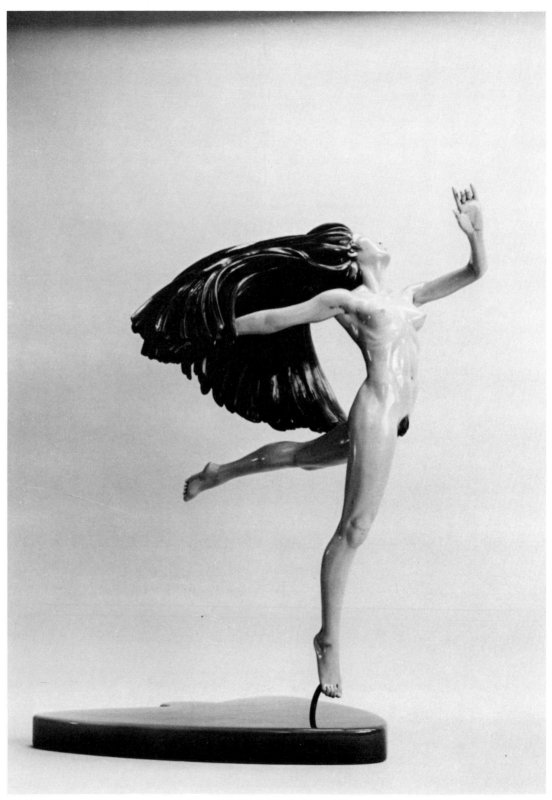

7. Airbrushed with a lacquer finish and mounted on a
lacquered wood base, *Toshiko,* by Ralph Massey (1973),
is completed. *Courtesy: Ralph Massey*

A translucent casting by the author (36″ x 48″) of water-white polyester resin, cast in a carved wax mold. Wax and polyester form a symbiotic relationship. The wax mold gives the polyester its shape when the polyester resin gels. Then the resin heats up as exothermic reaction occurs in the curing process. The wax mold melts. But, since the polyester as a gel already has its shape, when the polyester cools, so does the wax, taking the shape it originally gave to the polyester. Get it?

7

Large and Monumental Sculptures as Architectural Components

All the plastics that are applicable for smaller bas-relief and free-standing sculpture are also excellent for large and monumental forms that are to become architectural components. The only restriction in use is in weatherability. Most plastics need to be given a protective coating when used out of doors. The only exceptions are fiberglass/polyester (which requires some upkeep), polycarbonates, and acrylics (which also can be affected by pollutants). Although plastics do not easily decompose when exposed to the elements, they do lose their original finish after a while. When plastics are designed for indoor use, however, these problems are eliminated.

Besides using plastics as a direct and primary material, artists have made excellent use of plastics as mold materials and as lightweight fillers to provide bulk and reduce weight, as in Al Vrana's use of polystyrene foam and the use of epoxies as a mastic or glue.

DESIGN CONSIDERATIONS

Engineering criteria relating to design become a primary consideration that requires specialized assistance from a polymer engineer. Stresses, wind velocity, flexibility, particular use of fasteners, adhesives, length-to-thickness ratios, contraction and expansion ratios, warpage, shrinkage, attacks by actinic light are all factors to be reckoned with. The behavior of a plastic fabrication, such as the stresses induced, will affect the life of the end product. Incomplete care, overcure, poor mixing in the thermosetting resins will result in weak areas that may fail prematurely in a large form, whereas in a smaller piece those faults would not show up at all.

The environmental setting of a piece plays more than an aesthetic role; it is an important design consideration as well. Heat and the presence of corrosive elements in the atmosphere are considerations to be taken into account. Each environment imposes some

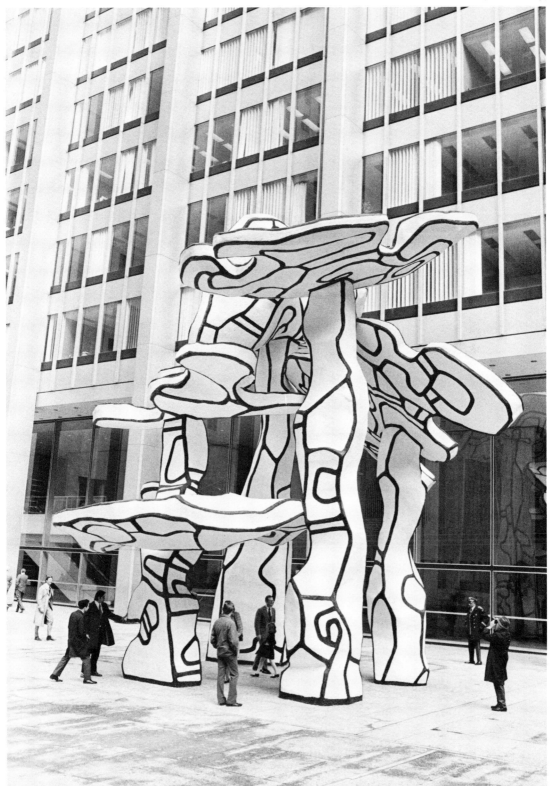

Jean Dubuffet's *Group of Four Trees* (1972, 42' high) is said to be the largest sculpture in permanent installation in New York City (Chase Manhattan Plaza). It is poly- chromed fiberglass and polyester resin over a cement and aluminum core. *Courtesy: The Chase Manhattan Bank; photograph by Arthur Lavine*

1. and 2. Two positions of Julia Busch's mural called *Projection*. Acrylic sheeting is etched, cut, and drilled. *Courtesy: Julia Busch; photograph by Shirley Busch*

problem that affects the performance of a material. Engineers are continually isolating new variables so that they can better predict performance and pinpoint potential difficulties. Many concepts are at an embryonic stage. Each experience with these materials produces new insights. Because the real parameters of many materials are not known, advice is not always dependable.

In general, selection of a particular plastic requires analysis of the strong and weak points of each material in a particular application. No one plastic will possess all the desired qualities and no weaknesses. The undesirable characteristics must be compensated for in the design. This becomes particularly critical when scale is increased. In industry the prototype of a product is field-tested in order to eliminate undesirable characteristics. But in sculpture a piece is often the one and only piece; it is prototype and final product, and

testing is not possible. Therefore, one must be certain of performance before beginning. Only when working in large scale, when costs can be considerable, would I suggest that creative adventures be avoided because of the possibility of failure.

When risks of failure must be minimized—if a piece is to be in a public place, for example— it would be best to list the desired characteristics and check these out against a properties chart that describes plastics. These charts can be found in *Modern Plastics Encyclopedia* along with a wealth of technical information. Double-check your selection of materials with a plastics engineer who works for the manufacturer. If it is a large company, such as Rohm and Haas in Philadelphia, Pa., the design department should be able to provide technical assistance.

Some specific processes are described in the captions of this chapter.

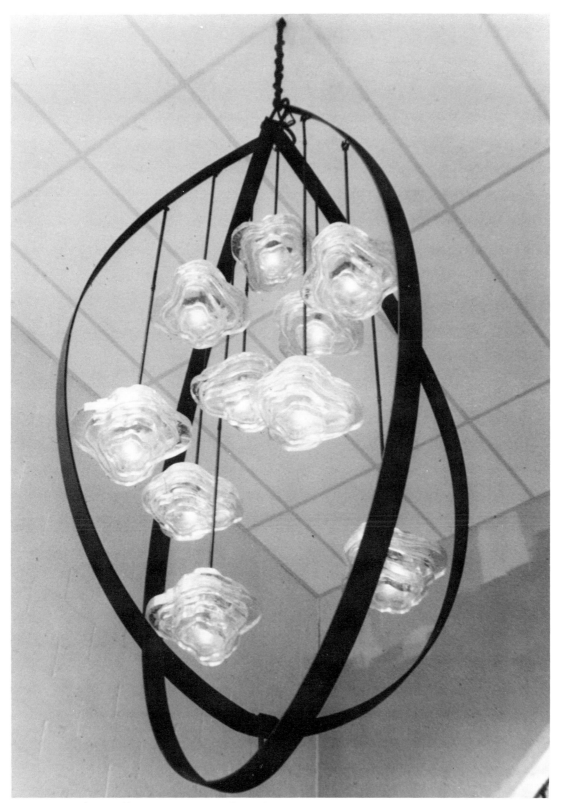

Sara Reid's 10' high, 6' diameter sculpture *Lamp for Picker.* Made of water-clear cast polyester. Picker X-Ray Corporation, Fairfax, Virginia. *Courtesy: Sara Reid*

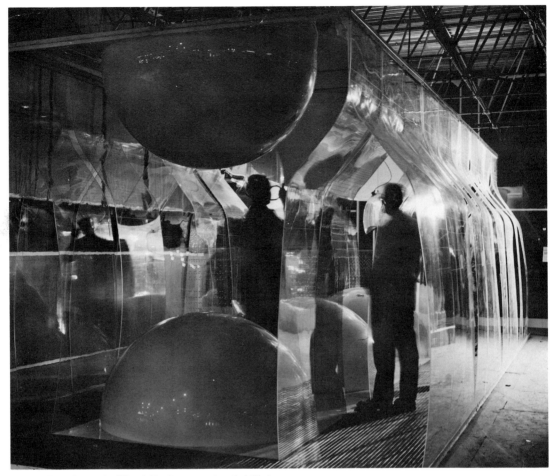

Ugo LaPietra's *Audio-Visual Environment* is of drilled, etched, and formed acrylic sheeting. *Courtesy: Ugo LaPietra*

A CASE HISTORY OF CONSTRUCT- ING A 52-FOOT MURAL[1]

The Bourse is the name of a mural in acrylic that Eugene Massin created for the City National Bank of Miami Beach.

A monumental or architectural work is a collaborative effort that takes a great deal of detailed planning. Sketches and scale drawings have to be made and conferences have to be held with architects, lighting engineers, interior designers, and construction engineers, before

[1]Documented with the help of Julia Busch.

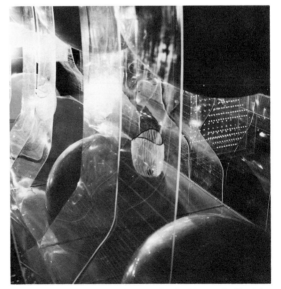

Another version of Ugo LaPietra's *Ambiente Audiovisiuo* (1968). *Courtesy: Ugo LaPietra*

even a scale model can be constructed, because there is little room for change once the project begins. Mistakes can be costly.

Plans are studied and sketches are made, scaled in this case one inch to the foot. Masked, colored, transparent acrylic is used for the model. It is cut into shapes and mounted onto background sheets which are then suspended in a scale model of the bank.

The work is studied in miniature. All problems are evaluated and solutions are sought. One of the difficulties is in achieving a bubble-free bonding. In order to avoid this, Eugene Massin cuts a second layer of "neckties." It is these that hold the entire silhouette on the background sheet of acrylic. Now that the bonding problem is solved, a team, consisting

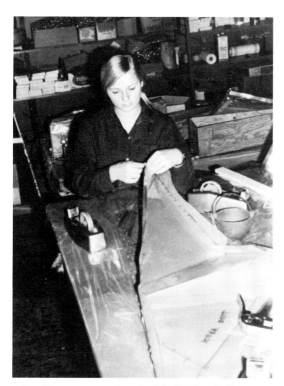

1. Sara Reid creating pylons for Manila Electric Company. Patterns are made for the pylon shapes.

2. Reinforced plywood boxes are lined with Mylar. They vary in width from 2″ to 4″ and are 8′ to 10′ tall. These pylons are hollow inside and are thicker at the bottom (each wall is at least 8″ thick) so that the center of gravity is at the base, preventing tip-over in the advent of an earthquake.

3. After boxes are lined, they are tipped and filled with polyester on each side until the walls reach the proper thickness. After each side cures, the other side is poured.

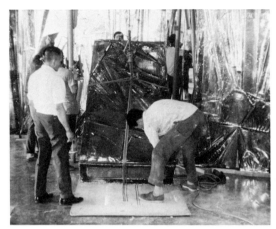

4. Eventually the weight ranges from 1,600 lbs. to 2,200 lbs. for each pylon. Pulleys are used to handle the molds. At this point, the Mylar-lined wooden mold is removed and the piece is ready for the addition of light catching cast polyester shapes that will catch light refractions later.

6. The pieces were crated and supported with poly-urethane foam to protect these huge castings from extremes of temperature; for example, in the studio to the truck, in the hold of the ship to the air conditioned building. Variations of more than ten degree difference would risk cracking the casting. Here the pylons are being installed over a pit that contained both programmed lighting and air conditioning to control the heat generated by these lights.

of Alex Styne and Dr. Augustine Recio, along with the artist, is ready to tackle another problem—lighting. Fixtures, filters, angles for optimal lighting are calculated with the aid of a computer. Baffles to shade the ceiling fixtures are decided upon with architect Herbert Mathes. And then the best manner of suspending the mural is worked out. Even the reflective percentile of the wall covering behind the mural is considered.

5. Meanwhile, other shapes are also cast from the same water-clear polyester for adhesion, with more polyester, to the main pylon form.

Now a larger model is constructed exclusively for the consideration of light reflection, projection, and experimentation with filters. At this point Sun Plastics of Hallandale, Florida, is asked to fabricate the full-size sections which are to be hung in the bank, because even such a fully equipped studio as Eugene Massin's may not be capable of handling such huge pieces.

Then, full-scale working cartoons are sketched on brown paper, which, at the factory, become patterns for acrylic or Masonite routing templates, or they are traced onto masked acrylic sheet which is cut on a band saw. While the silhouettes and the supporting "neckties" are cut in this fashion, background sheets are cut and frames are ripped on a panel saw. Edges are squared on a joiner, beveled with a router, and flame polished.

The panels are then assembled, taped and bonded with PS 30 (a polymerizable acrylic cement), packed, and shipped to the site (City National Bank of Miami Beach). There lighting tracks, baffles, and Kindorf channel are installed. The panels are lifted into place, hung, and cleaned.

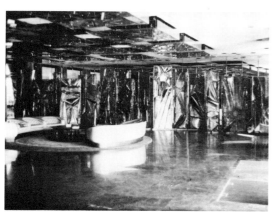

7. An incident lighted view of Sara Reid's installation in the lobby of the Manila Electric Company Building in Rizal, Manila, Philippines.

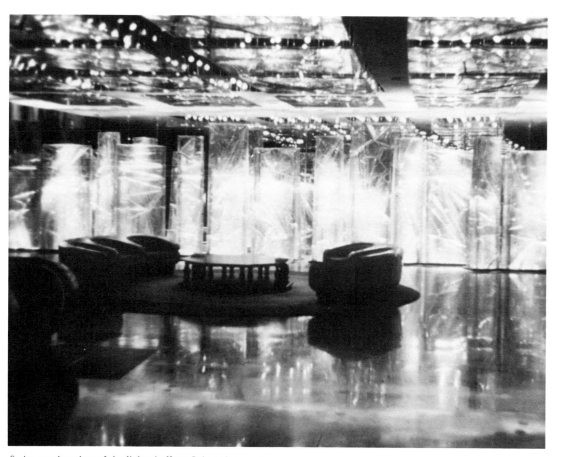

8. An evening view of the lighted effect. It is an impressive scene.

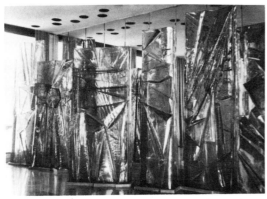

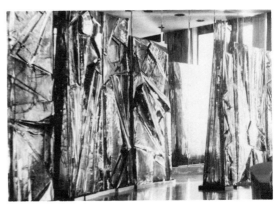

9. and 10. Two close-up views of the water-clear polyester resin castings. In this photograph the pylons look dark, when, in fact, they are actually crystal clear. *Courtesy: Sara Reid Designs*

The job is not completed, though. Days and nights are spent in adjusting light fixtures, filters, and focal lengths to edge-light the silhouettes and to project colored shadows onto the wall behind the mural, until the aesthetic concept becomes visually concrete.

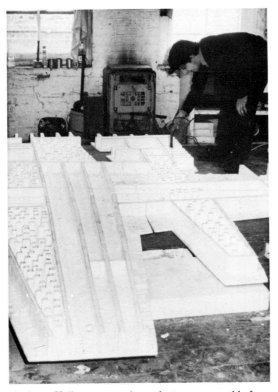

Anthony Hollaway preparing polystyrene as molds for a cement housing project wall. *Courtesy: Anthony Hollaway*

The mural is composed of 14 transparent colored acrylic panels 8' high x 52' long. Each panel consists of silhouetted figures in business suits—figures that seem to be running or talking, but are now encased, frozen in time. Aside from the philosophical implications provided by "frozen" figures, the aesthetics suggest an apparitionlike quality through the mirroring of the bank lobby and the busy activity on the surface of the acrylic. It seems to make the bank part of the mural rather than the mural part of the bank, causing an "'Alice into the looking-glass' surrealism," according to Julia Busch.

Figures of each panel may be blue and orange or bronze on alternate sheets of clear, yellow and blue. These colors echo on the panels and colors blend into similar repeating combinations, e.g., an orange coinciding with a blue projects, reflects, and mixes behind the panel to create a bronze. Depending upon the viewer's vantage point, new colors emerge.

Edge-lighting properties trace lines around the silhouettes, piping through to define figures with glowing accents. Edge-lighting and colored shadows continually change as the viewer's vantage point changes, causing an illusion that the figures themselves are emerging from frozen space and are indeed moving.

The effect results from a fascinating interplay of color, optics, light, and another philosophy.

Duane Hanson, *Artist with Ladder*. Fiberglass and polyester resin hand layed-up in a mold.
Courtesy: O. K. Harris Gallery

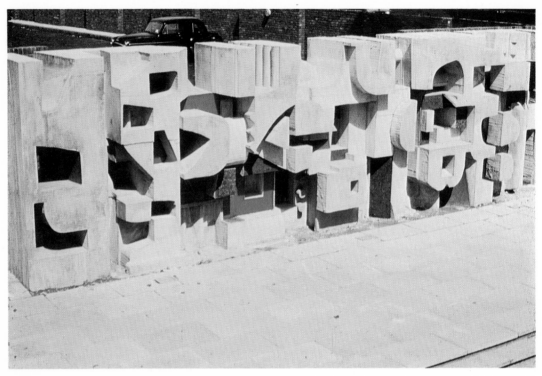

Anthony Hollaway, cement wall cast into polystyrene
molds, Paddington, (England). *Courtesy: Anthony Hollaway*

Lillian Schwartz, *#24.* Runaway acrylic with acrylic find-
ings. *Courtesy: Lillian Schwartz*

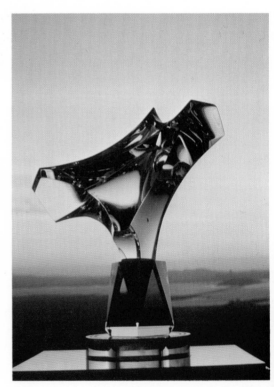

Jacques Schnier, *Award for Neil Armstrong* (1972). Carved
acrylic. *Courtesy: Jacques Schnier*

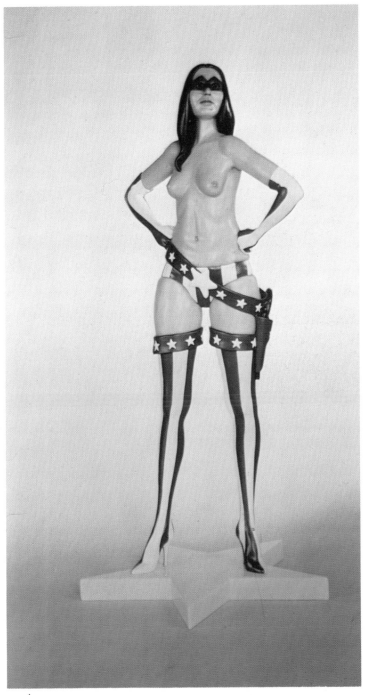

Ralph Massey, *Straight Shooter* (1970, 6′5″). Polychromed fiberglass and
polyester resin. *Courtesy: Ralph Massey*

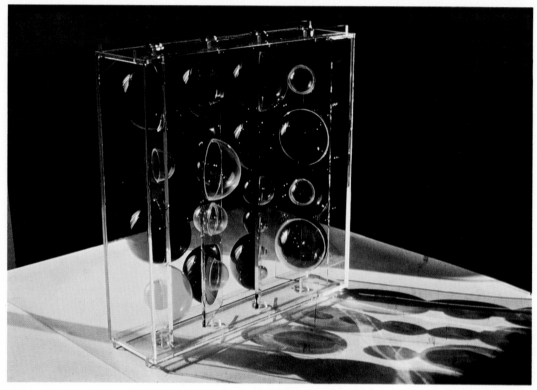

Anthony Hollaway, *Abacus IV*. Multicolored acrylic hemispheres on rotating louvers. *Courtesy: Anthony Hollaway*

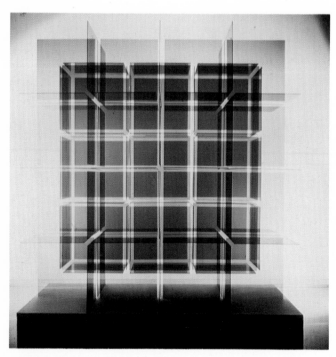

Sobrino. *Espaces Indefines* (1971, 68″ x 68″ x 33½″). Acrylic construction. *Courtesy: Sobrino*

1. Eugene Massin and assistant Julia Busch review architect's plans and elevations, along with scale drawings of the proposed mural.

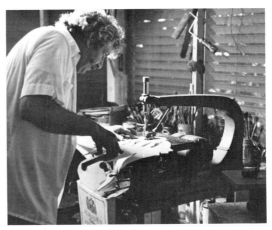

2. The aesthetic concept begins to take form in the studio as he cuts "sketches" from acrylic on a scroll saw into the shapes of men in silhouette.

3. These figures are then mounted into a miniature of the proposed mural, in a model of the bank, much as they will be seen in full scale. This is like a dress rehearsal.

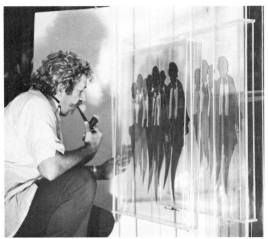

4. A larger model is then constructed in order to determine aspects of light reflection, projection, and experimentation with filters.

6. Or they may be traced onto acrylic . . . and cut on a band saw.

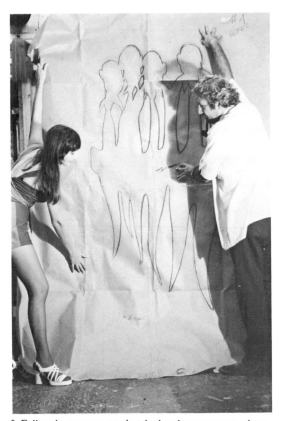

5. Full-scale cartoons are sketched on brown paper, where, at the factory, they will become patterns for acrylic and Masonite templates.

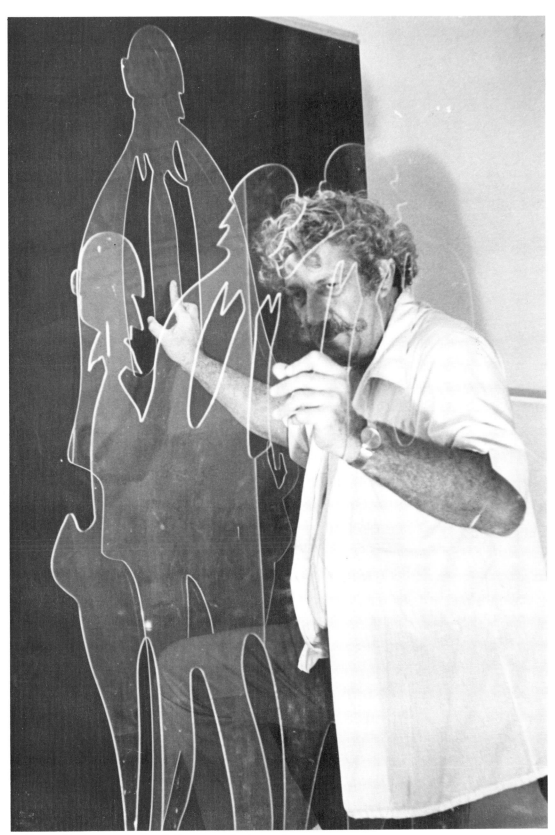

7. Eugene Massin arranging acrylic figures on a background.

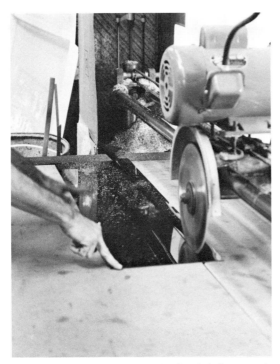

8. While silhouettes and supporting "neckties" are cut in this fashion, the background frames are ripped on a panel saw.

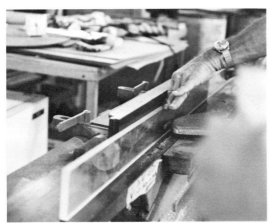

9. Edges are squared on a joiner . . .

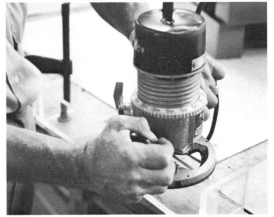

10. . . . and beveled with a router.

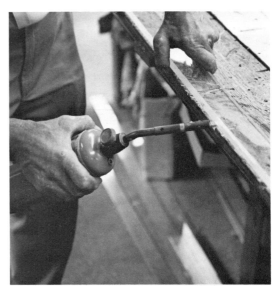

11. Then edges are flame-polished with a propane torch. Then panel parts are bonded with PS 30, packed, shipped, and installed in the bank. Here they are being cleaned.

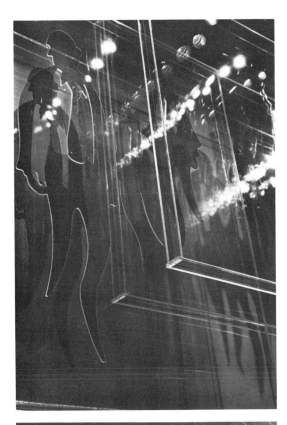

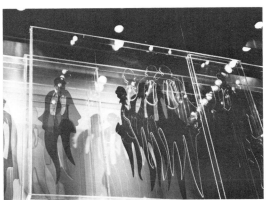

12., 13., and 14. Then comes the sensitive job of adjusting lighting, filters, and focal lengths to edge-light the silhouettes and project colored shadows onto the wall behind the mural. *Courtesy: Julia Busch and Eugene Massin; photographs in series by Shirley Busch*

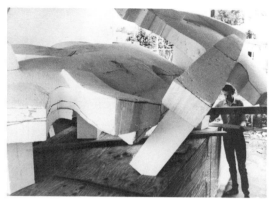

1. Albert Vrana's construction of *The Obelisk:* With hot wire and a two-man timber saw for deep cuts on Dylite (a polystyrene foam), huge elements are taking shape.

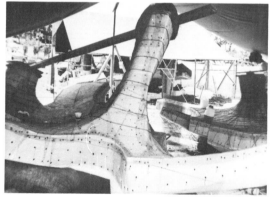

2. Al Vrana is smoothing and shaping the Dylite foam with heavy bird gravel glued to a board.

3. and 4. Under improvised tents, wire mesh is nailed with screw nails to the foam plug or core. Four layers of mesh are added with two layers of 1/8″ steel rods. This is to hold the covering of ferrocement. Epoxy is used to glue up rough forms of foam. A hand saw is used to fit the foam sculpture to a plywood mock-up of the tower. The foam core made it possible to fit the forms on a plywood tower (which was later to become a concrete tower) before the heavier concrete was added. The foam core also holds the mesh and rod cage rigid. Note the nails that hold the mesh in place.

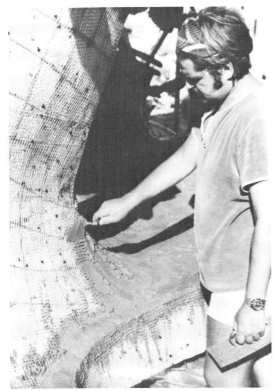

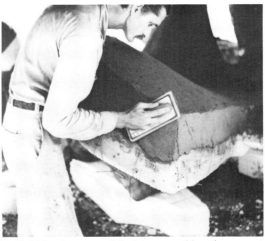

7. Finishing is accomplished by smoothing the cement with a sponge trowel. As many as six helpers were used here. Then forms were turned over and the same operation was started on the other side in mesh, rod, and ferrocement.

5. Ferrocement is troweled and worked into and onto the mesh. *Ferrocement* is a term coined by Professor Pierre Luigi Nervi to describe a thin-section portland cement mortar incorporating a high percentage of reinforcement in the form of multiple layers of light mesh. The product so obtained has a very high degree of elasticity and resistance to cracking and does not normally require the use of formwork, according to Albert Vrana.

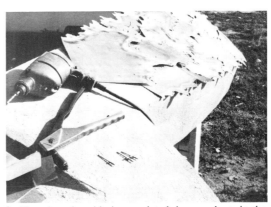

8. After the other side is completed, bronze sheet, in the form of "leaves" is riveted with pop rivets to demarcated areas. A small model was used constantly as a guide.

6. An electric pencil-type of vibrator is used to ensure penetration of the mesh by cement.

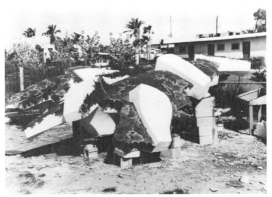

9. Nearly complete, the last coat of concrete, this time a white cement, just for color, is applied.

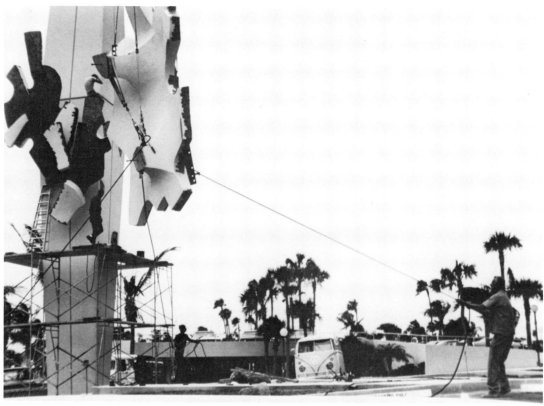

10. Quarter sections of the finished concrete tower are given inserts to receive the legs of the sculpture. These will be bolted and welded to the tower. A 110-foot crane was used to install *The Obelisk* tower on the site. The cement forms with bronze leaves are hoisted into place.

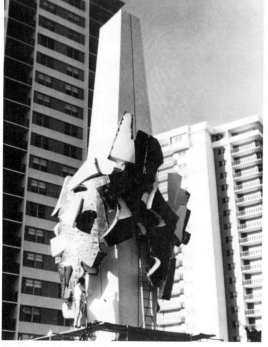

11. The welder and helper weld legs to the tower.

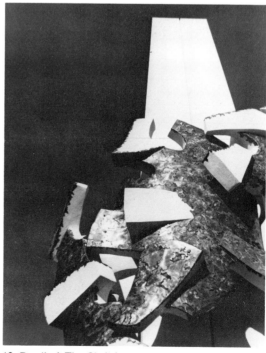

12. Detail of *The Obelisk*.

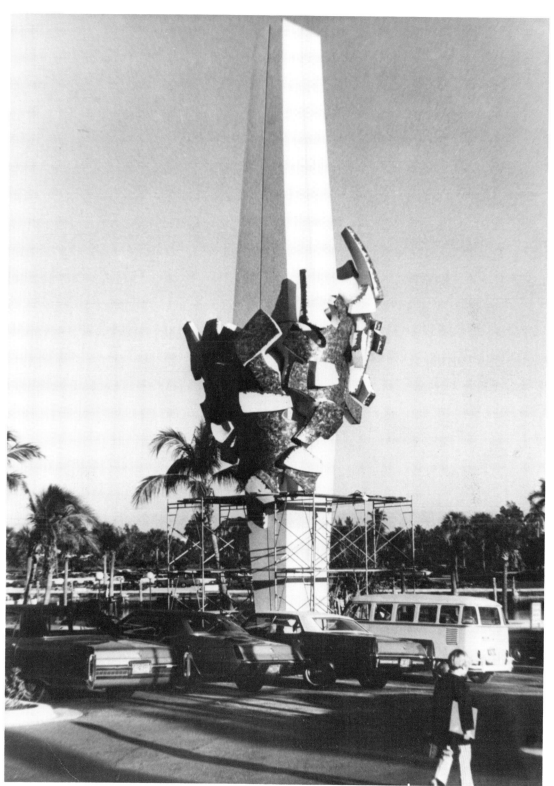

13. The completed *Obelisk* by Albert Vrana is located at Arlen House in Miami Beach, Florida. It consists of eight precast concrete units, 30' each; they form the tower, which is 60' high, 7'6" wide, and weighs 50 tons. Sculptural units are 16' x 10' and are made of Dylite foam covered with reinforced ferrocement. The base of the concrete piling is driven in bedrock. *Courtesy: Albert Vrana; photographs by Ray Fisher*

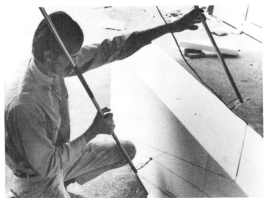

1. Albert Vrana's walls for Florida, International University, general-purpose building "Primera Casa." Abstract geometric patterns were used to fabricate molds of Dyplast. Large pieces are cut with a heated electric wire.

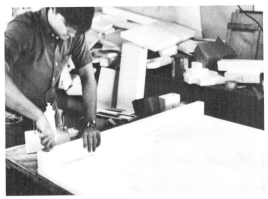

2. Parts are glued together with a white glue to form the Dyplast molds.

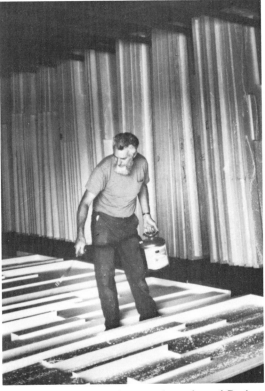

3. Al Vrana is spraying solvent on the surface of Dyplast molds, which results in a pebbled effect when the walls are cast of concrete. Behind the artist are panels in storage.

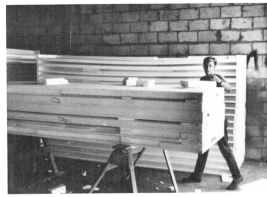

4. Since panels are 12′4″ x 28′ wide, it was impractical to fabricate these in one unit. Marking on the right side of the foam stacked on the sawhorse indicates the number of this panel and that it is composed of six sections. These are bundled and delivered to the building site.

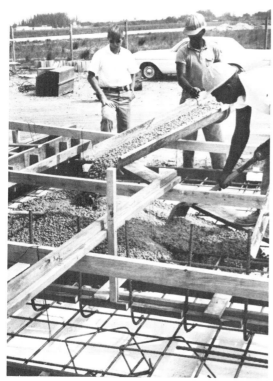

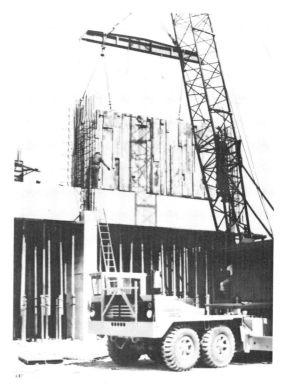

5. Upon delivery, the panels are placed in a perimeter form and reinforcing steel is placed in position (see bottom of photo); then concrete is poured in from transit mix trucks.

7. A panel is hoisted into position. A column is then poured at the end of the panel for support.

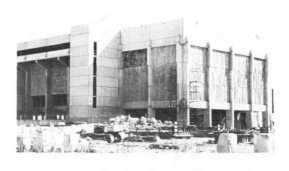

6. In 24 hours, panels are lifted off the casting bed and the foam mold is stripped away. In the stripping operation, a long wedge-shaped piece of wood is used by a cement worker to strip off the foam.

8. A building section showing the sculptured wall panels.

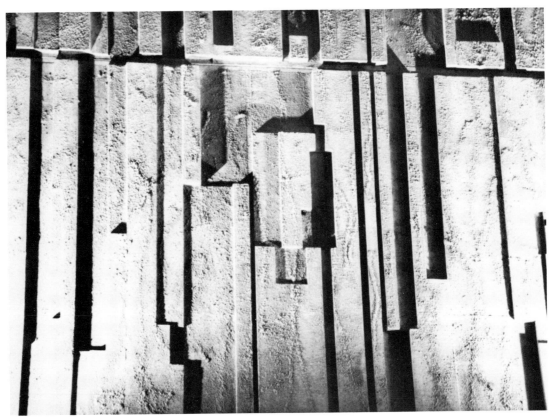

9. A close-up that shows the texture created when solvent
was sprayed onto the Dyplas molds.

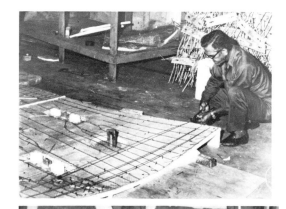

12. A close-up of the spider-like attachment points.

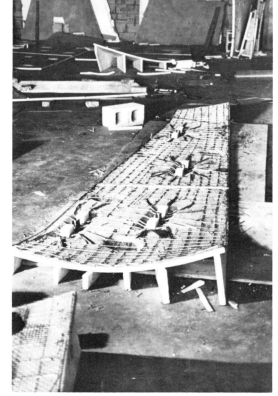

10. and 11. This operation involves the making of a sculptural panel for the building facade. In order to create concave shell-like forms in ferrocement, sheets of Dyplast were bent into the desired shape and tacked to a plywood base, covered with ½″ wire mesh in 6 layers and with layers of ⅛″ reinforcing rod. The spider-like inserts shown are connection points for bronze shapes that will be overlayed on the form and are also anchor points for the ferrocement to be attached to the wall. Rods are attached to the Dyplast forms.

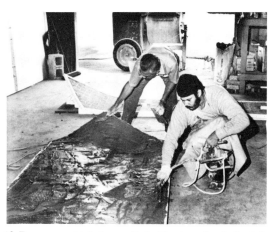

13. Ferrocement is being applied with a trowel and vibrated with a pencil vibrator. Two more sections behind the craftsmen are ready for this step.

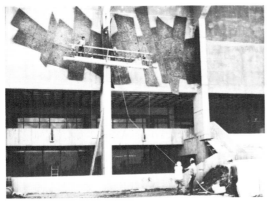

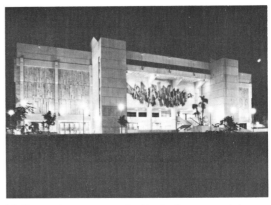

14. Bronze sheets are hammered and bronze rods are puddled onto the hammered bronze. Then, after brazing over iron rods, bronze legs are attached to the pieces for later attachment to the cement. Here the ferrocement forms are being hoisted into place on the wall over the entrance of the building.

15. Bronze shapes are attached to the ferrocement shapes. And the building becomes an integrated whole.

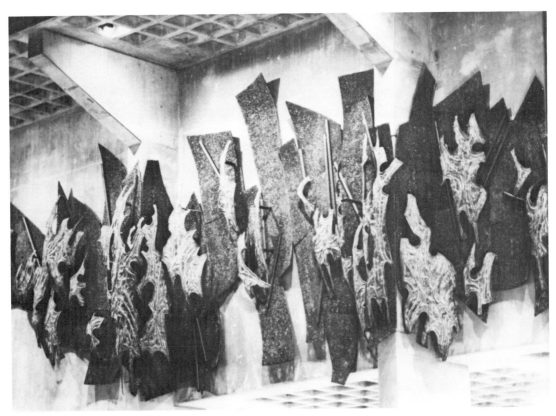

16. A close-up of the facade treatment. *Courtesy: Albert Vrana; photographs by Shirley Busch*

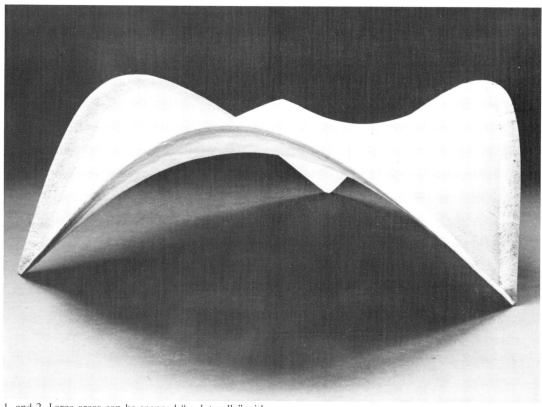

1. and 2. Large areas can be spanned "sculpturally" with
fiberglass skins using hyperbolic paraboloids.

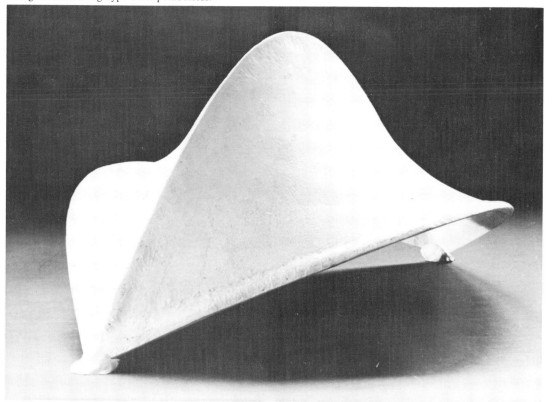

A sculptural model of a future house as single or multiple dwellings in FRP or urethane foam created by Daniel Grataloup. *Courtesy: Daniel Grataloup*

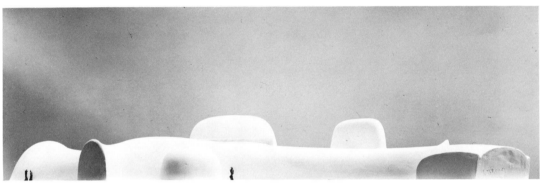

A side view of a model for a sculptural environment, envisioned to surround a park by Italian architect Angelo Mangiarotti. *Courtesy: Angelo Mangiarotti*

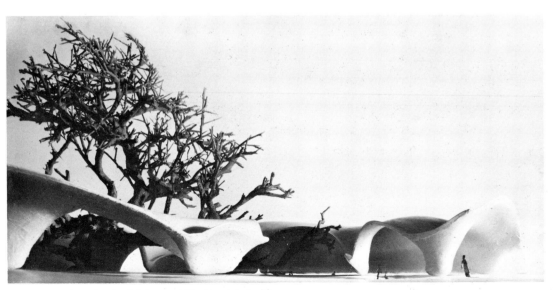

A top view of another model that could be translated with a spray-up of FRP or a spray-up of urethane foam. *Courtesy: Angelo Mangiarotti*

Wendell Castle, Sculpture, no title (1972). Fiberglass and polyester built up in a mold, gel coat finish. *Courtesy: Wendell Castle*

Mary Fish, Untitled (1971, 4' x 4'). RTV silicone, leather, rabbit, and thermoformed acrylic. *Courtesy: Mary Fish*

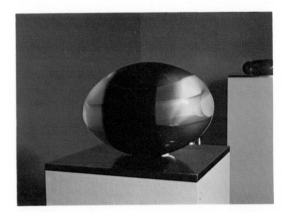

Helen Pashgian, cast polyester with colored acrylic inclusions (1970, 12″ length). *Courtesy: Helen Pashgian*

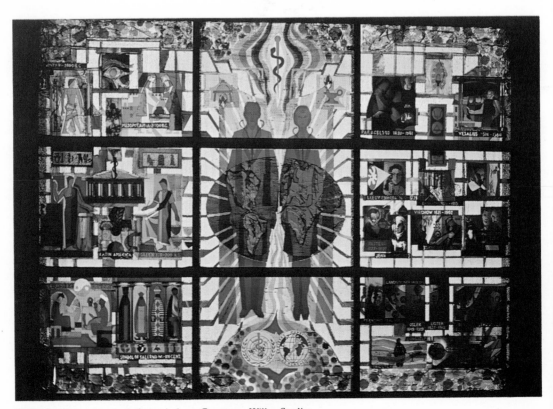

Willet Studios, epoxy and glass window. *Courtesy: Willet Studios*

1. and 2. Huge balloons are blown up to become molds for a spray-up of rigid urethane foam.

3. and 4. Workmen are spraying foam onto the balloon.

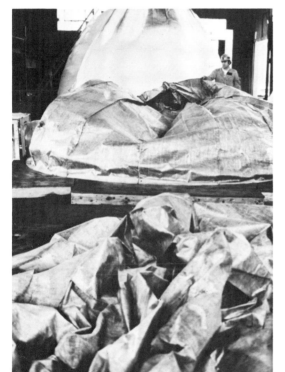

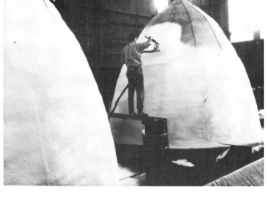

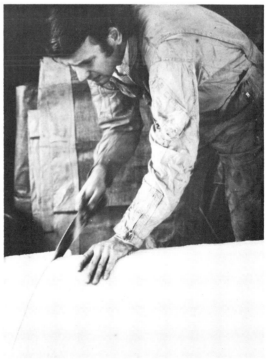

5. Sprayed-up parts are cut with a saw.

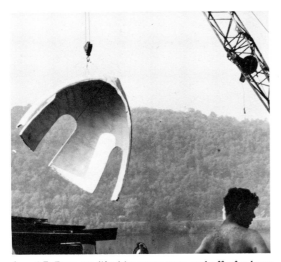

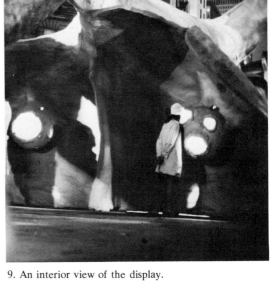

6. and 7. Parts are lifted by crane onto and off of a large and flatbed truck and brought to its site in Pittsburgh.

9. An interior view of the display.

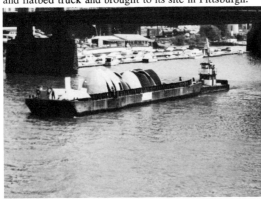

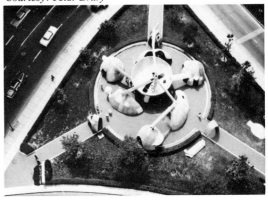

10. and 11. Two other views of Felix Drury's *Three Rivers Project*, an environment created for PPG Industries. *Courtesy: Felix Drury*

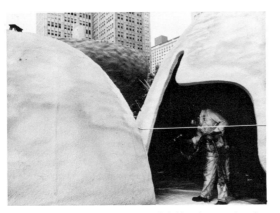

8. There, additional spray-paint finishing is completed as the units are being installed.

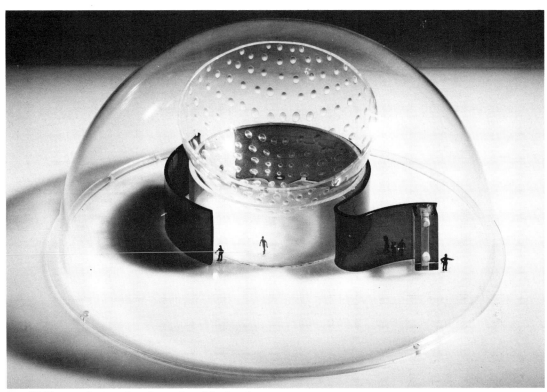

1. and 2. Two acrylic (or polycarbonate) models of environ-
ments by Ugo LaPietra. *Courtesy: Ugo LaPietra*

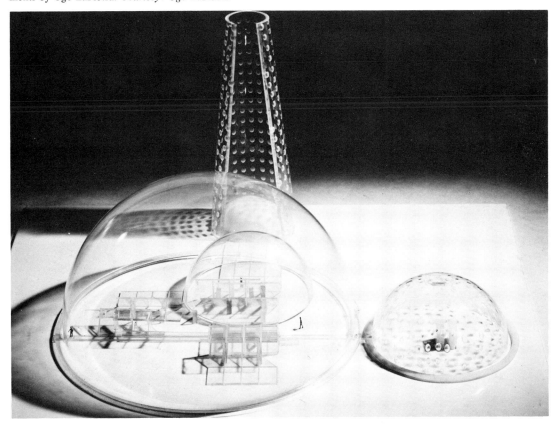

1. and 2. Filament winding can create huge, strong, light-weight forms by winding continuous strands of resin-coated glass filaments on a collapsible mandrel. It is also possible, in this technique, to incorporate strengthening ribs and supports. Size is of no importance. The concept was created by Professor Albert G. H. Dietz of M.I.T. School of Architecture and Planning. *Courtesy: Albert G. H. Dietz*

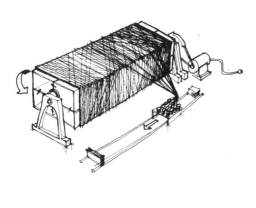

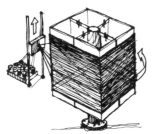

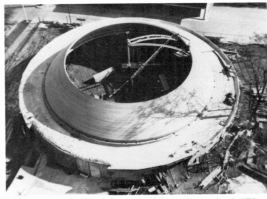

1. and 2. Another possibility developed by Professor Dietz is to create forms by continuous generation of plastic foam. The fast-rising and hardening foam can be pumped into a mixer and transferred to a small mold form at the end of an arm. As the arm rotates, the foam is deposited in a continuous spiraling of the form. A fixed arm generates a sphere as an articulated arm determines various shapes. Hyperbolic paraboloids can be formed by a moving slit running on inclined edge ribs. *Courtesy: Albert G. H. Dietz*

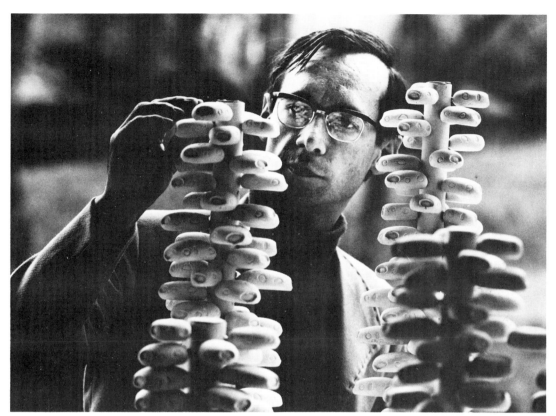

Another design for multiple dwellings as prefabricated plastic pods set on a servicing core. *Courtesy: Daniel Grataloup*

Safety Procedures

I. GENERAL (For Professional Users)

1. "Allergic" people should not handle these materials.

2. Mixing, molding, curing, and tooling should be done in separate areas containing a ventilation hood that does not pull fumes up in front of the user's face, and that is connected to ducts that carry the vapors and dust safely outside the building.

3. Avoid skin contact, exercise caution, and wear protective sleeves, cotton-lined rubber gloves, clean uniforms.

4. Acetone or related solvents should not be used to clean hands. Denatured alcohol is effective, followed by soap and water and then a lanolin hand cream.

5. Tables, machinery, tools, floors, walls, windows should be kept free of fiberglass spicules and resinous dust.

6. Paper towels should be used instead of rags for cleanup.

7. Grinding, sawing, polishing, dulling should be done under ventilated hoods to remove all dust and vapors.

8. Spilled solvents, resins, and catalyst should be washed from site with soap and water.

9. Neutral or acid soaps should be used in preference to alkaline or abrasive cleansers.

10. Water-soluble skin-protective gels which are neutral in their pH offer a moderate auxiliary protection.

11. Protect working areas with disposable paper.

12. Rings and wrist watches should not be worn, since they accumulate chemicals, sweat, and heat, and thus make that skin area more vulnerable.

13. Work clothes should be of closely woven material and should offer complete coverage.

14. Rashes should be considered and attended to immediately.

15. Keep fingernails short and clean.

II. STORAGE AND PROCESSING RULES FOR ORGANIC PEROXIDES

A. STORAGE

1. Organic peroxides should be stored in their original containers. Methyl ethyl ketone (MEK), for instance, comes with a specially vented cap.

2. The same peroxides should be kept together. Care should be taken that they do not spill and mix together or with any other materials.

3. Do not store excessive amounts.

4. Temperature control is important in some cases. Refrigeration, although not always necessary, is a good idea. This would eliminate the dangers of overheating.

5. Always keep peroxides covered.

B. PROCESSING

1. Avoid contamination of peroxides with other materials. In the case of benzoyl peroxide this can be extremely dangerous. Use clean mixing equipment.

2. Never mix a promoter (accelerator) with an initiator or catalyst. This may cause an explosion. If a promoter is to be employed, stir it into the resin well. Then add the catalyst and mix that well, too.

3. Do not permit the catalyst to contact ignition

sources. Do not smoke near a catalyst. Keep catalysts away from excessive heat.

4. Always use the proper amounts of catalyst with the monomer. Excessive amounts of organic peroxide will develop a very high exotherm. This often chars and cracks the product.

5. Be careful of impact and friction. Do not drop a bottle of peroxide. If some spills, wash it away with water, or soak up the peroxide with vermiculite or perlite, a noncombustible material, and then scrub the areas thoroughly.

6. Organic peroxides should not be added to hot materials or be placed in heated equipment. Beware of the opposite. When a peroxide has crystallized because of freezing, let it thaw before handling it. If the liquid has evaporated and crystals remain,

treat it as an explosive. Carry it in a container, not in your bare hands, and discard it carefully.

7. Allow for adequate ventilation.

If an organic peroxide fire should occur, do not use fire extinguishers. Just sprinkle and pour large amounts of water on the fire. If it is a fire that can reach large quantities of organic peroxides, evacuate the building.

Actually, over five million pounds of organic peroxides are used annually. Many handlers are nonchemists, as well. There are few accidents. However, the potential hazards should always be kept in mind and the material should be treated with the prescribed caution.

Sources
of Supply

Alphabetical Listing
by Company Name,
with Categories

This is by far an incomplete list of supply sources; it is only an attempt to sample sources. A more complete list may be found in the yearly issues of the *Modern Plastics Encyclopedia.*

AAA Saw & Tool Service and Supply Co. *(machines and accessories)*

ACE Drill Corp. *(machines and accessories)*

Ace Glass Inc. *(machines and accessories)*

Ace Plastic Co. *(plastic findings)*

Adhesive Products Corp. *(miscellaneous)*

Adjustable Clamp Co. *(machines and accessories)*

Ain Plastics *(general complete-line plastics supplier; resins and sheeting)*

Ajinomoto Co. of N.Y. Inc. *(catalysts)*

Alcan Metal Powders *(color)*

American Acrylic Corp. *(general complete-line plastics supplier)*

American Cyanamid Co. *(resins and sheeting)*

American Hoechst Corp. *(color)*

American Pyroxylin Corp. *(resins and sheeting)*

Americana Rotary Tool Company *(machines and accessories)*

Applied Synthetics Corp. *(films)*

Ashland Chemical Co. *(resins and sheeting)*

Atlas Minerals and Chemicals Division, ESB Inc. *(plastic putties; resins and sheeting)*

A-T-Hyde Co. *(resins and sheeting)*

Ayerst Laboratories *(miscellaneous)*

BASF Corp. *(color)*

The Biggs Company *(machines and accessories)*

Blue M Electric Co. *(machines and accessories)*

Borden Chemical Co. *(miscellaneous; resins and sheeting)*

Brown Paper Co. *(release agents)*

Brulin & Co. *(release agents)*

Burlington Glass Fabrics *(fillers and reinforcements)*

The Butcher Polish Co. *(plastic polishes and compounds)*

Cabot Corp. *(fillers and reinforcements)*

Cadillac Plastics and Chemical Co. *(general complete-line plastic supplier)*

California Titan Products *(resins and sheeting)*

Canadian Johns-Manville Asbestos Ltd. *(fillers and reinforcements)*

Carborundum Co. *(plastic polishes and compounds)*

Celanese Plastics Co. *(mold materials)*

Chemical Products Co. *(plastic polishes and compounds)*

Chempico Pigments and Dispersions Co. *(color)*

Chem-Trend Inc. *(release agents)*

Cincinnati Milackron Chemicals, Inc. *(promoters)*

Coating Products *(films)*

Columbia Cement Company *(adhesives)*

Crompton & Knowles Corp. *(color)*

Deep Flex Plastic Molds, Inc. *(resins and sheeting)*

De-Sta-Co. Division, Dover Corp. *(machines and accessories)*

Devcon Corp. *(plastic putties)*

Dexter Corp. *(release agents)*

Diamond Alkali Co. *(fillers and reinforcements)*

Diamond Shamrock Chemical Co. *(resins and sheeting)*

The Diffraction Co., Inc. *(diffraction gratings; miscellaneous)*

Ditzler Automotive Finishes *(color)*

DoAll Co. *(machines and accessories)*

Dow Chemical Co. *(resins and sheeting)*

Dow Corning *(release agents)*

Du Pont de Nemours & Co., Inc. *(fillers and reinforcements; films)*

Dymo Products Co. *(machines and accessories)*

Eastman Chemical Products, Inc. *(adhesives)*

Edmont-Wilson Division, Becton, Dickinson & Co. *(safety gloves; miscellaneous)*

Electric Hotpack Company, Inc. *(machines and accessories)*

Essex Chemical *(resins and sheeting)*

Fasson Products *(adhesives)*

Ferro Composites *(films)*

Ferro Corp. *(color; fillers and reinforcements)*

Phillip Fishman *(machines and accessories)*

Forrest Mfg. Co., Inc. *(machines and accessories)*

Geigy Chemical Corp. *(additives)*

General Aniline and Film Corp. *(additives)*

General Electric Co. *(release agents; machines and accessories; resins and sheeting)*

General Tire Chemical *(resins and sheeting)*

N. Glantz and Sons *(neon; miscellaneous)*

B. F. Goodrich *(resins and sheeting)*·

The Grieve Corp. *(machines and acessories)*

Guard Coating and Chemical Corp. *(adhesives)*

Guardsman Chemical Coatings *(release agents)*

H & H Paint and Lacquer Co., Inc. *(color; plastic putties)*

Hastings Plastics, Inc. *(plastic findings)*

Henley & Company, Inc. *(fillers and reinforcements)*

Henry L. Hanson Co. *(machines and accessories)*

R. M. Hollingshead Corp. *(resins and sheeting)*

Holophane Co. *(plastic findings)*

Hooker Chemical Corp. *(resins and sheeting)*

Hydrotherme Corp. *(machines and accessories)*

Hyprez Diamond Compounds *(plastic polishes and compounds)*

ICI America, Inc. *(adhesives)*

Imperial Chemicals Industries, Ltd. *(resins and sheeting)*

Indopol *(adhesives)*

Industrial Plastics *(general complete-line plastics supplier; plastic findings; resins and sheeting)*

Interchemical Corp. *(color; fillers and reinforcements)*

International Dioxide Inc. *(additives)*

Jefferson Chemical Co., Inc. *(catalysts)*

Jiffy Mixer Co., Inc. *(machines and accessories)*

Johnson Wax *(release agents)*

Kendall Co. *(fillers and reinforcements)*

Lea Mfg. Co. *(plastic polishes and compounds)*

Le Brecht Machine Co., Inc. *(machines and accessories)*

Lehigh Metal Products Corp. *(machines and accessories)*

Lucidol Division, Wallace and Tiernan, Inc. *(catalysts)*

Lunzer Industrial Diamonds, Inc. *(miscellaneous)*

John W. McNabb Laboratories *(resins and sheeting)*

M & T Chemicals, Inc. *(plastic polishes and compounds; resins and sheeting)*

Marblette Corp. *(resins and sheeting)*

Matchless Metal Polish Co. *(plastic polishes and compounds)*

Micro-Surface Finishing Products, Inc. *(plastic polishes and compounds)*

Miller-Stephenson Chemical Co., Inc. *(release agents)*

Mirro-Brite Coating Products, Inc. *(films)*

Mirror Bright Polish Co. *(plastic polishes and compounds)*

Model Craft Hobbies *(general complete-line plastics supplier)*

Mohawk Fabric Co., Inc. *(fillers and reinforcements)*

National Solvent Corp. *(color; solvents)*

Norton Company *(plastic polishes and compounds)*

O'Neil-Irwin Mfg. Co. *(machines and accessories)*

Orange Products, Inc. *(plastic findings)*

Paper Corp. of America *(release agents)*

Park Chemical Co. *(plastic polishes and compounds)*

Patent Chemical, Inc. *(color)*

Pittsburgh Plate Glass Co. *(fillers and reinforcements)*

Plastic Molders Supply Co., Inc. *(color)*

Plastic-Vac, Inc. *(machines and accessories)*

Poly-Dec Company, Inc. *(plastic pellets and tiles)*

Polyform Products, Inc. *(plastic putties)*

Potters Bros., Inc. *(color)*

PPG Industries, Inc. *(color; resins and sheeting)*

Price Driscoll Corp. *(release agents)*

PSH Industries *(machines and accessories)*

Pylam Products Co., Inc. *(color)*

Randolph Chemical *(release agents)*

Reichhold Chemicals Inc. *(catalysts; resins and sheeting)*

Reliance Universal, Inc. *(color)*

Ren Plastics *(resins and sheeting)*

Reynolds Metals Co. *(release agents)*

Rezolin Division, Hexcel Corporation *(adhesives)*

Rockland Dental Co., Inc. *(plastic polishes and compound; abrasive papers)*

Rohm and Haas Company *(resins and sheeting)*

Sax Arts & Crafts *(machines and accessories)*

Schwartz Chemical Co., Inc. *(adhesives; antistatic solutions; color)*

Science Related Materials *(machines and accessories)*

Sculpmetal Co. *(plastic putties)*

Seymour of Sycamore, Inc. *(resins and sheeting)*

Shell Oil Co. *(plastic powders, pellets and tiles; resins and sheeting; solvents)*

Simonds Saw Division *(machines and accessories)*

Smooth-On, Inc. *(mold materials; release agents)*

J. L. N. Smythe Co. *(miscellaneous; protective masking)*

Spencer-Lemaire Industries, Ltd. *(machines and accessories)*

Spraylat Corp. *(color; miscellaneous)*

Standard Plastics Co., Inc. *(plastic findings)*

Studio Plastique *(resins and sheeting)*

Taylor and Art Plastics *(resins and sheeting)*

3M Company *(adhesives; miscellaneous; films; plastic polishes and compounds)*

Tizon Chemical Company *(plastic polishes and compounds)*

Tra-Con, Inc. *(adhesives; resins and sheeting)*

Transene Co., Inc. *(mold materials)*

Union Carbide Corp. *(resins and sheeting)*

United Laboratories *(plastic polishes and compounds)*

U.S. Borax & Chemical Corp. *(additives)*

Valspar Corp. *(resins and sheeting)*

Velsicol Chemical Corp. *(additives; plasticizers)*

Western Fibrous Glass Products *(fillers and reinforcements)*

Witco Chemical *(miscellaneous; mineral oil)*

Woodhill Chemical Co. *(plastic putties; resins and sheeting)*

World of Plastics *(general complete-line plastic supplier; resins and sheeting)*

ACCELERATORS *(see "Promoters")*

ADDITIVES

Geigy Chemical Corp.
Saw Mill River Road
Ardsley, N.Y. 10502

Ultraviolet light stabilizer
Tinuvin P

General Aniline and Film Corp.
435 Hudson Street
New York, N.Y. 10014

Univul

International Dioxide, Inc.
518 5th Avenue
New York, N.Y. 10036

Destroys resin ordors by oxidation
Anthuim Dioxide powder

U.S. Borax & Chemical Corp.
3075 Wilshire Boulevard
Los Angeles, Calif. 90005

Flame-retardant additive for polyester resins
Firebrake ZB

Velsicol Chemical Corp.
341 E. Ohio Street
Chicago, Ill. 60611

A flexibilizer for polyester resin
Benzoflex 9-88

ADHESIVES

Columbia Cement Company
159 Hanse
Freeport, N.Y. 11520

Quik Stik®, rubber cement for urethane foam

Eastman Chemical Products, Inc.
Chemicals Division
Kingsport, Tenn. 37662

Eastman #910 and activator, glues almost anything,
water-white, very strong

Fasson Products
250 Chester Street
Painesville, Ohio 44077

Clear cold mounting double-faced tape
#333

Guard Coating and Chemical Corp.
58 John Jay Avenue
Kearney, N.J. 07032

Adhesive cements for: acrylics, butyrates, Mylars, nylons, cellophane, acetates, styrenes, PVA's, PVC's, epoxies, polyesters, cellulose

ICI America, Inc.
151 South Street
Stamford, Conn. 06901

A two-part acrylic monomer/polymer cured with a peroxide catalyst. A good adhesive for acrylic and for making small castings
Tensol Cement 7

Indopol
8434 Rochester Avenue
Cucamonga, Calif. 91730

A-3000 urethane adhesive. Flexible, waterproof, sticks to almost anything. Comes in a tube

Rezolin Division of
Hexcel Corporation
20701 Nordhoff Street
Chatsworth, Calif. 91311

Uralite Elastomeric Adhesives, for polycarbonates, ABS, polysulfones, reinforced fiberglass, polyester, epoxy acrylic, aluminum, and steel

Schwartz Chemical Co., Inc.
50–01 Second Street
Long Island City, N.Y. 11101

A clear water-white rapid-bonding adhesive for nonabsorbent materials—an alpha cyanoacrylate called Permabond®

3M Company
135 W. 50th Street
New York, N.Y. 10020

3M adhesive for polystyrene foam or polyurethane foam
EC-2296

Tra-Con, Inc.
55 North Street
Medford, Mass. 02155

Clear, water-white epoxy adhesive in a Bipax container
Tra-Con Bipax®

ANTISTATIC SOLUTIONS

Schwartz Chemical Co., Inc.
50–01 Second Street
Long Island City, N.Y. 11101

Antistatic agent for acrylic and polycarbonate based on a quaternary ammonium chloride compound
Rez-N-Kleen®
Also in a polish—Rez-N-Polish®

CATALYSTS

Ajinomoto Co. of N.Y. Inc.
745 Fifth Avenue
New York, N.Y. 10022

Room-temperature-curing epoxy curing agent
Ajicure- B-003, N-001

Jefferson Chemical Co., Inc.
P.O. Box 53300
Houston, Tex. 77052

Epoxy catalyst
Jeffamine® D-230 or D-400
(see "Promoters")

Lucidol Division
Wallace and Tiernan Inc.
1740 Military Road
Buffalo, N.Y. 14217

MEK Peroxide, et cetera

Reichhold Chemicals Inc.
RCI Building
White Plains, N.Y. 10602

MEK Peroxide, et cetera

COLOR

Alcan Metal Powders
P.O. Box 290
Elizabeth, N.J. 07207

Metal powders in aluminum, bronze, copper, lead, et cetera

American Hoechst Corp.
Carbic Color Division
270 Sheffield Street
Mountainside, N.J. 07092

Dry color, polyester paste and liquid dispersions

BASF Corp.

Chempico Pigments and Dispersions Co.
P.O. Box 203
South Orange, N.J. 07079

Polyester color pastes, transparent to opaque

Crompton & Knowles Corp.

Ditzler Automotive Finishes
Detroit, Mich. 48204

Acrylic lacquer for spray coating finished forms

Ferro Corp.
Color Division
Cleveland, Ohio 44105

Dry color, polyester paste and liquid dispersions

H & H Paint and Lacquer Co., Inc.
64 Spencer Street
Rochester, N.Y. 14608

Wholesale and retail autobody lacquers and finishes

Interchemical Corp.

National Solvent Corp.
3751 Jennings Road
Cleveland, Ohio 44109

TUF, transparent urethane finish

Patent Chemical, Inc.
335 McLean Boulevard
Paterson, N.J. 07504

Dry color, polyester paste and liquid dispersions

Plastic Molders Supply Co., Inc.
75 South Avenue
Fanwood, N.J. 07023

Potent freeze-dried colorants for styrene, polyethylene, polypropylene, ABS

Potters Bros., Inc.
Industrial Road
Carlstadt, N.J. 07070

Colored powdered glass filler

PPG Industries, Inc.
One Gateway Center
Pittsburgh, Pa. 15222

Durethane 600 Elastomeric lacquer and Durethane 100 Elastomeric thermosetting enamel, both for use over urethane foam

Pylam Products Co., Inc.
95-10 218th Street
Queens Village, N.Y. 11429

Dyes (acetamine) for acrylics

Reliance Universal, Inc.
Progress and Prospect Streets
High Point, N.C. 27260

Toners, stains, glazes, top coats

Schwartz Chemical Co., Inc.
50-01 Second Street
Long Island City, N.Y. 11101

Transparent lacquers and dip dyes for acrylics
Rez-N-Lac MM®

Spraylat Corp.
1 Park Avenue
New York, N.Y. 10016

Lacryl acrylic paint. Can be used with a removable masking material — Sign Strip

FILLERS AND REINFORCEMENTS

Fillers

Cabot Corp. 125 High Street Boston, Mass. 02110	Thixotropic filler Cab-O-Sil®
Canadian Johns-Manville Asbestos Ltd. P.O. Box 1500 Asbestos, Quebec, Canada	Various grades of powdered asbestos
Diamond Alkali Co. 300 Union Commerce Building Cleveland, Ohio 44115	Calcium carbonate
Henley & Company, Inc. 202 E. 44th Street New York, N.Y. 10017	Thixotropic filler Ultrasil® VN-3
Interchemical Corp. Finishes Division 1255 Broad Street Clifton, N.J. 07013	Thixotropic filler Thixogel®

Reinforcements

Burlington Glass Fabrics 1450 Broadway New York, N.Y. 10018	Fiberglass
E. I. du Pont de Nemours & Co., Inc. Old Hickory Plant Nashville, Tenn. 37211	Polyester fabrics Reemay®
Ferro Corp. Fiber Glass Division 200 Fiber Glass Road Nashville, Tenn. 37211	Fiberglass
Kendall Co. 95 West Street Walpole, Mass. 02081	Reinforcing material for use with polyester and epoxy Webril® non-woven Dynel® fabrics grades EM 470, M1410 and M1450
Mohawk Fabric Co., Inc. 96 Guy Park Avenue Amsterdam, N.Y. 12010	Reinforcing material for plastics and RTV silicone molds Dacron mesh
Pittsburgh Plate Glass Co. Fiberglass Division One Gateway Center Pittsburgh, Pa. 15222	Fiberglass
Western Fibrous Glass Products 739 Bryant Street San Francisco, Calif. 94107	Fiberglass

FILMS

Applied Synthetics Corp. 59th and Industrial Avenue East St. Louis, Ill. 62204	Syncel®, cotton-Dacron flocked on a film not unlike polyethylene

Coating Products
326 South Street
New Britain, Conn. 06051

Adhesive stock silver sheets #002

E. I. du Pont de Nemours & Co., Inc.
Wilmington, Del. 19898

Mylar polyester film and Tedlar® vinyl fluoride film

Ferro Composites
34 Smith Street
Norwalk, Conn. 06852

Cordoglas®, vinyl-coated fiberglass used in air-supported and frame-supported structures

Mirro-Brite Coating Products, Inc.
580 Sylvan Avenue
Englewood Cliffs, N.J. 07632

Chrome and gold Mylar-vinyl with adhesive, and .0075 gauge acetate with adhesive; comes in silver, different patterns and thicknesses

3M Company
Reflective Products Division
15 Henderson Drive
West Caldwell, N.J. 07006

Chrome polyester film, #530, with adhesive back, in roll or sheets

GENERAL COMPLETE-LINE PLASTICS SUPPLIERS

Ain Plastics
65 Fourth Avenue
New York, N.Y. 10003

A wide range of sheets, resins, and plastic findings

American Acrylic Corp.
173 Marine Street
Farmingdale, N.Y. 11735

Cadillac Plastics and Chemical Co.
15841 Second Avenue, P.O. Box 810
Detroit, Mich. 48232

Polyester resin, Plexiglas acrylic, and an assortment of many other plastic products, available throughout North America

Industrial Plastics
324 Canal Street
New York, N.Y. 10013

A jobber of a complete range of plastic resins and findings as well as blow-molded acrylic domes in various dimensions

Model Craft Hobbies
314 Fifth Avenue
New York, N.Y. 10001

Polyester resin, molds, and various related findings

World of Plastics
771 Edgar Road, Route 1
Elizabeth, N.J. 07202

MACHINES AND ACCESSORIES

Cutters

Le Brecht Machine Co., Inc.
12-90 Plaza Road
Fair Lawn, N.J. 07410

Machines for cutting flexible foams

Science Related Materials
Box 1422
Jonesville, Wis. 53545

Hot-wire cutter for rigid foams

Drill Bits

AAA Saw & Tool Service and Supply Co.
1401-07 Washington Boulevard
Chicago, Ill. 60607

Router bits and wheel brushes

ACE Drill Corp. Adrian, Mich. 49221	Ace-type "M" drills with polished flutes, slow spiral drills
Americana Rotary Tool Company 44 Whitehall Street New York, N.Y. 10004	Router bits
Henry L. Hanson Co. 25 Union Street Worcester, Mass. 01608	High-speed drills for acrylic, developed by Rohm and Haas Company
Lehigh Metal Products Corp. 134 Alewife Brook Parkway Cambridge, Mass. 02240	Self-tapping screws: Parker-Kalon-type "F" tapping screws, and Shakeproof Type 23 and Type 25 thread-cutting

Heat Gun (See under "Reusable Syringes for Applying Adhesives, Ace Glass Inc., Dura-Vac #1800 Desiccator")

Mixers

Jiffy Mixer Co., Inc. 515 Market Street San Francisco, Calif. 94105	All-purpose mixers for drills: models P and PS and larger, model HS for smaller quantities; does not suck in air or splash
PSH Industries 3713 Grand Boulevard Brookfield, Ill. 60513	Mixers for blending resins Gyro-Plastic® mixers

Ovens

Blue M Electric Co.
Blue Island, Ill. 60406

The Grieve Corp.
509 Hart Road
Round Lake, Ill. 60073

Saw Blades

DoAll Co. 254 N. Laurel Avenue Des Plaines, Ill. 60016	Band saw blades: Dart-Precision® with raker set
Forrest Mfg. Co. Inc. P.O. Box 189 Rutherford, N.J. 07070	Carbide-tipped saws, groovers, and cutters
Simonds Saw Division Fitchburg, Mass. 01420	Circular saw blades in high-speed steel and carbide tipped

Spring and Toggle Clamps

Adjustable Clamp Co.
417 N. Ashland Avenue
Chicago, Ill. 60622

De-Sta-Co. Division
Dover Corp.
350 Midland Avenue
Detroit, Mich. 48203

Strip Heaters

Electric Hotpack Company, Inc.
5083 Cottman Street
Philadelphia, Pa. 19135

General Electric Co. Calrod® heaters
1 Progress Road
Shelbyville, Ind. 46176

Hydrotherme Corp. Plastiheater®
7155 Airport Highway
Pennsauken, N.J. 08109

Syringes for Applying Adhesives, Reusable

Ace Glass Inc. Dura-Vac #1800 Desiccator
1430 Northwest Boulevard
Vineland, N.J. 08360

Box 996 #2074 Heat Gun Master
Louisville, Ky. 40201

54 Mood Street
Ludlow, Mass. 01056

The Biggs Company Reusable polyethylene syringes with removable tips
1547 Fourteenth Street
Santa Monica, Calif. 90404

Phillip Fishman Full line of syringes
7 Cameron Street
Wellesley, Mass. 02181

Vacuum Forming Machines

Dymo Products Co. Dymo-form
P.O. Box 1030
Berkeley, Calif. 94701

O'Neil-Irwin Mfg. Co. Di Arco Plastic Press
Lake City, Minn. 55041

Plasti-Vac, Inc.
1901 N. Davidson Street
Charlotte, N.C. 28205

Sax Arts & Crafts A low-cost vacuum-forming machine, 18″ x 24″
207 N. Milwaukee Street
Milwaukee, Wis. 53202

Spencer-Lemaire Industries, Ltd.
Edmonton, Alberta, Canada

MISCELLANEOUS

Adhesive Products Corp. A two-part polyester-type buttering plastic
1660 Boone Avenue DA Monzini or 4520 Monzini
Bronx, N.Y. 10460 Lumizini with 3254 hardener

Ayerst Laboratories Kerocleanse®, hand cleaner for removing resin
Department A from hands
685 Third Avenue Kerodex® #71 blocks skin against irritants, corro-
New York, N.Y. 10017 sives, or allergenic compounds; does not wash off
 but wears off with skin; should not be put on irri-
 tated tissue

Borden Chemical Co. Masks, sealants, and tapes
360 Madison Avenue Mystik®, clear Mylar tape, #8063, tear-resistant
New York, N.Y. 10017

The Diffraction Co. Inc.
Riderwood, Md. 21139

Iridescent Diffraction
Foil patterns with or without adhesive backing

Edmont-Wilson Division
Becton, Dickinson & Co.
Coshocton, Ohio 43812

Gloves for hand safety for use with epoxy, polyester,
et cetera
Tan Rubber #26-671

N. Glantz and Sons
437 Central Avenue
Newark, N.J. 07107

Neon
All parts and materials for making neon signs; trans-
formers, paint, plastic sheeting, et cetera

Lunzer Industrial Diamonds, Inc.
48 W. 48th Street
New York, N.Y. 10036

Etching tool for acrylic, polycarbonate
Lunzer's Lancer Scriber® 90°

J. L. N. Smythe Co.
1300 W. Lehigh Avenue
Philadelphia, Pa. 19132

Clearmask®

Spraylat
1 Park Avenue
New York, N.Y. 10016

Spraylat® is a latex that is water-soluble and can
be brushed on to protect acrylic while one is work-
ing on it. It takes 45 min. to dry after applying; when
dry, it can be peeled off like paper

3M Company
St. Paul, Minn. 55101

Masking paper, No. 343 and No. 344
"Scotch" protective tape

Witco Chemical
Sonneborn Division
277 Park Avenue
New York, N.Y. 10017

White mineral oils, can be used for filling shells of
acrylic to give appearance of a solid

MOLD MATERIALS

Celanese Plastics Co.
290 Ferry Street
Newark, N.J. 07105

Cellulose acetate film for making molds
Sheet S-704 GG finish

Smooth-On, Inc.
1000 Valley Road
Gillette, N.J. 07933

Polysulphide rubber flexible mold compound
FMC, FMC 301, FMC 100, 200, and 201
Urethane flexible mold compound PMC-709 and
704

Transene Co., Inc.
Route 1
Rowley, Mass. 01969

Silicast®, silicone elastomer systems: Silicast
10—for epoxy; Silicast 20—for polyester; Silicast
30—for polyurethane

PLASTIC FINDINGS

Ace Plastic Co.
91–30 Van Wyck Expressway
Jamaica, N.Y. 11435

Acrylic balls, rods, and tubes

Hastings Plastics, Inc.
1704 Colorado Avenue
Santa Monica, Calif. 90404

Full gamut of plastic supplies, from release agents
to Mylar film to resins

Holophane Co.
Edison, N.J. 08817

Acrylic prismatic lenses

Industrial Plastics
324 Canal Street
New York, N.Y. 10013

Full range of plastic resins, sheets, findings, and
supplies

Orange Products, Inc.
Passaic Avenue
Chatham, N.J. 07928

Solid precision-ground acrylic balls from ⅛″ to 1½″ in diameter

Standard Plastics Co., Inc.
Attleboro, Mass. 02703

Acrylic half domes

PLASTIC POLISHES AND COMPOUNDS

The Butcher Polish Co.
Boston, Mass. 02148

Polishing compounds and wheels
Butcher's white diamond wax

Carborundum Co.
Niagara Falls, N.Y. 14302

Sandpapers and sanding belts—fast-cut, wet-or-dry, silicon-carbide cloth sanding belts

Chemical Products Co.
3014 N. 24th Street
Omaha, Neb. 68110

Antistatic cleaners and polishes
Kleenmaster Brillianize®

Hyprez Diamond Compounds
Engis Corp.
8035 N. Austin Avenue
Morton Grove, Ill. 60053

Full range of diamond-based polishing compounds and polishing cloths

Lea Mfg. Co.
E. Aurora Street
Waterbury, Conn. 06720

Muslin buffs. Coarse, fast-cutting compound: Learok #765, #857. Medium cutting, medium finish: Learok #155, #884

M & T Chemicals, Inc.
Rahway, N.J. 07065

Muslin buffs. Coarse, fast-cutting compound: Bobbing compound. Medium cutting, medium finish: M & T #PC-52

Matchless Metal Polish Co.
Glen Ridge, N.J. 07028

Domet flannel buffs, with one row of sewing. Coarse, fast-cutting compound: Matchless #327 and #962. Medium cutting, medium finish: Tripoli #114, Triple XXX Diamond

Micro-Surface Finishing Products Inc.
Box 456
Wilton, Iowa 52778

Polysand cushioned abrasives—for a very fine finish

Mirror Bright Polish Co.
P.O. Box CT
Irvine, Calif. 92664

Mirror Glaze Cleaner®

Norton Company
Coated Abrasive Division
Troy, N.Y. 12181

Tufbak-Durite®, wet-or-dry, abrasive paper

Park Chemical Co.
8074 Military Avenue
Detroit, Mich. 48204

For fiberglass molds and chairs: fast-cut hand compound #711 Gray (concentrate)

Rockland Dental Co., Inc.
S.E. Cor. 21st and Clearfield Streets
Philadelphia, Pa. 19132

Flex-i-Grit, aluminum-oxide-coated Mylar abrasive

3M Company
St. Paul, Minn. 55101

Three-M-ite® Resin-Bond cloth belts, aluminum oxide sanding belts, grit sizes 80 and 100, for dry sanding only
Wet-or-dry Tri-M-ite paper

Tizon Chemical Company
Flemington, N.J. 08822

Lustrox, Plastic Grade, a submicron-size zircon polishing compound

United Laboratories
E. Linden Avenue
Linden, N.J. 07036

Muslin buffs. Coarse, fast-cutting compound: Plascor® #205, #215. Medium cutting, medium finish: Plascor #708, #726

PLASTIC POWDERS, PELLETS, AND TILES (FUSABLE)

Poly-Dec Company, Inc.
P.O. Box 541
Bayonne, N.J. 07002

Poly-Mosaic® tiles, versatile heat-fusable, gluable, ¾″ square tiles, transparent in stained glass colors

Shell Oil Co.
Plastics Division
110 W. 51st Street
New York, N.Y. 10020

Polystyrene pellets

PLASTIC PUTTIES

Atlas Minerals and Chemicals Division
ESB Inc.
Mertztown, Pa. 19539

Two-part claylike epoxy putty-adhesive in various colors

Devcon Corp.
Danvers, Mass. 01923

Plastic steel and epoxy bond

H & H Paint and Lacquer Co., Inc.
64 Spencer Street
Rochester, N.Y. 14608

Plastic auto body putty

Polyform Products Inc.
9420 Byron Street
Schiller Park, Ill. 60176

A modeling plastic that stays soft until heated to 275°F. for 15 to 30 minutes
Polyform

Sculpmetal Co.
701 Investment Building
Pittsburgh, Pa. 15222

Plastic steel and epoxy bond

Woodhill Chemical Co.
18731 Cranwood Parkway
Cleveland, Ohio 44128

Duro-plastic, Aluminum, Liquid Steel, Gook®, Celastic®

PLASTICIZERS

Velsicol Chemical Corp.
341 E. Ohio Street
Chicago, Ill. 60611

Plasticizer for polyester resin: Velsicol® Benzolflex 9-88

PROMOTERS

Cincinnati Milackron Chemicals, Inc.
4701 Marburg Avenue
Cincinnati, Ohio 45209

Polyester promoter
Advocat® 97

RELEASE AGENTS

Brown Paper Co.
Kalamazoo, Mich. 49004

Wallhide 626, self-releasing paper (#40 base)

Brulin & Co.
2920 Martindale Avenue
Indianapolis, Ind. 46205

Brulin's #731 for use before casting urethane foam; also, 300M cleaner to clean mold

Chem-Trend Inc.
3205 E. Grand River
Howell, Mich. 48843

Liquid, sprayable release agent for urethane foam

Dexter Corp.
Midland Division
Waukegan, Ill. 60085
 or
Rock Hill, Conn. 06067

Barrier coat in a spray can for urethane casting

Dow Corning
Midland, Mich. 48640

Silicone release paper

General Electric Co.
Chemical Materials Department
1 Plastics Avenue
Pittsfield, Mass. 01201

Dry Film CS-87

Guardsman Chemical Coatings
1350 Steele, S.W.
Grand Rapids, Mich. 49502

Guardsman's 72-365 clear basecoat primer for urethane masters and molds

Johnson Wax
Service Products Division
Racine, Wis. 53403

Wax Plate, Bright-Plate, Solve-Cote, Permacote, wax coatings, and mold releases

Miller-Stephenson Chemical Co., Inc.
Route 7
Danbury, Conn. 06810

Release agents, degreasers, strippable protective film, et cetera

Paper Corp. of America
630 Fifth Avenue
New York, N.Y. 10020

Part Wick, breathable, textured release paper

Price Driscoll Corp.
75 Milbar Boulevard
Farmingdale, N.Y. 11735

Yellow Label mold release for general-purpose release, including wax
Epoxy ParFilm and Polyester ParFilm for those resin systems

Randolph Chemical
Carlstadt, N.J. 07072

Barrier coat in a spray can for urethane

Reynolds Metals Co.
6601 W. Broad Street
Richmond, Va. 23230

Polyvinyl alcohol

Smooth-On, Inc.
1000 Valley Road
Gillette, N.J. 07933

Several kinds of releases
Sonite #815 Wax and Sonite Seal Release

RESINS AND SHEETING

Acrylic

Ain Plastics
65 Fourth Avenue
New York, N.Y. 10003

A wide range of sheets, resins, and plastic findings

American Acrylic Corp.
173 Marine Street
Farmingdale, N.Y. 11735

Decorative acrylic structural sheets in a variety of patterns; called LUMAsite; can be used as standard acrylic sheeting

A-T-Hyde Co.
Grenloch, N.J. 08032

Cast acrylic rod and tube

Cadillac Plastic
148 Parkway
Kalamazoo, Mich. 49006

Outlets throughout the country

General Tire Chemical
Plastics Division
Newcomerstown, Ohio 43832

Polyvinyl, chloride, and acrylic sheeting
Acrylevin

Imperial Chemicals Industries, Ltd.
Plastics Division
Welwyn Garden City,
Herts, England

Industrial Plastics
324 Canal Street
New York, N.Y. 10013

Jobber of a large assortment of resins, sheetings, fillers, findings, et cetera

Rohm and Haas Company
6th and Market Streets
Philadelphia, Pa. 19106

Plexiglas, MMA monomer, Rhoplex, AC-33, Acrysol GS, Tamol 731, Acryloid B7, B72

Studio Plastique
W. H. Glover, Inc.
Atlantic Highlands, N.J. 07716

Acrylic, polyester, epoxy, molds, and findings

World of Plastics
771 Edgar Road, Route 1
Elizabeth, N.J. 07202

Sheeting and some findings; supplies neon tubing and apparatus

Acrylic-based Polyester

Rohm and Haas Company
Independence Mall West
Philadelphia, Pa. 19105

Paraplex® P-444A

Epoxy

Atlas Minerals and Chemicals
Mertztown, Pa. 19539

Moldable two-part epoxy putty
Epoxy Bond

Dow Chemical Co.
Midland, Mich. 48640

DER 332 and DOW

M & T Chemicals Inc.
Rahway, N.J. 07065

Epoxy rapid-curing system
Apogen® 101

Marblette Corp.
37–31 30th Street
Long Island City, N.Y. 11101

Marblette®

John W. McNabb Laboratories
313–317 E. Fulton Street
Lancaster, Pa. 17604

Soft epoxy dough in two parts; cures at room temperature to be buttered on a form or used as an adhesive; called McNabb

Ren Plastics
5656 S. Cedar Street
Lansing, Mich. 48909

Epoxy two-part clear system
RP-106/H-953

Shell Chemical Co.
Industrial Chemicals Division
110 W. 51st Street
New York, N.Y. 10020

Epon®

Tra-Con, Inc.
55 North Street
Medford, Mass. 02155

Clear casting epoxy system
Tra-Cast® 3012

Union Carbide Corp. ERL
Chemicals and Plastics Division
270 Park Avenue
New York, N.Y. 10010

Flameproof Polyester Resin

Hooker Chemical Corp. Hetron resins
Durez Plastics Division
North Tonawanda, N.Y. 14120

Packaged Polyester Casting Resins

California Titan Products Polyester resin and contingent supplies sold in
2501 S. Birch Street small quantities et cetera
Santa Ana, Calif. 92707

Deep Flex Plastic Molds, Inc.
2740 Lipscomb Street
Fort Worth, Tex. 76110

Industrial Plastics Wide range of plastic materials, including resins,
324 Canal Street fillers, reinforcements, et cetera; all quantities
New York, N.Y. 10013 available

Seymour of Sycamore, Inc. Spray Gel®, unique spray can for a two-part system
Sycamore, Ill. 60178 of polyester gel for fiberglass

Taylor and Art Plastics
1710 E. 12th Street
Oakland, Calif. 94606

Valspar Corp.
200 Sayre Street
Rockford, Ill. 61101

Polycarbonate

General Electric Co. Lexan® is a trade name for sheet polycarbonate
Plastics Department
1 Plastics Avenue
Pittsfield, Mass. 01201

Polyesters

American Cyanamid Co. Laminac®
Plastics and Resins Division
Wallingford, Conn. 06492

Diamond Shamrock Chemical Co. Excellent water-clear all-purpose casting resin—
300 Union Commerce Building Dion 6914
Cleveland, Ohio 44115

PPG Industries, Inc. Selectron®
Coatings and Resins Division
One Gateway Center
Pittsburgh, Pa. 15222

Reichhold Chemicals, Inc. Polylite® 32-032 et cetera
RCI Building
White Plains, N.Y. 10602

Polyvinyl Chloride

Borden Chemical Co.
350 Madison Avenue
New York, N.Y. 10017

B. F. Goodrich
Chemical Division
1144 E. Market Street
Akron, Ohio 44305

Pyroxylin

American Pyroxylin Corp.
72-86 Second Avenue
Kearny, N.J. 07032

Woodhill Chemical Corp. Celastic®
18731 Cranwood Parkway
Cleveland, Ohio 44128

Sprayable Vinyl (cocoon)

Essex Chemical
Clifton, N.J.

R. M. Hollingshead Corp.
728 Cooper Street
Camden, N.J. 08108

Styrene

Dow Chemical Co. Styrene monomer
Midland, Mich. 48640

Water-extended Polyester

Ashland Chemical Co.
Columbus, Ohio 43212

Water-filled Polyester

Reichhold Chemicals, Inc. Polylite 32-180
RCI Building
White Plains, N.Y. 10602

SOLVENTS

National Solvent Corp.
3751 Jennings Road
Cleveland, Ohio 44109

Shell Chemical Co. Acetone
110 W. 51st Street
New York, N.Y. 10020

Union Carbide Co.
Chemicals and Plastics Division
270 Park Avenue
New York, N.Y. 10017

Bibliography

Baldwin, John. *Contemporary Sculpture Techniques.* New York: Reinhold Publishing Corp., 1967.

Bick, Alexander F. *Plastics: Projects and Procedures with Polyesters.* Milwaukee: The Bruce Publishing Co., 1962.

Bunch, Clarence. *Acrylic for Sculpture and Design.* New York: Van Nostrand Reinhold Co., 1972.

Burnham, Jack. *Beyond Modern Sculpture.* New York: George Braziller, Inc., 1969.

Cook, J. Gordon. *Your Guide to Plastics.* Watford, Herts, England: Merrow Publishing Co., Ltd., 1968.

DuBois, J. Harry, and Frederick W. John, *Plastics.* New York: Reinhold Publishing Corp., 1967.

Martin, J. L., Ben Nicholson, and N. Gabo, (Eds.). *Circle.* Great Neck, N.Y.: Hearthside Press, Inc., 1969.

Modern Plastics Encyclopedia. New York: McGraw-Hill Publications, Vol. 49: No. 10A, October 1972.

——, New York: McGraw-Hill Publications, Vol. 48: No. 10A, October 1971.

Newman, Jay Hartley, and Lee Scott. *Plastics for the Craftsman.* New York: Crown Publishers, Inc., 1972.

Newman, Thelma R. *Plastics as an Art Form.* Radnor, Pa.: Chilton Book Company, Revised Edition, 1969.

——, *Plastics as Design Form.* Radnor, Pa.: Chilton Book Company, 1972.

Panting, John. *Sculpture in Fiberglass.* New York: Watson-Guptill Publications, Inc., 1972.

A Plastic Presence. The Jewish Museum, New York, Milwaukee Art Center, San Francisco Museum of Art, 1969-70. A catalog.

Plastics and New Art. Institute of Contemporary Art of the University of Pennsylvania and The Marion Koogler McNay Art Institute, San Antonio, Texas, 1969. A catalog.

Plastics as Plastics. The Museum of Contemporary Crafts, New York, 1968-69. A catalog.

Roukes, Nicholas. *Sculpture in Plastics.* New York: Watson-Guptill Publications, Inc., 1968.

Schwartz, Therese. *Plastic Sculpture and Collage.* Great Neck, N.Y.: Hearthside Press, Inc., 1969.

Index

Numbers set in bold indicate illustrations

Thelma R. Newman has become an internationally recognized authority on plastics since the publication of her definitive and monumental books, *Plastics As An Art Form* and *Plastics as Design Form.*

She received her bachelor's degree from the College of the City of New York, her Master of Arts degree from New York University, her doctorate from Columbia University, Teacher's College, and studied design engineering for plastics at Newark (N.J.) College of Engineering. She has also studied sculpture under Seymour Lipton at the New School for Social Research, photography with Carlotta Corpron, Aaron Siskind and Josef Breitenbach, and stained glass window making as an apprentice to J. Gordon Guthrie at Durham and Sons.

Widely known as a lecturer and a recognized teacher and authority on plastic sculpture and other art forms, she has exhibited her work expressing light and transparency in cities throughout the country. She has her own studio in which, between consulting and lecturing, she constantly seeks new worlds to conquer in the realm of plastics.

She has taught at New Jersey State College, North Texas State College, Newark State College and for four years was director of art for the Union Township schools, Union, New Jersey.

In addition to *Plastics As An Art Form* and *Plastics as Design Form,* Thelma Newman is the author of numerous other books on art and craft. She has also written numerous articles in technical, art and learned journals. She is a senior member of the Society of Plastics Engineers and is president of and a plastics designer for Poly-Dec. Company, Inc.